THE
PENCIL PERFECT

The Untold Story of a Cultural Icon
by **Caroline Weaver**

gestalten

Preface

This book is about a sole object—the pencil, or, specifically, the marvel that is the wood-cased pencil. It's a thing that every person of every culture is familiar with and is something that has become an icon of modern engineering over the roughly four centuries of its existence. Chances are, you have a pencil on your desk right now, or at least hidden somewhere in a drawer, despite the regularity of its use. It's the star of school-supply shopping lists and is often forgotten by adults in the modern world as we've become accustomed to more advanced forms of writing and communication. All of this considered, the pencil is something that deserves a second look now more than ever.

As a person who has dedicated their adult career to sharing and preserving the history of pencils past and the glory of the unknown pencils of today, I've made it my mission to bring the object to light again. What we get from a pencil is an experience that's opposite of what we gain from our obsessive use of digital technology. The pencil is a tangible thing: it's made simply of wood and graphite and it provides a sensory experience unlike any other object of its kind. What you might think to be nothing more than a basic of the office-supply closet is actually something that exists only because of the ingenuity of craftsmen of centuries past. It's something whose physical characteristics have been informed by countless wars, cultural shifts, and feats of industrialism.

The history of the pencil is not only one that is full of anecdotes and connections to other important events but also one that is little shared, especially in an accessible form. Its relevance in the twenty-first century is often questioned, but the conversation surrounding the pencil now is a different one. The nature of the world we live in is beginning to encourage us to consider the benefits of using analog tools as devices for thoughtful communication as well as for the purpose of cognitive experience. What a computer can't do, a pencil can. We're experiencing the beginning of an analog revolution that forces us to reconsider the way we go about our daily tasks with an increased urgency to slow down, take a step back, and evaluate what technology has done to our minds and to our lifestyles.

With a pencil, one can experience an intimacy that can't be found elsewhere. Each part of the pencil—as simple as those parts are—stimulates a different sense. The wood smells of the tree it came from, the graphite feels a certain way to write with, the eraser uses friction and heat to remove the marks, and the whole thing can disappear after a finite number of words and a quick spin in a pencil sharpener. A combination of each action creates a soundtrack unique to that pencil. The interaction is purely physical and completely connected to the thoughts and ideas in the user's mind. A person is completely free to use their pencil in any way possible—after all, it's erasable.

The founder of Kita-boshi, a small Japanese pencil factory, was once quoted as saying: "A pencil sacrifices itself to serve people. Both humans and pencils need cores." Mr. Sugitani was right—the pencil is an object of an extremely poetic and ephemeral nature. It's a man-made example designed to proudly show its wear at the benefit of the user. From the discovery of graphite in the sixteenth century, to the nineteenth-century

beginnings of wood-cased pencils as we know them now, it required the skills, knowledge, and innovation of many to create a writing instrument. The solidarity of all of these innovators is unquestionable and like many early inventions of the industrialized world, it was a collaborative effort.

What we can learn from the pencil is that with political, social, and technological shifts, some things have stood the test of time not necessarily out of need but because of reliability. The pencil is one of those non-essential objects that will always exist because of its permanence in so many cultural landscapes and for its ability to be there when your phone is dead or your pen runs out of ink. Each pencil tells a different story, and each context is different depending on geography or history. The wannabe anthropologist in me wants to believe that it's the perfect, most simple, utilitarian example of cultural development. From the invention of the kiln-fired pencil core during the French Revolution to the physical changes made due to shortages during the Second World War to the establishment of icons like the yellow American pencil—each pencil is representative of a person, a place, or a time.

We simply can't ignore the fact that the story of the pencil in our current age holds value in the telling of a greater story—that of communication. Before the pencil there was the fountain pen; and, after the pencil and its contemporary writing counterparts, is the computer. The one thing I hope we can gain from pausing to pay attention to such an object is a mutual respect for communication technology and for the simplicity of something made of materials sourced from nature but perfected by human beings.

ABOUT THE AUTHOR

Caroline Weaver is a lifelong pencil obsessive who owns a shop in New York City dedicated solely to wood-cased pencils, new and old, from all over the world. As a child she coveted a set of Caran d'Ache Prismalo colored pencils and proudly sharpened six early-2000s-era black Ticonderogas before school each day. From there, her love of the pencil and knowledge of the subject flourished. After traveling the world in search of the finest pencils still in production, she opened her shop in 2015. Caroline lives in the East Village neighborhood of Manhattan and has a tattoo of a pencil on her forearm.

THE

16th / 17th

CENTURIES

Imagine the sprawling, green landscape of Cumberland, England, in the sixteenth century. Unbeknownst to the travelers who crossed the rolling, grass-covered hills, there was a mineral hiding beneath that was so strange and so mysterious it took over a century for it to be fully understood. In this lush and serene land, graphite was discovered by sheer accident during a raucous storm around 1565. The black, slippery substance—the immediate physical qualities of which can be likened to lead—was unlike anything else ever discovered in the natural world. Chunks of pure graphite were appropriated for a multitude of purposes, including the marking of livestock and eventually as a lubricant, a medicinal remedy, and, of course, as a drawing material, which was sold on the streets of London wrapped in string.

This mineral—so common to us and so imperative to the pencil—spent nearly the first 100 years of its existence without a known chemical identity and even without a universal name. We might think of the pencil as something that's unquestionably simple in its design and function, but the story of how it got there is more complicated than one might believe. How to effectively use graphite as a portable writing tool posed serious scientific and engineering challenges, which led countless innovators to attempt not only to understand it but also to realize its full potential. Carpenters and cabinet makers during this time used their wood-working skills to box in the pure graphite to make it more easily useable, but little did they know, their innovation would lead to centuries of wooden pencil making.

The Borrowdale mine, situated in England's picturesque Lake District, was the source of some of the highest-quality graphite of its time. It had its heyday in the early 1600s.

The *Discovery* of Graphite

The pencil has always been defined by a single ingredient. It's dark in color, slippery, erasable, and has a sort of metallic quality to it. Without it, the pencil couldn't exist.

The discovery of this substance is a bit of a mystery, usually told through romanticized stories of serendipitous encounters. It can be found on almost every continent in the world, though one place is especially recognized as its origin.

As the story goes, sometime in the 1560s in the Lake District in England, an extraordinarily strong gust of wind uprooted a large ash tree (some accounts claim it was oak) in the lush, sprawling hillsides of the North West. The crater left in its place gave way to the single most crucial discovery in the history of the pencil. Found underground in the county of Cumbria was a deposit of an unknown mineral substance, the very substance that we call graphite.

Who actually found the tree and recognized the new material's potential, no one knows for sure. Most stories related to the origins of graphite are undocumented and have been told so many times over that they've become the stuff of legends. One tale tells of a shepherd who encountered the deposit while tending to his sheep. He immediately found the new substance useful for marking and tracking his flock and was credited for being the first to appropriate the graphite. Another speaks of a mountaineer who came upon the tree during a hike and noticed black powder stuck to its roots.

What we do know is that graphite wasn't exactly a new material, it just wasn't a widely known one. It's also unknown how far back its existence dates, but tales have been told about its use in just about every era of humankind. During the Neolithic Age, it was allegedly used to paint pottery. There are accounts of graphite being found in lump form in Ancient Egypt. In the 1907 book *Graphite: Its Properties, Occurrence, Refining and Uses*, Fritz Cirkel writes about it being used to paint on stone

→ Even now, Cirkel's work on graphite is the most comprehensive and accurate despite being 100 years old. Though more easily read by a chemist than a reader interested in pencils, it covers every aspect of the mineral.

vessels to be buried in ancient graves. Mines in Belgium and the Netherlands have been said to have existed prior to Borrowdale and to have exported graphite to Italy, where it was sold to artists as "Flemish Stone." As far back as the 1400s, graphite was allegedly being mined locally and used to make crucibles in Bavaria. Any number of these accounts may or may not be true, but the discovery of the Borrowdale mine, as it was called in Keswick, was by far the most credible and most widely known.

Before it was named graphite, the mineral was called many other things. Plumbago was the most common, as it means "that which acts like lead" in Latin. In Germany, it was often referred to as bismuth because of its seemingly metallic qualities. In Cumbria, the local name for the homegrown substance was wad, likely because it was found in wad-like chunks in the veins of the mine. In other places, it was simply called black lead. Interestingly, neither pencils nor graphite have ever contained actual lead in any capacity, except maybe for the brief use of lead paint. It was assumed that it was something of the sort merely because of its dark color and generic physical characteristics. For some reason, this assumption and label stuck and is often considered true to this day. You don't need to worry—your pencil won't kill you. The earliest graphite was found long before the science of chemistry was fully understood and new discoveries were classified based on the little information that could be observed and what was already known to exist.

The first major ground that was broken in the study of the chemistry of graphite happened around 1779, about two centuries after the founding of the Borrowdale mine by German-Swedish chemist and pharmacist Karl Wilhelm Scheele, who specialized in the study of acids. This interest in acids led him to find that graphite burns to carbonic acid in a current of oxygen, which led him to the very important inference that graphite is in fact made entirely of carbon. This notion

was debated and widely doubted by other well-known chemists of the era, but was eventually recognized after graphite's resistance to other agents was more thoroughly tested. Mineralogist A.G. Werner further studied its properties towards the end of the eighteenth century and is credited with naming it graphite, from the Greek *graphein*, meaning "to write."

Carbon is an element mostly known for making up graphite and diamonds, whose structures are surprisingly similar except for a few details. Diamonds occur under high pressure and high temperature conditions while graphite could be considered their lower-maintenance sibling. Really though, it's rather simple. The crystal structure of graphite is hexagonal while the structure of diamonds is cubic. For decades it's even been possible to make diamonds from graphite—interesting, as graphite is entirely erasable and diamonds are virtually indestructible. Apart from that, graphite is a material all its own. It occurs in igneous rock (often limestone) or in meteorites and mostly in one of two forms: flake graphite or crystalline graphite. Flake graphite is most regularly used in pencils and for other things made with graphite. Crystalline, though rather common, is only actively mined in Sri Lanka. One of the more curious characteristics is that graphite is not a metal, though it appears to be so, and is also the only non-metal that is electrically conductive.

If you've ever wondered what a graphite mine looks like, you can visit the Graphitový Dul Český Krumlov in the Czech Republic or the Seathwaite Mines of the Borrowdale valley in England. The famous Borrowdale mine was closed for good in 1891, but not before a couple of centuries of heavy activity. In the immediate years following its discovery, the graphite was cut into pieces, wrapped in paper, string, or sheepskin, and sold to local farmers, who used it for marking livestock, and to artists, who used it to sketch out paintings. With encouragement

from Queen Elizabeth as part of a new mining initiative, German miners came to the United Kingdom in the late 1700s and began doing serious mining work in Borrowdale. By the early seventeenth century, Borrowdale graphite was being exported all over Europe and was being sold regularly on the streets of London as an everyday product. Graphite had become popular as a writing material, especially for trades that involved keeping field books, and was favored by many innovators of the time. Around this time, other parts of the world had begun tapping into graphite mines of their own but quickly realized that Borrowdale graphite was uniquely pure compared to all the rest, which usually contained too much quartz and/or mica to be cut and used in chunks as Borrowdale graphite was.

The heyday of the Borrowdale mine is considered to have been the early 1600s, when the graphite was pure and plentiful and the demand was high. The mine was closed in 1678 because of the belief that it was totally used up. By 1710 it was opened up again and found to have been raided over the years by thieves hoping to capitalize on the mine's reputation. It's hard to imagine now since practically every inch of our earth has been scoured for all its available resources, but at the time there was nothing better than

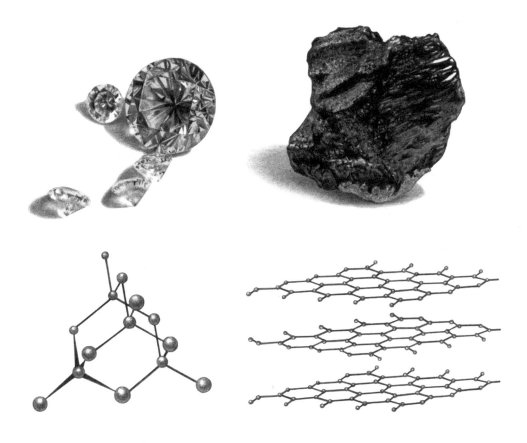

The carbon atoms in graphite [RIGHT] are structured in sheet-like layers—very different
to that of the material's almost indestructible relation, the diamond [LEFT].
The layers slide apart when they come into contact with other surfaces, leaving a mark.

In the early 1600s, graphite was wrapped in
string and sold as a drawing material.

Borrowdale graphite and people went through great lengths to get their hands on it even though there was much more graphite to be found. Security measures were taken and once reopened, the mine continued to produce the product with lesser quality until it was permanently closed towards the end of the nineteenth century. The closing of Borrowdale wasn't necessarily because there was no graphite left to be mined, but rather because graphite had become more readily available and major advancements had been made that allowed inferior graphite to be processed into better quality without having to pay a premium for something chemically pure.

Nothing quite as perfect as Borrowdale graphite has been found to this day. Mines in Siberia and parts of Asia have come close, but apparently nothing was better than the original source. From what I gather there are no known pieces of original Borrowdale graphite left in the world. These days, most pencils are made from a combination of graphites from different places.

Should you wish to pursue "pencil tourism," Keswick is also home to the Cumberland Pencil Museum, which is full of artifacts and information about pencil making, particularly in the Lake District. Though the county of Cumbria once played host to an impressive number of pencil factories, only one remains.

→ Derwent, formerly known as the Cumberland Pencil Company, still makes graphite pencils in the region, though only ones marketed as drawing pencils.

Many different objects and industries have benefited from the discovery of graphite. Its simple structure, heat resistance, and conductivity have long been useful traits for a number of industries. It is said that graphite has been used for the manufacture of crucibles since the fifteenth century. A slightly more contemporary Joseph Dixon invested in a graphite mine in Ticonderoga, New York, from which he used the raw material for his crucible company in the 1800s. The density, stability, and resistance of the substance was ideal for making the molds, which also usually involved the use of clay and fine sand. It didn't hurt that graphite is a particularly slick and smooth mineral and can withstand temperatures of over 600 degrees Celsius (1,112 degrees Fahrenheit). This was especially useful in the making of bombs and cannonballs. Dixon also used it in powdered form to line molds in his foundry to make them more non-stick. Much of the credit for the creation of the American graphite industry is owed to Dixon and his Ticonderoga mine.

→ You might recognize the names Ticonderoga and Dixon as the name of the pencil made by the very same company. More on that later.

Because of the aforementioned slipperiness of natural graphite, it was and still is often used as a lubricant when in powdered form. It oxidizes slowly, is low friction, and most importantly is not affected by acids or gases. Here's a little tip: the next time you've got a sticky lock or

any sort of jam, just crush the end of your pencil and either use it dry or mix it with oil.

More recently, batteries are being developed for use in smartphones that are made of aluminum and graphite. They're meant to hold a charge longer, be less expensive than the current lithium-ion batteries, and also more environmentally friendly. On a less high-tech scale, graphite batteries can be made at home with aluminum foil, water, salt, vinegar, and a few tools.

One use I hadn't considered before doing research on this subject is graphite paint, which has been around since the late 1800s. Generally it's used as a protective coating, especially beneficial for iron structures. It's a terrific agent to protect against rust, and though it used to be made with linseed oil, it is now usually water-based. These days it's most common for painting the bottoms of lawn mowers because it keeps grass from sticking, keeps the machine rust-free, and is low friction so as to not cause mechanical problems.

There are a few more unusual uses for graphite. Tennis rackets are often made entirely or partly out of the mineral because it's rigid but also very lightweight. For centuries graphite has also been used for medicinal purposes and is often considered an under-appreciated natural remedy. In the realm of homeopathy, it is said to help with cold sores, metabolic problems, eczema and other skin ailments, ul-cers, hair loss, menopause, *→ Graphite, as used as a homeopathic treatment method, is often referred to as Graphites or often still as Plumbago.* and mood swings among many others symptoms. It's either applied as a topical solution or mixed with water and ingested. If you've ever been told not to chew on your pencil because you might get lead poisoning, it's actually quite the opposite case, though I wouldn't go so far as to recommend it either.

Though preferred in its natural form for most uses, especially for the making of pencils, graphite can rather easily be made synthetically as well. Whether you're marking your sheep, writing a novel, casting metals, or playing tennis, graphite is a mineral that is undoubtedly important. The Borrowdale mine may be closed forever, and greater advances in the study of carbon have been made, but graphite is still plentiful all over the Americas, Europe, Asia, and Africa, and likely will be for as far as we can see into the future.

Before erasers came bread. Instead of a rubber eraser, a slice of bread was used to eliminate unwanted marks.

Wood-Cased Pencils Enter the World

Though it has disputed origins, the wooden
object we know today didn't come
into being until Friedrich Staedtler decided
to defy the Nuremburg Council.

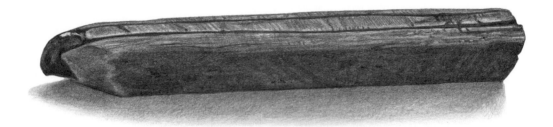

A clunky-looking piece of graphite encased in wood;
this is thought to be one of the first pencils.

Before the pencil as we know it, there was no name for such an object except for "stylus," which was what you'd call a long stick used for mark making, usually made out of lead, silver, or other metals. Eventually, the English language arrived at the word "pencil" but not for the graphite variety; it was used to describe a long, pointy artist's brush. It took a while for the term to catch on in the context of the graphite writing instrument, with little help from the *Encyclopaedia Britannica*, which still defined the pencil as a brush through 1771, though wood-cased pencils had existed for about a century already.

The first mention of anything resembling a wood-cased pencil occurred in 1565, around the same time as the discovery of graphite in England. The Swiss naturalist Conrad Gesner described a piece of wood that had been hollowed out and filled with a piece of "English antimony" (which we can assume to be graphite or something similar) in his *Treatise of Fossils*. It was briefly written about and il- → The Treatise of Fossils lustrated in a small drawing *was one of about 70 books* along with that of a fossil. *Gesner published in his* From the illustration, the *lifetime, including a Greek–* pencil itself appears to be *Latin dictionary that* a cylindrical stick of wood *he published at age 21.* with a piece of lead pointing out of the bottom and some sort of elaborate knob affixed to the end, which was meant to be used to tie the pencil to a tablet or field book. This illustration never really garnered much notice as the first evidence of a pencil as it was only an aside to his work on fossils, but Gesner was certainly on to something …

The oldest known wood-cased pencil was found on the roof of a seventeenth-century German house and is currently kept as part of the Faber-Castell Collection, but beyond that there's not much documentation that wood-cased pencils existed before an ambiguous date in the 1600s. Much of early pencil history is said to have happened in Germany, but many contend that the first pencils were made in England and associated with the Borrowdale mine, mostly made by Keswick joiners for use by clergymen. This is where it all gets a bit blurry. Sure, graphite was being used in the United Kingdom as a writing instrument in the seventeenth century, but most histories tend to favor that the first cased-in pencils came from Nuremberg, Germany, somewhere in the middle of the seventeenth century.

We must keep in mind that at this time the world's graphite supply was still mostly coming from the Borrowdale mine in England, which was quickly depleting. Considering this, the idea of having a wood-cased pencil instead of just a stick of pure graphite made sense. Graphite was a slippery, messy material and was becoming increasingly precious, so casing it in wood would not only lessen the mess, but also require less of the raw material. The other benefits were that it allowed for more precise use, since it could be sharpened to a point, and it was also supported by a wood casing that would keep it from breaking. Though unrecorded, evidence of the first truly wood-cased pencils can be traced back to Nuremberg, where carpenters had been making pencils for their own use and for limited trade. Nuremberg from here on out became an increasingly important city in the history of the pencil and was eventually recognized as not only the pencil's birthplace, but also the pencil capital of the world. At this point, the pencils resembled something similar to what we know now as a carpenter's pencil: a rectangular stick of graphite was boxed in with wood and often left open on one side, with the graphite level to the wood. Design wasn't a concern at all, it was really just a matter of utility. The mere invention of the instrument was groundbreaking, though its potential as a commodity wasn't realized to its full potential. This was long before Faber-Castell or any of the major German brand names that we now know—with the exception of one.

Friedrich Staedtler, son of a metal drawer, learned the art of pencil making from his

father-in-law, who was a gun stocker by trade (in other words, he made the wood part, or stock of the gun). Staedtler, who was a shopkeeper at the time, was fascinated by the prospect of pencil making and sought to make pencils of his own, from start to finish. This wasn't something that had been done before. At the time, pencil making was divided into two trades: the cutting and processing of the graphite was dealt with by lead cutters and lead melters, and the casing-in of the pencil was handled exclusively by carpenters, gun stockers, joiners, knife handle makers, or basically anyone who specialized in wood craft. Since this was many, many decades before the invention of useful wood-working machinery, each step of the process had to be done by hand and was therefore assigned by specialty. In 1662, at the age of 25, Staedtler sought permission from the Nuremberg Council to make his own pencils as an all-inclusive trade and was harshly rejected because he wasn't a member of the carpenter's guild and the privilege of participating in pencil making was strictly reserved for qualified tradesmen.

Friedrich Staedtler's rebellious ways not only initiated a new trade, they started a company that would become a household name.

A very brazen Friedrich Staedtler didn't care about the Nuremberg Council's verdict. He began making his own pencils, for which he cut the graphite and cased the pencils himself. It was indeed a tedious art, as he had to craft each pencil individually and entirely on his own. As the story goes, Staedtler is fabled to have created the first useable graphite cores with inferior graphite by grinding it and combining it with sulfur. As Staedtler gained a reputation as a pencil maker, the city of Nuremberg eventually took notice of his skill despite the fact that he had been previously deemed unqualified. His workshop was marked by a moon that hung above its door. After Staedtler proved to the

In the 1800s, Staedtler developed from a craft workshop into an industrial enterprise. In 1840, the company already produced 63 sorts of pencils in Nuremburg.

city of Nuremberg that it was indeed possible to make pencils from start to finish in one workshop, the council changed their regulations on the craft and the term "pencil maker," or Bleistiftmacher in German, slowly gained recognition as a legitimate trade. By 1731, pencil makers had their own guild and were no longer at the mercy of other trades and city manufacturing rules.

We have one man's determination and ambition to thank for the very beginnings of the pencil

→ *In the early days of pencil-making in Nuremberg, a group of people labeled "bunglers" often tried to sell poorly made, less expensive imitations on the street. This is what encouraged pencil companies to adopt a logo to print on their pencils as their brand's trademark.*

industry. If it weren't for Staedtler, who paved the way for non-English pencils, the craft and the object likely would have taken decades longer to become a worldwide commodity. From Gesner's mention of wood-cased pencils to hints of the likes from Keswick, the tradesmen of Nuremberg became innovators without even realizing it and Staedtler played a major role in creating one of the world's most influential everyday objects without thinking beyond the immediate need. It is comical to think that so much of this is unrecorded history when it involved the advent of an object that ultimately helped make history more easily recordable. Despite that, the stories of these "pencil heroes" have stood the test of time.

THE

18th

CENTURY

Just about everything we know about pencils came about sometime during the eighteenth century—a century that proved to be a big one for the development of pencils as writing instruments. By the 1760s, A.W. Faber, founded by cabinet maker Kaspar Faber, was up and running in Germany and began crafting wood-cased pencils for the commercial market. In the wake of the Scientific Revolution, more and more was being discovered about the chemical properties of graphite, which opened the door for better pencils and a new industry for craftsmen and engineers alike.

While England and Germany were making pencils the best they knew how, the French Revolutionary Wars had broken out and France was in dire need of an easy-to-use writing instrument—something that was to prove difficult to acquire as all trade lines to pencil-making countries were shut off. In a last ditch effort to find a solution, Napoleon contracted young engineer Nicolas-Jacques Conté to try his hand. According to legend, in a mere eight days, Conté found a way to grind inferior graphite to a fine powder, mix it with clay, and fire it in a kiln to improve its strength. Afterwards dubbed the Conté method, this new discovery shook the pencil-making world like no other and paved the way for superior pencils.

Out of
Conflict Comes...

Nicolas-Jacques Conté (1755–1805), an engineer who specialized
in hot air balloons, turned his attention to pencils
after injuring his eye in a balloon-related experiment.

As France was at war with England, where the best pencils of the time originated, the country enlisted the help of painter-turned-engineer Nicolas-Jacques Conté and the graphite core we know today was born.

As with the history of many consumer products, times of war greatly affected the development and existence of the pencil. Out of need comes innovation, which was very much the case during the eighteenth century. A lot was going on in the world in the late 1700s: scientific discoveries were being made left and right in the wake of the Scientific Revolution, the American Revolutionary War happened, as did the Anglo-French War as a result, and later the French Revolution. Territories were being lost and gained all across Europe and there was little political order. You might wonder where the pencil comes in, especially as it was still quite a new commodity. If you think about it, at this time in history the only alternative writing instrument was a quill and ink. The first fountain pens didn't exist until the very end of the century, so portable writing instruments weren't much of a thing in the 1700s. During wartime, the pencil was in huge demand worldwide due mostly to its convenience and ease of use. The only good pencils were coming out of England, made with infamous Borrowdale graphite. Pencils were being made in Germany also, but the graphite used wasn't as pure. They were being produced with a combination of graphite dust, sulfur, and

→ The exact period of time classified as the Scientific Revolution is up for debate, but generally from around 1550 to 1700 huge advancements were made in math, physics, biology, and especially chemistry. Major players included Nicolaus Copernicus and Isaac Newton.

glue, which resulted in a rather unpleasantly brittle and scratchy pencil.

By the end of the eighteenth century, the Declaration of Independence had been signed in the United States, the American Revolutionary War was over, and France (having sided with America during the war) was hugely in debt under the reign of King Louis XVI and on the verge of a revolution of their own. England was furious with France, and many other European nations got involved—the result being a story we know well from history books: the overturning of the French monarchy, the execution of King Louis XIV and the takeover by Napoleon. The point is: the lack of good pencils wasn't the only problem—France was in serious trouble and many nations were in turmoil.

Because all of the best pencils were being made in England at the time, it was impossible for France to get a hold of them. Out of need, Lazare Carnot, the French Minister of War, enlisted a man by the name of Nicolas-Jacques Conté to find an alternative. You might recognize his name if you are already a little familiar with the history of pencils, but there's a longer story as to why it's so synonymous with the humble pencil than most realize.

Nicolas-Jacques Conté was born into a farming family in Normandy, France, and grew up as one of six siblings. Legend has it that at the age of nine he fashioned a violin using only a knife. This story is unconfirmed, though it seems

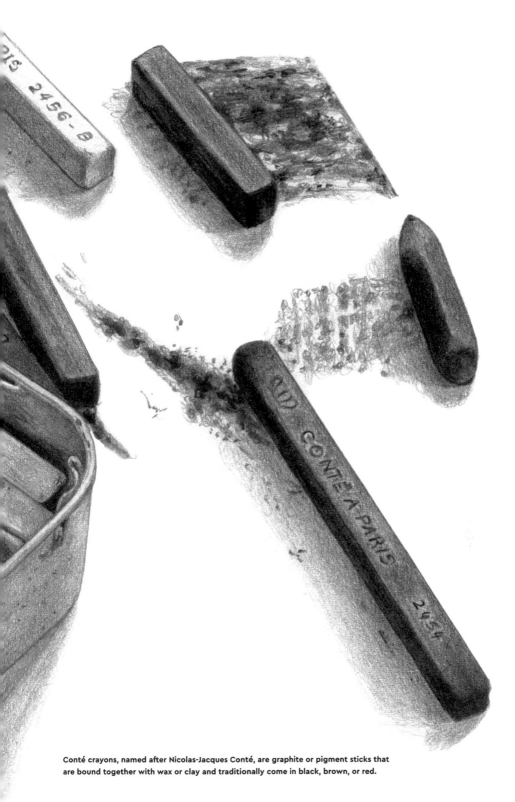

Conté crayons, named after Nicolas-Jacques Conté, are graphite or pigment sticks that are bound together with wax or clay and traditionally come in black, brown, or red.

viable based on the genius that Conté grew up to be. In his early years of adulthood, he worked as an assistant to a portrait painter and became a rather talented painter himself, but during the beginning of the Revolution he was pressured to abandon his career for something more practical and beneficial to the war efforts. Conté had long had an interest in aeronautics, so the career switch to engineer came naturally for him.

During his time as an engineer he dabbled in chemistry, physics, and mechanics—all of which were newly developed areas of science at the time. Hot air balloons were his specialty and he contributed greatly to the development of the hydrogen gas used to fly them. After a balloon-related explosion, he severely injured his left eye, which may or may not have had something to do with him being tasked to make a better pencil. After all, making pencils was significantly less dangerous a job.

In 1794, at the age of 39, Nicolas-Jacques Conté discovered something that would overturn every previously existing method of making pencils. He had completed his mission for Carnot and developed a simple technique to make a graphite core from inferior raw materials that was significantly better than anything else on the market. The most remarkable part is that he did it in only eight days. The first part of the process was an obvious one, which involved grinding natural graphite to a fine powder and removing the impurities in a way similar to what the Germans had been doing for a while already. He then added careful amounts of water and potter's clay and worked it into a paste, which would then be put into molds in the shape of long rectangular sticks similar to a cut piece of Borrowdale graphite. The final and most important step was to pack the graphite-filled molds into a ceramic container that was then filled with charcoal. These ceramic boxes were fired in a kiln at a high temperature to harden and strengthen the mixture, just as you would do with ceramics. Really, that's it. A better pencil was born.

The clay was the vital ingredient, as it held the graphite powder together and created a result that was anything but brittle. Knowing what we know now about ceramics, it makes complete sense to use clay as a hardening material, but at the time it was a truly innovative discovery. After their time in the kiln, the pencil cores were inserted into deep grooves that were cut into individual strips of wood. Another piece of wood filled in the rest of the cavity where graphite was laid and the pencils were shaped to be round. This was close to how wood-cased pencils were being made elsewhere—individually and with the graphite held in some sort of groove. To the naked eye the Conté pencil looked just like those from England or Germany, but wrote so much more smoothly. It wasn't a Borrowdale pencil, but it was less expensive and it wrote like a dream compared to the rest of the available alternatives.

In 1795, the patent for the Conté pencil was issued and the rest is history. The wildest part of the story is how quickly he came up with the process when others had been trying for nearly a century. We should keep in mind that he did have experience with graphite from the making of crucibles, but otherwise had little experience with the pencil. Graphite (or plumbago as it was originally called) had long been a mystery until the eighteenth century, when advances in chemistry allowed for proper research, which led to the discovery that it is actually a form of carbon. For someone like Conté who was first and foremost a scientist, this likely would have aided him tremendously in knowing where to start. Henry Petroski, in his wonderfully comprehensive book *The Pencil: A History of Design and Circumstance*, questions whether it was Conté's lack of tunnel vision that led to his discovery. This could very

→ *Since its discovery, graphite was common in the making of crucibles, or molds, for use while casting metals, especially for manufacturing cannonballs. It was an ideal material because it could withstand high temperatures and had terrific lubricating qualities.*

well be true, as anyone who had tried and failed before him were carpenters and cabinet makers who were all too familiar with the subject. Regardless of how he did it, the profound impact of the Conté method speaks for itself. Perhaps he was a genius, or maybe he was just a little ahead of his time. Either way, we have him to thank for the pencils we're using today.

In the eighteenth century, word of new scientific discoveries in other countries didn't travel very fast, but when news did make it outside of France it changed the way pencils were made on a global scale. In fact, it traveled so slowly that Austrian architect-turned-pencil maker Josef Hardtmuth claimed he had come up with the same method three years prior to Conté. This isn't properly documented, so we'll never really know who did it first, though history tends to favor Conté. Something else to consider is that Conté wasn't quick to give up his secret method. It took a while for everyone else to figure out what he was doing right, but eventually German pencil makers used the method to improve their practices and it slowly was adopted in the very new American pencil industry where Henry David Thoreau took to the books to learn the science of how the Europeans were doing it to improve the otherwise sticky, greasy pencils his father's pencil company was making. Even today the graphite core of a pencil is made essentially the exact same way. The use of clay and heat also allowed pigment to be turned into a pencil core and colored pencils came to be. Nicolas-Jacques Conté later went on to invent machinery to make the leads round—yet another discovery that changed the way pencils are manufactured. By the middle of the nineteenth century there was no other way to make a pencil. His legacy is full of small but impactful inventions

→ Hardtmuth was said to have invented many other things in the industry, including the pencil-grading scale and the first yellow pencils. The sad truth is that there are many versions of all of these stories and Hardtmuth never really got the credit he deserved.

and discoveries, but his advancements in pencil making were by and large the most influential.

Had there not been a war that spawned the need, what would the pencil be? What would Conté have discovered instead? If you ask me, we owe Conté much more credit than he's given in this day and age, not just as the guy who figured out how to make a functional pencil core but also as an innovator who was capable of taking what little was known about science and apply it to any field necessary. Even Napoleon recognized him as a "universal man" and he was certainly right. Centuries later, a French brand of pencil bears his name as the founder. Conté à Paris still makes pencils in France, of course using the Conté method, though they specialize more in other colors and Conté crayons than they do in graphite pencils.

→ Conté's new technology also allowed him to invent Conté crayons— chunky sticks of graphite or pigment, compressed and held together with wax or clay.

Let us not forget this history, not only because it's vital to the story told in this book, but because we'd be writing an entirely different one had it not been for the son of a farmer who knew how to make violins.

Zum Stein

The Founding
of *Faber-Castell*

The tale of this family-run business and household name begins near Nuremburg in 1761 and is one of backstabbing, generational disputes, intrigue, and the first wax-core pencil.

Conté method and casing in the pieces of lead by hand. It seemed that Kaspar had little interest in advancing the method, as did his son Anton Wilhelm Faber, who inherited the business in 1784. Anton officially named it A.W. Faber and ran it with enough success to keep it afloat. In turn, Anton's only son Georg Leonhard took over the enterprise in 1810. Competition had grown and the ability to produce pencils was greater than the demand: it became clear that change was needed in order to compete with superior French and English methods.

By the time Georg Leonhard died in 1839 and his son Lothar had taken over, things were starting to change. Lothar took an interest in searching for a market outside of Germany and began to travel to find other places to sell his goods. In Stein, the factory fully embraced the superior French method of making pencils and experimented with clay and graphite ratios to make a range of drawing pencils. Meanwhile, Lothar's brother Eberhard moved to the United States to explore opportunities for the family business. The pencil industry was just getting started stateside and Eberhard set up shop in New York City with the hope of selling A.W. Faber pencils as a competitive product. When he discovered that the United States is home to plentiful cedars, he purchased land on Cedar Key off the gulf of Florida and began exporting cedar slats to Germany.

Back in Europe, by the middle of the nineteenth century Faber pencils were gaining recognition, especially after the debut of the new products at the first World's Fair, The Great Exhibition of Works of Industry of all Nations, which took place in London in 1851. Shortly thereafter, something major happened that would give the Faber family the edge they needed to become a true worldwide competitor. At the time, the best graphite was still coming from the Borrowdale mine in England. The biggest disadvantage of the pencil industry everywhere else stemmed from the fact that the graphite they had access to was

O ne of the most famous names in pencil history is Faber (pronounced Fahber). You probably recognize it as one half of Faber-Castell, who are still a dominating company in the pencil field. They're a family known for tradition and legacy—as well as conflict. Like most family feuds, it was rooted in greed and competition …

It all began when cabinet maker Kaspar Faber set up shop in 1761 in Stein, Germany. Nuremburg, the nearby city, had been the home of many pencil makers for about a hundred years already at the time. Kaspar engaged with the craft as most other pencil makers in the world during that period, using some version of the

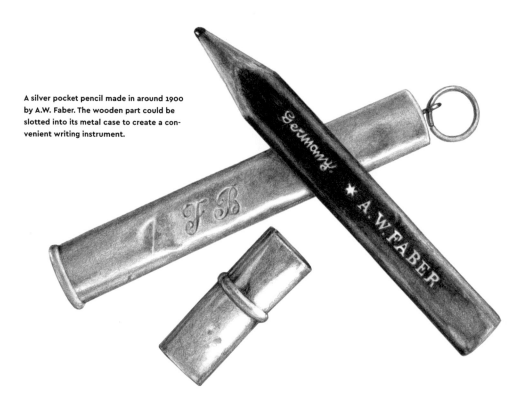

A silver pocket pencil made in around 1900 by A.W. Faber. The wooden part could be slotted into its metal case to create a convenient writing instrument.

never going to be as rich and pure as the one coming from the United Kingdom. This is where a man by the name of Jean Pierre Alibert comes in. While searching for gold near the Chinese border in Siberia, Alibert came across a previously undiscovered graphite deposit. Once he realized that the graphite was possibly as good or better than Borrowdale graphite, he decided to give exclusive rights to A.W. Faber, which he considered to be the chief pencil producer in Europe at the time. Though it took many years to come to an agreement, the Fabers gained access to the nearly perfect graphite and officially took the stage as the most celebrated pencil company in the world.

Still, Eberhard was over in New York pushing German-made pencils. By this time, the Civil War had broken out and it was becoming too expensive to import the pencils from Stein.

Eberhard did the only thing that made sense: he opened his own factory and began making A.W. Faber pencils in the United States, importing only the precious Siberian leads from Stein. His factory was large and had arguably more advanced equipment than that at the Faber camp in Germany. Though demand was especially high during the war, it was difficult to harvest and transport the cedar needed for production from Florida, which was a Confederate state.

→ Eberhard's original factory was on 42nd St. in Manhattan—the same piece of land where the United Nations sits now. At the time, most of the population of the Stein/Nuremburg region was involved in the pencil industry and employee retention was a concern for Lothar. Since the industry was booming in Stein, Lothar expanded the factory, building housing, a school, a church, and a library among other on-site facilities. Because of his success

26

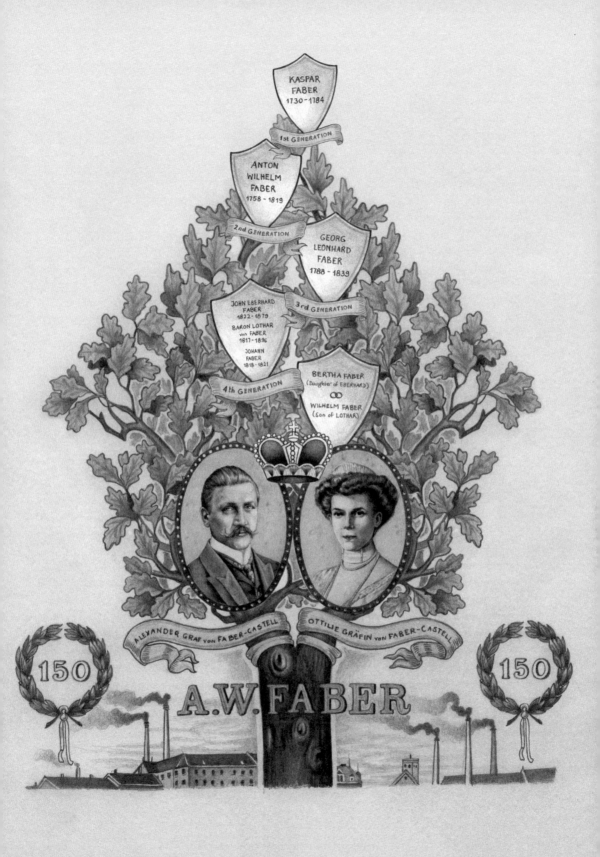

and generosity, Lothar became a celebrity of sorts and was made a baron by the German government. The drama really began when in 1876, Lothar's younger brother Johann (who was previously the factory's manager of engineering and production) decided to open his own factory with newer, more efficient equipment. This made Lothar angry enough to spawn a public announcement claiming that any Faber pencils under any name other than A.W. Faber were "spurious imitations." A court case followed, which favored Johann. Though his company stuck around for long enough to build a reputation of its own, it never gained the momentum to be a true competitor, and Johann's relationship with his brother was never the same.

→ Johann Faber patented the first drafting lead-holder, a cylindrical brass-barreled pencil with a lead inside of it. It didn't quite catch on at first but paved the way for future, better-designed versions.

The Fabers grew to become industry tycoons and German royalty thanks to Lothar's business sense and dedication to the pencil. He decided to pass on the family business to his son Wilhelm, who married his Uncle Eberhard's daughter Bertha. Wilhelm had high hopes of building the family legacy but died suddenly in 1893, just four years after Eberhard and three years before his father.

→ In the late 1800s and early 1900s silver pocket pencils were fashionable as accessories kept in a waistcoat pocket or even worn on a necklace and watch chain. Johann Faber, Eberhard Faber, and A.W. Faber each made their own version. They were usually silver and held a slim, flat pencil that fit into the cap. Often the ends were detailed with a decorative stone or a loop.

During the aftermath in Germany, Lothar's granddaughter Baroness Ottilie von Faber and her husband Count Alexandar zu Castell-Rüdenhausen took over the company after the death of her mother and changed the name to the now eponymous Faber-Castell. Around the same time in New York, Eberhard Faber II and Lothar W. (sons of Eberhard Faber) incorporated under E. Faber Pencil Company, independent of the German counterpart.

By now, the nineteenth century was coming to a close and the families on both continents had further separated themselves from each other. While the German Fabers continued to build their legacy, product range, and an actual castle, the American Fabers became completely independent, much to the dismay of their relatives. Johann and his offshoot company continued making their own products, and in the beginning of the twentieth century, the succeeding Eberhards (of which there were three) kept coming up with enough

→ The "New Castle" was built in 1903 and commissioned by Alexander and Ottilie von Faber-Castell. Its interiors were art nouveau in style, and the façade resembled a castle to represent the name Castell.

innovative products to further fuel the family rivalry. They are credited with making the first writing pencil with a prominently waxy core, the infamous Blackwing 602 (which we'll discover in more detail later on) and a long list of other American pencil icons. They continued to dominate the American pencil industry through the middle of the 1900s with clever advertising and new products that took over the relatively new American market.

All of this came to an end when Eberhard IV sold the Eberhard Faber pencil company back to A.W. Faber-Castell in 1988 and all production in the United States ceased. The same went for Johann's business, which was also acquired a few decades prior. Apart from a lawsuit in 2010 between Faber-Castell and neighbor/rival pencil maker Staedtler over whose company was old-er (Faber won), there hasn't been a tremendous amount of drama since.

In a way, Faber's high-profile and sometimes backstabbing business ventures paved the way for advancements and creativity in pencil production. They certainly made the collectors' market more interesting with three different Faber brand names to be discovered. Should you

ever find yourself in Stein, you can even visit the Faber-Castell castle, factory, and museum, which has become the biggest pencil tourism destination in the world and is a testament to the dedication of the pencil's most famous family. These days, Faber-Castell is known for making more than just pencils: they've stepped up their game by adding a stunning line of luxury writing instruments and continue to prove that they are still in the game and always will be.

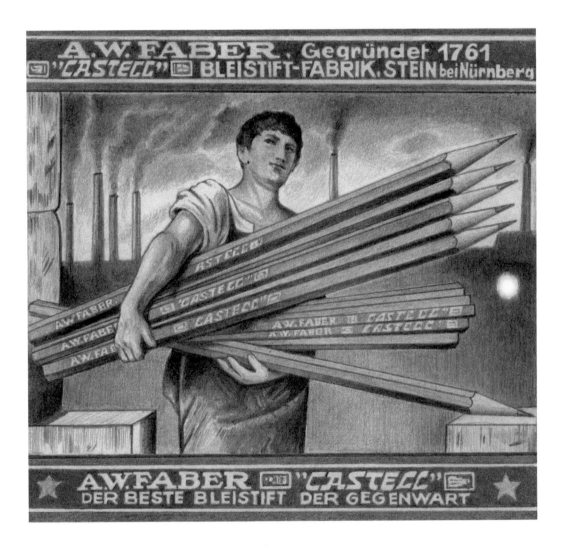

A.W. Faber-Castell ad promoting the factory at Stein, near Nuremburg, and proclaiming their product the best present-day pencil.

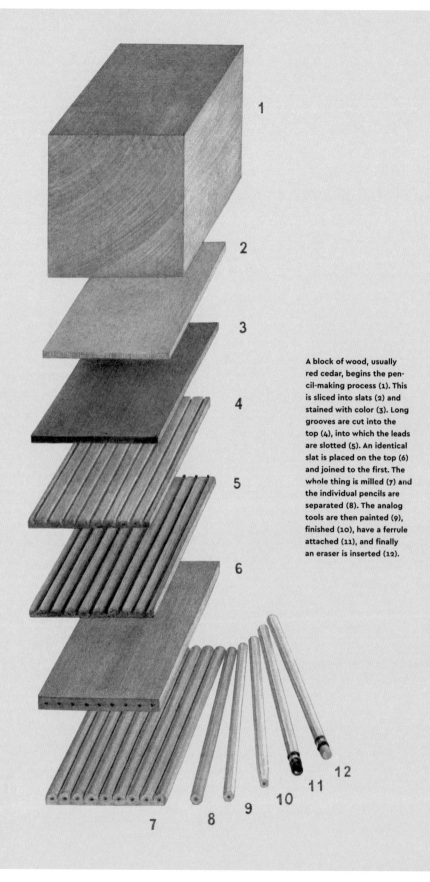

A block of wood, usually red cedar, begins the pencil-making process (1). This is sliced into slats (2) and stained with color (3). Long grooves are cut into the top (4), into which the leads are slotted (5). An identical slat is placed on the top (6) and joined to the first. The whole thing is milled (7) and the individual pencils are separated (8). The analog tools are then painted (9), finished (10), have a ferrule attached (11), and finally an eraser is inserted (12).

How a Pencil Is _Made_...

Though the materials used are simple—wood, graphite, clay, and water—the pencil-making process is complex and it took centuries and countless individuals to figure it out.

The pencil as we know it is a seemingly simple thing. It looks like a stick of wood with lead down the center, with no other materials involved save for a few coats of paint and maybe an eraser. For most of my childhood, I believed that a hole is drilled through the wood and the graphite is then filled into the cavity. It made sense—why would you piece it together any other way if you can just fill it with molten pencil just like you would a jelly donut? Picture a factory full of tiny graphite-filled syringes carefully inserted into thousands of upright pencils.

Another uninformed theory is that the wood is cut, the hole down the middle is drilled, and the cured stick of graphite is subsequently just slid down inside it. This particular theory seems to be the most common, which I blame on those pencils made out of sticks that are often sold in natural history museum gift shops. Those are made precisely in the way conventional pencils are not: a branch is cut off of a tree, the hole is drilled through it, and a generic premade pencil core is inserted. Of course these are meant more as a novelty than a useful object—let's understand that they are not the same thing as what I'm talking about here.

The truth is that the making of a pencil is actually quite complicated. There are several very specific machines involved and materials that you probably wouldn't expect to be necessary. There's a famous essay called "I, Pencil" written in 1958 by economist Leonard E. Read in which the story of how a pencil is made is told from the perspective of a pencil itself, specifically the popular Eberhard Faber Mongol 482. At the beginning of this essay, the Mongol 482 shares that it is a mystery and that it feels taken for granted by those who use it. It even goes as far as to say that "not a single person on the face of the earth knows how to make me." The essay goes on to describe every single part of the process, from the harvesting of the wood to the growers of the castor beans from which the castor oil is extracted to make the lacquer. Perhaps it is true that there isn't a single person who could make a pencil

from start to finish (those repurposed branch pencils don't count)—at least "I, Pencil" certainly makes the reader believe that to be true. I like to think that if I had to make a pencil, and by that I mean making it my life's mission to make my own pencil, I could do it. After all, it would take decades just to grow the tree to harvest the wood from, so I'd have plenty of time to think about it.

The most important part of the pencil is what's inside, whether it be a mixture of pigments, charcoal, or graphite. You can't have a pencil without a core. Although there is one exception I can think of: the Dummy Pencil made by esteemed Portuguese pencil company Viarco. There is no graphite inside, it's just wood cut and painted as a pencil that is dipped in graphite on the end merely for appearances' sake. Truly though, it's a hilarious prank. The stump of a pencil tip skids awkwardly across the page and leaves only a faint gray mark. I wish I'd had one of these in grade school to offer when someone asked to borrow my pencil. Fake pencils aside, it took centuries to come up with an effective way to make a graphite core, and there's a reason why. Aside from graphite, there's a list of other ingredients and meticulous processes that go into making the inside of a pencil. If you've ever had a pencil that keeps breaking, it's probably because the core is either of inferior quality or it has shattered. Think of the wood of a pencil as bubble wrap for what's inside. It's fragile and worth handling delicately.

When making the core of a pencil you must first start with the obvious ingredient: natural graphite. Graphite can be found in a long list of different countries on just about every continent with varying characteristics depending on which mine it comes from. Most pencil makers use a mixture of graphite from different parts of the world to create an ideal texture. If you've ever seen a chunk of natural graphite it's easy to understand why it was once mistaken for lead. It's dark, rather lightweight, and incredibly shiny, especially when polished. Alone, most graphite

tends to be crumby and sometimes too gritty when used for mark making.

The second most important ingredient in a graphite core is clay, which strengthens the graphite and adds character to the texture of the pencil. Most common is kaolin, which is a fine, white clay also used for colored pencil cores. Quite frankly, until recently I hadn't given much thought to precisely what type of clay is in a pencil. After doing some research and learning about the chemical composition, I ended up on a shopping website and learned more about kaolin and its uses from the reviews written by consumers. It turns out other common uses for kaolin include pest control and making homemade toothpaste, face masks, or quick clot bandages. Not only is it a very soft, remarkably absorbent material, but it is also apparently very versatile as a household substance.

Grind the graphite into a fine powder, add some powdered kaolin, and you're halfway to having a pencil core. Okay, maybe it's not quite that simple. Pencil hardness is determined by the ratio of clay to graphite—the more graphite there is, the softer the pencil. This means that it will be smoother, darker, more smudgy, and often shinier. The more clay is added, the harder, firmer, lighter, and finer it is. These two things can't hold each other together on their own, though—that's what the water and wax do. Wax is often used as a binder and an agent to make the pencil smoother to write with, as wax glides differently than dry minerals. If we're talking about more high-tech varieties, there's also polymer involved, which is often the case with pencils made in Japan. This makes the pencil more breakproof, smoother, and less messy. More traditional pencils feel remarkably different in comparison to pencils that utilize slick binders. They're often scratchier and run a little harder in comparison.

One thing that I often preach is that the pencil-grading scale is not universal. A German HB might feel harder than a Japanese HB. A Swiss HB might have better point retention than

an American HB. An Indian HB might be lighter than a Portuguese HB. It just depends on where it comes from, who is making it, and what guidelines are being followed. That's one thing I love about pencils: they all have different defining characteristics and each one tells a different story about its origins.

→ *Point retention is one of the staples of pencil jargon. It's used to describe how well a pencil holds its point before it needs to be sharpened again. Of course, this varies depending on the pencil you're using, the paper you're writing on, and how heavy-handed you are.*

In a pencil factory, the ingredients for a given pencil core are all thoroughly combined through processes that vary slightly from factory to factory. When it's done it takes on a thick, doughy quality and is quickly put into a machine that presses it into a continuous strand that looks like a wet noodle. At this point, the pencil core is heated so it temporarily becomes malleable as it is fed into the cutter, which chops it to the correct length. Before the little graphite sticks cool down completely, they're put into crucibles in which they will bake at about 980 degrees Celsius (1,800 degrees Fahrenheit). It's a process that's not completely dissimilar to firing ceramics in a kiln. The whole point is that the process of heating and curing the mixture will harden it and make it stronger. Thank you, Mr. Conté, for your genius in figuring all of this out.

Graphite isn't the only common base for pencil cores. Pigment can also stand in its place for colored pencils, which are processed rather similarly. The difference with pigment is that depending on the hue, the physical consistency can vary drastically. It's difficult to make a really good colored pencil because it has to be light-fast, it has to feel consistent with the others in its range regardless of color, and it has to be as vibrant as possible. Colored pencil cores are traditionally made with wax or oil, but they

→ *Lightfastness describes how resistant a color is to fading. Most pencils have a star rating printed on them, 5 stars being the most lightfast and 1 star being the least.*

can also be made with gum arabic, which makes them water-soluble. This allows the pencil to be used like watercolor paint. The core of a colored pencil endures an almost identical process as a graphite pencil, though they often have to set for a longer period of time as they are significantly more fragile.

The biggest pencil conundrum I deal with on a daily basis is that of lead breakage. If the pencil is fragile enough, all it takes is dropping it on the floor once to shatter the entire core. This is especially the case with colored pencils, charcoal, and softer graphite cores. Unfortunately, there's no official way to repair a broken pencil, though it has been recommended to me more than once to put a broken colored pencil in a microwave for long enough to fuse it back together. It won't melt into a gooey puddle of color but certainly the heat of a microwave would alter the pencil's carefully concocted formula. I'll admit that I've never tried this before, mostly because I don't own a microwave but also because it almost seems blasphemous. Instead, there are plenty of things you can do with a useless pencil. You can use it to stir your coffee, to rewind a cassette tape, to put your hair up, to reset your internet router … The possibilities are endless.

Once the graphite cores are finished and cured, they have to go into something. As we know well, they are most likely cased in wood. Despite all of the theories I had as a child, upon close inspection of a sharpened pencil it is pretty clear that it is made out of two pieces of wood. Have you ever seen a pencil that's been stepped on or run over by a car? You'll notice that it is split in two. Let's think of it as a graphite sandwich. The earliest pencils were made this way, but in a more primitive fashion by basically boxing in a rod of graphite with wood on each side. We can thank the Industrial Revolution for streamlining and perfecting the process as we know it now. We'll skip the chopping down the tree part and go straight to what the wood looks like when it makes it to the factory. If you run a

In its raw form, graphite is shiny, lightweight, and crumbly. To form a
strong and textured pencil core, the material needs to be mixed with clay.

The red cedar, *Juniperus virginiana*, is ideal for pencil making as its wood is light and sharpener-friendly.

has a tight wood grain that isn't too dense but also isn't too splintery. It certainly doesn't hurt that its natural fragrance is warm, earthy, and a little bit spicy. Though most quality pencils are made from incense cedar, there are a few alternatives. Linden, poplar, and vatta are also common but quite different to cedar. They're often a bit lighter in weight and more likely to splinter. Most of the time, pencils are made out of a non-cedar wood to cut costs or simply because an alternative wood is indigenous to the pencil's origin location, as is the case for pencils made in India. Sometimes pencils are made out of more exotic wood, like the Caran d'Ache Swiss Wood, which is made from beechwood from the Jura forest. It's noticeably heavier than cedar, much darker in color, and very strongly smells like brown sugar. Other rare woods have been used for pencil making in the past, not always for general use as a pencil but often because they make beautiful collectors' objects. Regardless of the type of wood, the process always starts with a slat.

Those slats are cut along with the grain of the wood to be about 18 centimeters (7 inches) long with varying width depending on the type of pencil being made. Pencils come in a few different sizes, namely standard diameter, mini-jumbo, and jumbo. Mini-jumbo logically is the size between standard and jumbo and is probably the least common. Usually jumbo pencils are marketed towards children as they're meant to be easier for tiny hands to hold but quite honestly, they're generally more comfortable for anyone to hold especially for long periods of time. Occasionally you'll find smaller than standard pencils, especially Bridge pencils, which are made for scoring the card game of the same name. All things considered, though, the average pencil has a diameter of about 6 millimeters (15/64 inches) and is made eight to a slat.

Once the slats are cut, they go through a machine that carves grooves down them lengthwise, one for each pencil-to-be. This is where it starts to get a little bit tricky. The sticks of

pencil factory, chances are you order pencil-specific slats from a supplier who has pre-cut them to be the right size, which is more-or-less standardized. In the early years of pencil manufacturing, eastern red cedar was the norm but most commonly these days they're usually made from incense cedar sourced from California or Oregon. Cedar tends to be the wood of choice because it's lightweight and therefore easy to sharpen and

graphite or whatever is going inside the pencil has to fit into the groove so perfectly that the margin of error for a high-quality pencil is about 0.01 millimeters. Have you ever had a pencil that has an annoying sliver of wood that runs up the point on one side after sharpening? That is because the grooves weren't cut precisely enough and the pencil isn't well centered. Once those grooves are cut, the most visually satisfying part of the process occurs: the slats go through a machine that carefully squirts just the tiniest bit of glue into the freshly cut grooves. Just enough to hold the core in place but not so much that it compromises the physical integrity of the pencil. From there, the cores are carefully put in place and another identical slat with identical grooves is laid on top and pressed together.

Once that's done and the pencil cores are comfortably settled into the wood, the slats are put into a press where they'll stay for a few hours to ensure that they can endure any amount of use in the future. From there they go through yet another machine that will cut them one side at a time into the shape they'll end up being, usually hexagonal, round, or triangular. And there you have it! A pile of slightly rough-looking, freshly cut pencils. Before they get coated in paint or whichever finish they're meant to have, they'll be sanded down so they aren't at all splintery, should you want to use them unpainted.

When visiting a pencil factory, the one thing I found most mesmerizing was the painting process. This might have been because the repetitive motion of seeing naked pencils dipped in

A 1950s colored-pencil packing
machine in the Faber factory.

Pencils are sharpened to a point in the factory
by being rolled over a rough surface.

layers and layers of colorful paint seriously satisfied my slightly OCD tendencies or maybe it was because the smell of the paint was particularly intoxicating. Not all pencils are painted. Some are left "naked", as I like to label them, though they do usually get some sort of clear coat to prevent splinters. Those that are painted, however, endure a long process where they are funneled through identical painting machines anywhere from four to 14 times. Yes, that's a lot of paint. Have you ever noticed how Japanese pencils are usually super glossy and a tiny bit bigger than most others? It's because of all that paint. The paint not only decorates the pencil, but it also holds the whole thing together and almost acts as a back-up sealant for the pencil sandwich. In lieu of paint, there are some other creative alternatives, like the scented pencils made by Viarco in Portugal. These are simple, round, barreled cedar pencils that are soaked in fragrance, making them smell like common plants found in the backyards and gardens of Portugal (fig, peony, orange blossom, lily of the valley, and jasmine). They're shockingly fragrant and mingle nicely

with pencils of a more regular variety in a pencil cup. An example of a particularly interesting paint job comes from Hindustan Pencils in India. My favorite model is hand-marbled so each pencil has a different colorway and pattern. As a marbled paper hobbyist, I've tried to figure out exactly how this is done (especially by a company that makes nine million pencils a day), but I just haven't quite figured out the secret.

Next comes the question of what goes on the end of the pencil. Some very brazen pencils will just go on the way they are with their interior exposed. Others will go through one of many other processes. In Europe and Asia especially, it is common practice to "tip" a pencil. By that I mean that the pencil is carefully (very, very carefully) dipped in a vat of paint so it just barely kisses the surface. Some even have tiny designs painted on the end. In general, the more decorative the end cap, the higher quality the pencil probably is. A more common practice is attaching a ferrule and eraser onto the end of the pencil. A ferrule is the metal piece at the end of the pencil that holds the eraser onto the body. There is really only one successful example of a pencil that has an eraser attached without a ferrule of some sort; it was designed by Eiichi Kato in Japan and simply looks like a very minimalist rubber end cap. Apart from that exception, a pencil with an eraser always needs a ferrule. Some ferrules are prettier than others and some are representative of a specific type of pencil, but in general, especially in the twenty-first century, they all look very similar. The part where the ferrule and eraser are both

attached has always been a mystery to me. Is the ferrule attached first or is the eraser glued and then the ferrule slid over it? Or maybe they're assembled together? I've never witnessed this particular action in real life so I wasn't ever sure. I remember being in grade school and chewing the ferrule on the pencil until it was misshapen and simply fell off the pencil. From there it appeared that the eraser would have had to have been put in first, because the ferrule is squeezed onto the pencil and thus there would be more room for error when sliding it on the pencil. I never bothered to research this because it seemed like superfluous information. It wasn't until I started selling pencils that I started to notice the occasional faulty example, where there's a thin curtain of eraser that hangs over the top of the ferrule. In the most anti-climatic way, my question was answered. First goes the ferrule and then the eraser.

After all of the fuss and detail with the paint and the ends of the pencils, there are still a couple of optional things that need to happen before the pencil is ready to leave the factory. The first is branding. Almost any pencil you come across will have some sort of text on it. Whether

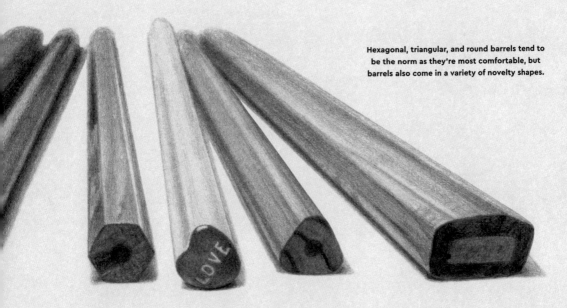

Hexagonal, triangular, and round barrels tend to be the norm as they're most comfortable, but barrels also come in a variety of novelty shapes.

it be a brand name or an advertisement for something else, you are likely to find it laden with text. There are a couple of ways to do this, but for the most part, text is added to a pencil with hot foil. It's a simple stamping process where a plate cast with text is heated up and pushed into the sheet of foil that lies against the surface of the pencil. The text is transferred through the sheet of foil and there you have it: a branded pencil. Some pencils have barcodes and lots of text, whereas some are just stamped on one side. Japanese pencils are famously elaborate and one unique feature is that they almost always have the intended purpose of the pencil written in English on the opposite side of the brand. For example, it'll say "For Master Writing," "For Academic Writing," "For Special Drawing and Retouching," or "For High-Precision Drafting." The designated uses are almost always more specific than they need to be, but that's part of the charm of an over-the-top Japanese writing instrument.

Disclaimer: I'm not a huge fan of visible branding on consumer products. I would never buy a handbag covered in a monogrammed print. Nor would I wear a T-shirt with a brand name across it. It's mostly just a pet peeve, but I also believe that the things I wear, carry with me, or use shouldn't speak for me. With pencils it's a little bit different. Often the only thing that clearly distinguishes one pencil from another to the untrained eye is the branding, and since the surface area of the pencil is so small it can be a crucial factor to its design.

By now the pencil is just about ready to head out into the world. Sometimes it is pre-sharpened to a slightly dull point for immediate use, which is usually done with a belt sanding apparatus. Other times it needs a couple of finishing touches to its design. The one thing that it has to go through without question is quality control. Is the paint finish even? Is the text stamped correctly? Is the pencil core perfectly centered in the wood barrel? Are there any obvious cosmetic flaws? Once all of these questions are addressed, the pencil is carefully put into whatever type of packaging it's destined to live in and is shipped out to a shop where you or I will purchase it and put it through rigorous use.

Even as a pencil-obsessive, I'd never thought much about the exact nuances of how pencils are made until I stepped into an actual factory. Sure, I knew extensive amounts of information about each component involved, but to see the physical process of assembling the whole object is a completely different thing. The machines move so seamlessly and every step appears so natural that it's hard to imagine it ever being done any other way. It makes sense that the first pencils were made by cabinet makers. Even with modern machinery there is an incredible amount of craft and skill that goes into making each individual pencil. Part of the charm of the pencil as an object is that it's such a compact, tidy little thing that is capable of so much creativity. The same goes for a pencil factory itself. The raw materials start as organic globs of matter and stacks of simple wood slats. The floor is coated in a thin but slippery layer of graphite dust and the machines are whirling as faulty sticks of lead are being thrown on the floor into a humorously disorderly pile of reject pencils. It's like being in Willy Wonka's chocolate factory where everything is so tactile and engaging to the senses. It's hard to believe that such a streamlined thing is made by such a messy and organic process. By the end, there's no more graphite on the floor and flawlessly formed pencils are being perfected like they're the most important objects in the world. It's hard not to reach out and touch it all. That's okay though, because the actual pencil at the end of the conveyor belt is still the best part.

The average pencil diameter is around 6 mm (15/64 inch), though this varies between countries. Mini-jumbo pencils are 8 mm (5/16 inch), and jumbos are 10 mm (25/64 inch).

Before erasers, people used an unlikely tool to rub out their mistakes: breadcrumbs. Thankfully, in 1770, an "elastic gum" that could do the job much better was discovered.

An eraser pen: the cleanest option for erasing fine lines or delicate text.

On *Erasing*

One of the most beautiful and unique things about the pencil is that you can erase it. Yet the pencil existed for quite some time before the eraser as we know it came to be. In the earliest days of the pencil, breadcrumbs were used to smudge away the marks because the abrasion worked to gently scratch away the graphite. It wasn't until 1770 when a man by the name of Joseph Priestley found that a new substance usually referred to as "elastic gum" was effective in rubbing out pencil marks, hence the name "rubber," which is still used in place of "eraser" in the United Kingdom, Australia, New Zealand, and South Africa. Before Priestley's realization, rubber was a fairly new discovery that didn't yet have a practical application. It is found naturally by cutting the bark of the *Hevea brasiliensis* tree. When cut, the bark of the tree leaks a milky liquid that is then

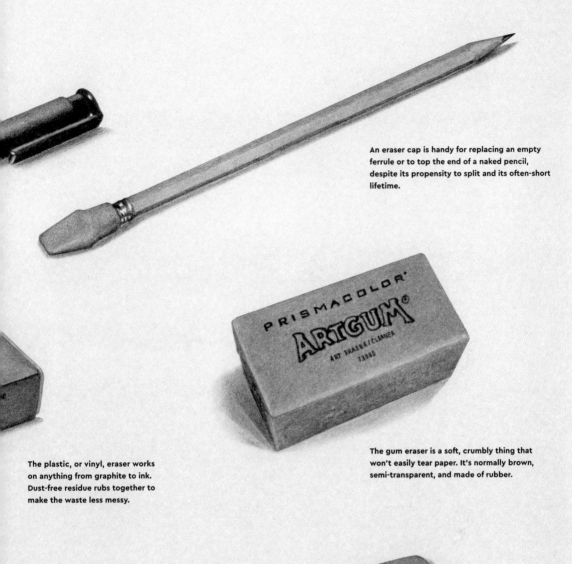

An eraser cap is handy for replacing an empty ferrule or to top the end of a naked pencil, despite its propensity to split and its often-short lifetime.

The plastic, or vinyl, eraser works on anything from graphite to ink. Dust-free residue rubs together to make the waste less messy.

The gum eraser is a soft, crumbly thing that won't easily tear paper. It's normally brown, semi-transparent, and made of rubber.

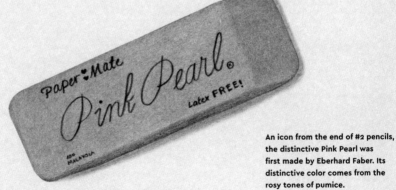

An artist's friend, the kneaded rubber eraser removes mediums from pencils and pastels to charcoal and chalk, and only needs some gentle kneading to clean it.

An icon from the end of #2 pencils, the distinctive Pink Pearl was first made by Eberhard Faber. Its distinctive color comes from the rosy tones of pumice.

43

hardened into the solid form we most commonly know it as.

Engineer Edward Nairne is credited for being the first to create and sell cubes of rubber marketed specifically for pencil erasing, which he sold out of his shop in London. After the eraser caught on as a commercial product, most manufacturers began mixing rubber with Italian pumice—and the modern eraser was born. The slight abrasion of the pumice and the heat caused by the friction of rubbing makes the eraser slightly sticky and able to pick up the graphite particles. For about a hundred years the eraser was purely a pencil accessory, until American stationer Hymen Lipman patented a pencil with an eraser attached to the end, and in 1858 the whole pencil game changed. In fact, March 30th, the day the patent was issued, is still considered to be National Pencil Day in the United States. The eraser wasn't held onto the end with a ferrule as we're used to, but rather cased into the pencil on the opposite side of the graphite core so the user could cut away the wood to expose and use it. Four years later, entrepreneur Joseph Reckendorfer purchased the patent for $100,000 with the intent of making improvements on the design. It wasn't until the middle of the twentieth century that the idea of having an eraser on the end of the pencil caught on. Until then, the eraser-clad pencil was considered a luxury as it was significantly more expensive to produce than a pencil without one. On a worldwide scale, a separate eraser has always been preferable because the amount of eraser that can go on the end of the pencil is often not enough for an avid user. Despite this fact, the advent of the attached eraser was crucial to the popularity of the eraser as an essential pencil accessory in the nineteenth century.

Erasers have played many different roles since then. One of the most iconic is the typewriter eraser. Mostly common in the middle of the twentieth century, the typewriter eraser was made to be hard and especially gritty so as to remove typewriter ink. It existed in two forms, one as a flat, round disk with a nylon brush affixed to it and the other as a pencil with an eraser core instead of a graphite one and a nylon brush instead of an eraser on the end. The brushes played a key role as they were used to brush away eraser and paper dust to avoid jamming the typewriter. Though these types of eraser are completely defunct now, a large-scale version lives permanently in the National Gallery of Art Sculpture Garden in Washington, D.C., in the form of a rather famous sculpture by contemporary artists Claes Oldenburg and Coosje van Bruggen. Since the typewriter eraser, the tool has existed in the form of a cap that fits on the end of a pencil, a stick that goes into a retractable holder, a glob that is kneadable like clay, and many others. My favorite eraser memory involves an electric erasing machine that my mother kept on her drafting table in our dining room when I was a child. It plugged into the wall and was a handheld device with a stick of eraser in the inside that vibrated when turned on. Of course I used it more as a toy than a tool, but the purpose was to erase effectively, easily, and with little harm to the paper. Though I don't think wall-plug electric erasers exist anymore, battery powered ones are still popular for precision erasing.

In this day and age, the erasers found in offices and art supply stores are usually made from plasticized vinyl, which is even more effective and considerably less messy than rubber. Actual rubber erasers are few and far between, though Koh-i-Noor still makes many different types in the Czech Republic. Classics like the Pink Pearl are instead made with synthetic rubber, as are most school-quality erasers. Though the eraser has come a long way since 1770, it still plays a vital role in our use of the pencil and the freedom we get from using it. At the end of the day, it's all erasable.

→ The color pink is synonymous with erasers because the pumice used, which comes from volcanic rock, gives it a pinkish hue. Eberhard Faber named their iconic eraser the Pink Pearl because of the natural coloring.

H. L. LIPMAN.
Assignor, by mesne assignments, to J. RECKENDORFER,
Pencil.

No. 7,992. Reissued Dec. 11, 1877.

Fig. 1.

ERASER GRAPHITE

Fig. 2.

Witnesses: Inventor:
M Georgi Joseph Reckendorfer
R. E. Grant assignee of Hymen L. Lipman
 by Munduxt Bailey
 his attorney

An 1877 reissue of Hymen Lipman's patent for securing an eraser onto the end
of a pencil. The idea was to have a huge impact on U.S. pencils in particular.

THE

19th

CENTURY

Up to the nineteenth century, Europe had dominated the pencil industry—that is, until graphite was discovered in the eastern United States and the red cedar of the South was found to be the best wood for pencil making. Among the pioneers of American pencils were John Thoreau and his son Henry David Thoreau, who are credited with making the first American pencil. Later joined by Joseph Dixon, an industrialist and inventor, and Eberhard Faber, great-grandson of Kaspar Faber, the American pencil industry quickly developed into a force to be reckoned with.

Especially with the newfound ability to alter a pencil's hardness, pencils were becoming an increasingly more desirable commodity. The pencil-grading scale, which would take the form of the Hs and Bs that still mark pencils today, opened up a new market for "drawing pencils." No one made finer drawing pencils than Franz Hardtmuth, who introduced his Koh-i-Noor 1500 at the World's Fair in Paris in 1889 and later at the Chicago World's Fair in 1893. The shocking yellow lacquer and unbelievable range of hardnesses made it the crown jewel of pencils, and the American industry in particular took a liking to it, adopting the yellow paint color as a signifier of quality. That wasn't the only thing American pencils became known for. As a product of the Industrial Revolution, the machinery being used to make American pencils was unbeatable and it allowed for the newly invented attachable eraser to become a standard. The iconic yellow #2 pencil was born, leaving the rest of the world trying to catch up.

Graphite is _Born_ in the U.S.A.

Whether or not its inception was the result of a schoolgirl's shrewdness, the widespread mining and use of graphite in the U.S. gave rise to an industry that would quickly thrive.

About a two centuries after the discovery of graphite in England, the story of the pencil takes us to America, where graphite wasn't as well known a substance and pencils certainly didn't exist yet. In a neighboring town of Boston, Massachusetts, a school-girl had acquired a few small pieces of the precious Borrowdale graphite. She crushed them into a powder, mixed it with some sort of gum and stuffed it into a hollow twig from an elder tree. This, apparently, was the first pencil ever made in America. Let it be known that there is no evidence that this ever happened, though it's been told for a couple of centuries and is still a widely known and widely cherished fable. It originated in an article written in 1880 by Horace Hosmer, who was a pencil maker himself. We don't even know her name or even the exact part of Massachusetts where the event took place as many other versions of the same story have been told since, but the ingenuity of this mysterious schoolgirl can't be denied.

At the dawn of the nineteenth century, the only known graphite mine was in Sturbridge, Massachusetts. Since the fifteenth century, the Tantiuesques mine had been used off and on by the Native American Nipmuc tribe, who made ceremonial paints from the graphite they found there. Tantiuesques was purchased by John Winthrop Jr. in 1633 with hopes of finding lead and iron. The mine changed hands through the seventeenth and eighteenth centuries and much to the disappointment of its various owners, not much other than graphite was ever found there. This leads us into the very beginning of pencils in the United States. Not only were there few sources of graphite, but there was also not much knowledge of pencils stateside. No one really knows just how much was known by the general public at the time, but we can understand that there were likely rumors about the pencils being made in England, Germany, and France.

The first person who is said to have made and sold pencils in the United States is a man by the name of David Hubbard of Concord, Massachusetts, who allegedly made only a few pencils of very poor quality before he ceased his efforts. The first pencils made in the United States were of particularly terrible quality, but as European pencils weren't being imported in the first part of the nineteenth century, they had to suffice. Bad pencils were usually made in Massachusetts—you'll start to notice a pattern here. Early pencil makers only had access to pencils made locally, so naturally they mimicked each other.

This is where William Munroe comes in. Munroe's name has long been synonymous with American pencil making, not because he was the greatest, but because it is fair to believe that he was the first to make it his life's work. Another pattern you'll notice is that many of these early American pencil makers, even the better ones, weren't in business long—not because there wasn't a demand, but because the economic and political climate wasn't quite ripe for such a business and it took a very savvy and innovative pencil maker to run a profitable business.

Munroe's first job was as a farmhand on his grandfather's property in a small town in Massachusetts. It is said that he did love farming but wanted to become more skilled. Young Munroe took a place as a cabinet maker's apprentice and picked up the craft quickly. He was a good student, perhaps the best in the shop, but had ambitions to escape poverty and work on his own. Once he finished his apprenticeship he married Patty Stone, the daughter of a wealthy captain who died shortly before the marriage. The couple settled in a house owned by Patty's family in Concord, where Munroe began work making all of the things he knew how, including furniture, clock cases, and cabinet marker's squares. This profession, however, wasn't enough for Munroe, who apparently had said to himself, "If I can but make lead pencils I shall have less fear of competition and can accomplish something." He had first heard word of the scarcity of the pencil in the States and endeavored to make pencils of his very own.

Without much knowledge of the object, he obtained some graphite, which he then crushed with a hammer and suspended in water to separate the impurities. The results were less than satisfactory. Initially discouraged, Munroe continued to make cabinet squares while he worked on his pencil-making practice in his free time. Though the Conté method existed in France and similar methods were being used all over Europe, Munroe had no information to help him figure out

how to make his pencils successfully, so he spent months trying to crack the code on his own. One thing he realized was that he was going to need better materials to make it work. He searched to find higher-quality graphite and cedar in which he could case his pencils.

On July 2nd, 1812, Munroe took his first 30 pencils to the hardware store in Boston to which he had been selling his cabinet squares. The shop owner, Benjamin Andrews, was impressed and agreed to sell them for him. For all we know these were the first pencils ever available for purchase commercially in the United States. Andrews encouraged Munroe to keep making pencils and only 12 days later he reappeared with 432 pencils to sell. In awe of Munroe's enterprise, Andrews drew

Likely the first person in the U.S. to dedicate their life to the pencil, William Munroe helped develop a new breed of sophisticated pencil-making machinery.

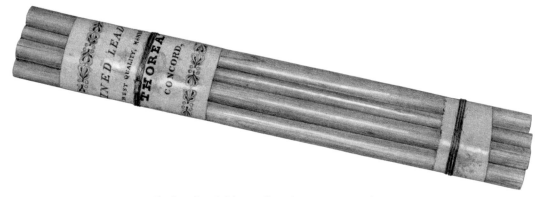

Simply made and plain, yet still worth 25 cents more per dozen
than the competition, Thoreau pencils were the best in the United
States in the 1840s.

up a contract and continued to order Munroe's pencils.

As he made more pencils, Munroe developed a more sophisticated process. He began working in a way similar to that of Europe. The powdered graphite was mixed with some sort of glue and filled into grooves cut into slats. When the graphite was dry, it was removed from the slat, planed, and glued into a veneer of cedar, which could hold 8 to 10 pencils. This way of making pencils, though not terribly efficient, was the first example of pencils being made in slats in America as opposed to being made individually. Munroe was quite secretive about his process and did all of the graphite mixing and finishing alone. He had help from a few trusty assistants for everything in between.

Only 18 months after his first pencil sale, Munroe was forced to close shop because of difficulty acquiring graphite. The War of 1812 significantly lessened trade between Europe and America, which meant that foreign graphite could not be imported, and nor could European pencils. These were dire times for the pencil in America, and pencil makers were forced to make do with what they had. Because of his successes selling pencils in Boston, Munroe had a decent amount of capital and decided to spend his time

making toothbrushes and watch brushes as well as resuming his practice as a cabinet maker.

When the war ended in 1815 and trade lines between America and Europe were open again, a new problem arose as superior European pencils began to make their way onto U.S. shores. During his time off, Munroe had been studying further ways to make his product better, but it still wasn't quite up to par with the more seasoned European pencil industry. He continued to search for better materials and year by year improved his product and got closer to making pencils of comparable quality to those coming out of Germany. In 1819 he hired fellow craftsman Ebenezer Wood to help him operate the two-man saw he needed to make pencils with his newly improved method. Under Munroe's guidance, Wood designed the first machines specifically for pencil making. These machines were revolutionary, as they eliminated a great deal of the manual labor.

Among these machines was a wedge glue press, which was designed to press freshly glued pencil slats as they dried. He also designed a pencil-trimming machine, and most notably the first circular saw in the business, which was used to cut grooves into the slats. From this he was able to come up with another machine that used circular blades to cut pencils in a hexagonal or

octagonal shape. Most pencils in the early 1800s were round but once the system of using slats was popularized, Munroe realized that not only were round pencils harder to cut, but they also wasted more wood. Cutting the pencil in a hexagon or octagon was economical in more ways than one.

Though Wood's inventions significantly changed Munroe's business and put him in a much better place to compete with Europe, he made one critical mistake: he never patented his machinery. Once word got out, they were replicated and used to help other budding pencil makers get ahead.

While Munroe was conquering the pencil industry of the 1810s, John Thoreau, also of Concord, Massachusetts, was learning the art of pencil making from young industrialist Joseph Dixon. John Thoreau had four children at the time including Henry David Thoreau. The Thoreau family left town to open a grocery store, but when the business failed they returned to Boston so Thoreau could teach. He didn't really get his start as a commercial pencil maker until 1821 when his brother-in-law, Charles Dunbar, came across an undiscovered graphite deposit in Bristol, New Hampshire. Because of a complicated legal situation involving mineral rights, Dunbar was only able to secure a seven-year lease on the mine and joined with a partner who was also a Concord native to begin the manufacture of pencils. Naturally, he enlisted the help of John Thoreau because he'd already developed an incomparable wealth of knowledge on the subject. When Dunbar's partner left the business shortly after its founding, it was appropriately re-named John Thoreau & Company.

By this point, Massachusetts was the hot spot for pencil manufactures in the United States. In the 1830s Munroe's protégé and expert machinist had gone off on his own to open a graphite mill, where he ground and purified raw graphite mostly for the pencil trade. His two biggest customers were Thoreau and Munroe, and as Munroe had a history with Wood, he reportedly asked him to stop working with Thoreau as his business was being jeopardized by Thoreau's pencils, which had become better and more popular than his own. Much to Munroe's surprise, Wood's response was to drop him entirely in favor of Thoreau, from whom he was making more money.

Meanwhile, the supply of graphite at Dunbar's Bristol mine was beginning to run dry and the lease was up. They sought graphite from Sturbridge, Massachusetts, and continued producing, though the graphite wasn't as high quality as the one from Bristol. Apart from Sturbridge, there were still a few mines operating in the eastern United States. The only other known one was a recently discovered mine near Lake George in New York. Many changes were happening not just in the Thoreau business, but in the family. Thoreau's third child, Henry David, was heading to the prestigious Harvard University and needed money to pay for his tuition. The Thoreaus went to New York City, a relatively untapped market. Though they were able to sell their pencils, they also noticed a whole bevy of German-made pencils that were being imported.

While his son and principal helper was away at school, Thoreau got to work on making his pencils better. Though there had been tremendous improvements in manufacturing during the early nineteenth century, due mostly to Wood, Munroe, Dixon, and Thoreau, they still had a long way to go until they could make pencils that could compare to the greatest. Thoreau started mixing his graphite with a bit of glue, bayberry wax, and sometimes spermaceti (which is a waxy substance that comes from whale sperm). He applied the mixture carefully with a brush and cased it in with another piece of wood. His pencils were more difficult to make, but resulted in a much better core than the others being made in America. The lack of gum arabic, which had been the binder of choice for non-Conté pencils, made them less greasy than the competitors'.

In 1837, Henry David Thoreau graduated from Harvard with no plans to follow in his father's footsteps. He took a job as a teacher at his childhood school, but resigned after a mere two weeks because of a problem with the administration. Out of a job, Henry David moved home to Concord to resume work with his father at the pencil workshop.

After college, Thoreau considered himself to be a civil engineer. This was before engineering was considered a field of its own. You couldn't go to a university to study it and the parameters of such a career were undefined. Most "engineers" were academics who had an understanding of math and science. Many of them were creative types who could more easily think outside of the box when searching for pragmatic solutions to problems. Henry David wasn't satisfied just making pencils the same old way. As a newly, highly educated man, he had the voracity to make something of his circumstances.

He first realized that the problem with the existing pencils was the filler. There's no proof, but it's been suggested that he'd tested German pencils, presumably made by Faber, and noticed a significant difference. They weren't as brittle or gritty and didn't melt in the way American pencils did. Henry David was on a mission to find a way to emulate them. Legend has it that he went to the library at Harvard to research alternative methods. In a Scottish encyclopedia (which could be inferred to have been the *Encyclopaedia Britannica*), he found an entry on pencils in which German pencils are described to contain graphite mixed with clay—that is then just like the Conté. In *The Pencil: A History of Design and Circumstance*, Henry Petroski seriously questions the validity of this claim because encyclopedia writers at the time couldn't have know about any of this. Petroski instead suggests that it was possible that Thoreau had found an edition of the *Encyclopaedia Perthensis,* in which the entry on blacklead describes graphite's use with other materials for other trades, including the

→ *Though there were many brands of encyclopedia in the nineteenth century, most copied their entries verbatim from each other.*

use of clay with graphite, though not in reference to pencils. This claim is more reasonable, but the truth of the matter is that we'll never really know if Thoreau had actually learned of the Conté method or if he had used clues from other information.

Regardless of the details of his research, he obtained some clay and began experimenting with it, but not without the help of his father. Henry David worked on his new pencil formula until he believed it to be perfect and worked out all of the mechanical details. The Thoreaus were extremely secretive about their new method and let almost no one into their workshop because they didn't want to have to patent it. By the 1840s John and Henry David Thoreau were making the best pencils in America.

Once their new graphite core was perfected, the duo began experimenting with different ratios of clay and graphite. From this they realized that the hardness can differ, as could the darkness of the mark. We don't know whether the Thoreaus knew that this was already being done in Europe, but it's probably safe to assume that they didn't. Their scale was numbered 1 to

→ *This is the original U.S. grading scale which is still used to mark our #2 pencils today.*

4, 1 being the softest and containing the most graphite and 4 being the hardest and containing the most clay. Some records show that they also used S, SS, H, HH to grade them, H for hard and S for soft. The Thoreaus considered these to be drawing pencils and marketed them to any trade that they thought needed a bit of specificity with their writing implements. The only problem with this new incarnation of the Thoreau pencil was that it was expensive. At the time, most good- quality pencils were selling for about 50 cents per dozen while Thoreau pencils cost 75 cents or more per dozen. To promote the superior quality of their product, the Thoreaus published a number of testimonials from happy customers, most of whom

were known in the local community. Thoreau pencils were known for having been simply made and rather plain in appearance. They were round and had a subtle imprinting on them with the brand name and hardness grade, and nothing else. Partly due to their age and importance in the history of pencils, but mostly because of their connection to Henry David Thoreau, original Thoreau pencils are extremely rare and highly collectible. Single pencils have been known to sell at auction for nearly $1,000.

In 1845, in the wake of his brother's death, Henry David left home to build a cabin at Walden Pond. He was away for two years, which were documented and published in the eponymous work of literature that would later make him famous. When he came back to Concord he was trying to publish his first work and went to New York to sell his pencils to raise the funds to do so. Much to his disappointment, he found that the market had been totally flooded with German pencils and there was little interest. It was a far cry from the success found 10 years earlier when he and his father went to the city to find money for Harvard.

By now, William Munroe's business had become a bit out of control. Counterfeit pencils started to appear in Boston and one merchant in New York was reportedly caught selling pencils imported from Germany with the printing "W. Munroe" on them. In 1848, Munroe retired and handed the business over to his son, who was well equipped to take over for him. He continued to make pencils in smaller and smaller quantities until he wrote the whole thing off in 1854.

For the Thoreaus, this seemed like the beginning of the end of their business as well. Just when John and Henry David were beginning to feel hopeless, they started receiving large orders just for ground graphite from the printing company Smith & McDougal, who refused to disclose what they needed it for. The Thoreaus feared that they were setting up a competitive business, but the truth was that they had developed a yet unpatented process for electrotyping, which required large amounts of powdered graphite. Pencils became merely a front for their powdered graphite business, which was significantly more lucrative. Eventually, in 1853, Henry David Thoreau made the executive decision to stop making pencils: "I would not do again what I have done once," he is known to have said. When his father died only six years later, Henry David kept the business open for a while longer but focused mostly on publishing, lecturing, and writing. Though he is mostly certainly best known for his involvement with the Transcendentalists and for his many novels that have become American classics, Henry David Thoreau was indeed first a pencil innovator, or pencil hero as I like to call him. It seems he often resented the trade and his obligations to the family, but his 20 years in the business during its infant years is a testament to the type of visionary he was. Dedicated, thorough, and wickedly smart, Henry David Thoreau fully immersed and applied himself to everything he did in his lifetime, whether it be making a better pencil, building a cabin by hand, or writing books that would move an entire nation.

By the end of the nineteenth century, graphite was being mined in much of the United States, including Alabama, New York, Pennsylvania, North Carolina, and Rhode Island, making it easier for pencil makers to set up shop. Thanks to the unpatented advancements of Ebenezer Wood, William Munroe, and Henry David Thoreau, pencil making was starting to become a streamlined process. During the Paris Exposition of 1867, American machinery was celebrated as being the most advanced in the world, with three things in particular being recognized: the sewing machine, a machine to make buttonholes, and machinery that could made six pencils in one operation. Despite the ultimate failure of both the Thoreau and Munroe pencil companies, the American pencil industry was well on its way to being a worldwide force.

Though he was the creator of the famous Dixon Ticonderoga, the first to mass-produce pencils in the U.S., and a prolific inventor, Joseph Dixon still remains a somewhat mysterious figure.

Mister
Dixon

Pencil pioneer Joseph Dixon [OPPOSITE PAGE] refined the use of crucibles—
containers that can withstand high temperatures and which are used for graphite.

In the history of the American pencil industry, one name stands out as the most recognizable: Joseph Dixon. Dixon was a pencil innovator known for mechanizing its manufacture and for America's most well-known pencil, the Dixon Ticonderoga.

Dixon is perhaps the most mysterious of all of the pencil heroes, with very little personal information known about him. Even his cause of death is a mystery as it's impossible to find an obituary online or anywhere else. All we do know is that Dixon was buried in the sprawling, beautiful, and famed Greenwood Cemetery in New York City on June 17th, 1869, alongside just about every tycoon, celebrity, and innovator of his time. He left behind a legacy that is nothing if not well deserved. Very little about making pencils has changed since his death, and though other people in other places had been making pencils for much longer a time, so much of what we know about the modern pencil is owed to him.

Unlike the majority of his predecessors, it was not cabinet making or woodcraft that brought Joseph Dixon to the pencil, but rather the quest to investigate the practical uses of graphite. John Thoreau, William Munroe, and a handful of others were already making and marketing their pencils by the time Dixon joined the game officially. The market was becoming more crowded, which is ultimately what drove his early competitors out of business, but Dixon proved that he had more going for him than just being a skillful craftsman.

Joseph Dixon was born in 1799 in Marblehead, Massachusetts, a picturesque coastal town in New England. He was the son of a ship owner whose ships carried goods to and from the Orient, namely Ceylon (now Sri Lanka). At the time, graphite was plentiful in Ceylon and his father's vessels used large chunks of it as ballast as they traveled back to the United States. Once the ships reached port, there was no use for the graphite so it was simply dumped into the surrounding waters.

Though Dixon had little formal education, he was a curious young man. According to legend, when he was young he created a machine for cutting files. He'd also experimented with print making but didn't have the money for metal type so he crafted his own out of wood. As he entered adulthood, he was struck by the amount of graphite being disposed of through his father's business and sought ways to make use of it.

First, he tried pencils. From what we know, he'd never seen a pencil himself, let alone made one, but learned of them from his chemist friend Francis Peabody, who had informed him of the basics of how they're made, especially the inclusion of clay in the core. The pencils he made as a result were of decent quality, considering how terrible American pencils were at the time.

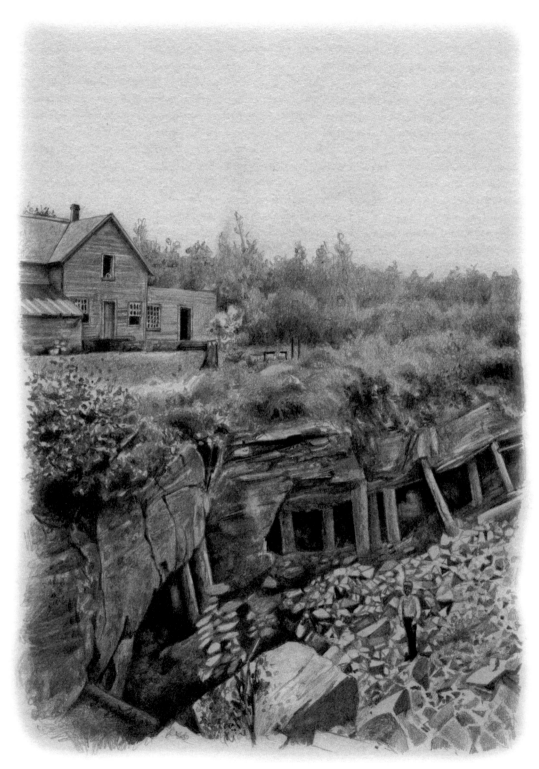

The famous Ticonderoga pencil was named after the town in New York
where the graphite for it was mined. The mine is shown here in 1890.

However, there was no market for them. This was in the second decade of the nineteenth century and America hadn't quite developed a taste for pencils the way the Europeans had. Instead of continuing with pencil making, Dixon got a job at a kiln to save money and learn more about baking ceramics so he could improve his methods of making a pencil core.

In 1822, Joseph Dixon married Hannah Martine, daughter of cabinet maker Ebenezer Wood (the same Ebenezer Wood we know to have worked with William Munroe and who was also an early master of designing pencil-making machinery). Though his passion lay in making pencils, Dixon knew he had to find a better method before they could turn a profit. In the meantime, he took advantage of his immense graphite resource by making other things, namely crucibles for the making of molds in which to melt metal. He set up shop in nearby → *Crucibles, the things* Salem, Massachusetts, and *in which metal is melted,* got to work. There was a *used to have crosses* limited market for crucibles *marked on them, which is* as well, so he used graph- *where the name comes* ite to make stove polish for *from.* supplemental income.

From the cottage where he and Hannah lived, Joseph very persistently continued to master his pencil craft. From there he developed a hand-crank machine, which was used to cut grooves into the cedar. The main problem for him though, was that he wasn't refining his graphite well enough and though he had rather effectively mastered using clay in the cores, the pencils were gritty and weren't cased in very well. Because pencil competition was so stiff, it was crucial that every pencil be branded with who made it and where it came from, so the consumer knew what to expect. Since Joseph had skill as a printer, he lithographed → *Graphite stove polish is* them himself, but allegedly *still a widely used product.* made the mistake of leaving *It's wax based and the* the "a" out of Salem. This *shininess of the graphite* was around 1828, the year *is what makes it a polish.*

that is still recognized as Dixon Ticonderoga's founding, though the pencils were far from being commercially produced.

Still, Dixon continued making crucibles with the seemingly unlimited supplies of graphite from his father's docks. Though he wasn't making much money, the raw material was inexpensive as he was mostly only paying for the labor of it (the graphite chunks being loaded on to the dock instead of dumped). Graphite was and still is the most suitable material for crucibles because molten metal can't fuse to it, which gives it an advantage to the alternatives, which in the nineteenth century were made of clay. Making crucibles out of graphite wasn't at all a new idea in America, just not a popular one because there wasn't enough local graphite to make an enormous amount of them. For that reason, most foundries preferred clay crucibles because it was what they were accustomed to.

Dixon's crucibles were better than anything else out there in the 1800s. They were almost perfect to a fault, as they could survive about 80 firings and didn't need to be replaced often. That's where the stove polish came in. It was easy to produce, and Joseph could make it less expensively than his competitors. Others even tried to counterfeit his product with little success.

For a brief period of time, Dixon put the pencils on hold almost entirely and instead focused on developing projects that were more financially promising. The great mind that he was, Dixon is most recognized as being an inventor in written history. With the help of fellow inventor Isaac Babbitt, he developed an anti-friction alloy that didn't disintegrate under the heat of extreme friction, which was used in bearings for machinery. The Babbitt metal, as it was called, is still used in car engines to this day.

His interest in print making also led him to cameras, the new technology that they were. With this he came up with a mirror that allowed the camera operator to see the image being

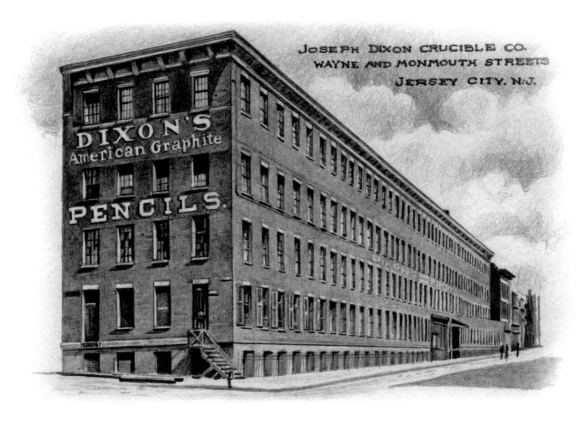

JOSEPH DIXON CRUCIBLE CO.
WAYNE AND MONMOUTH STREETS
JERSEY CITY. N.J.

DIXON'S
American Graphite

PENCILS.

The Dixon factory in the early 1900s.

photographed in the correct orientation instead of upside down.

Perhaps most interestingly, Dixon is also credited as an early pioneer of photolithography. According to the *Photographic Journal* Vol. 20, in 1896, he "copied bank notes by mixing gum with potassium bichromate, spreading the mixture on a lithographic stone, exposing to light through a bank note, and inking up the exposed stone and printing proofs the usual way." In other words, he invented the printing process that would allow the U.S. Treasury to print paper money that couldn't easily be counterfeited. This wasn't his only involvement with U.S. currency—he also made crucibles in which the mint would melt silver and gold for the making of coins.

In 1846, Dixon's entire business would change drastically. The start of the Mexican–American War created an urgent need for crucibles for the making of weaponry, and Dixon was quick to respond. He moved his family to Jersey City, New Jersey, on the Hudson River directly across from Manhattan where he set up the Joseph Dixon Crucible Company in a brand-new factory. With a steady cash flow and the facilities to do so, he slowly started making pencils again. He was meeting two different demands during the war—one for crucibles, the other for a writing instrument that wasn't as fussy as a quill. The factory was set up for both industries, with crucibles on one end and pencils on the other.

With the establishment of a proper factory, Dixon could officially make the claim that his

was the first pencil factory in the New York metro area. Reportedly, in its first year operating in Jersey City, the company made $60,000 in profit from crucibles and lost $5,000 on pencils. The pencil sector of the business had always been a labor of love, not a moneymaker, and Dixon was well aware of this.

The 1840s also brought rough times for the American pencil industry as more and more German pencils were being imported to U.S. soil. Dixon still wasn't heavily pushing his pencils to the mass market, but he certainly had ambitions to do so. Being the perfectionist that it seems he was, he wanted to make sure he was making the best pencils he could in the most efficient way possible before he made his brand known. With the start of the Civil War in the 1860s, rather extreme trade taxes were imposed and it became more difficult and more expensive for foreign manufacturers to get their pencils into the United States. German brands, the main source of competition, only continued to import their very finest pencils, which totally cleared the market to make room for more affordable products made on U.S. turf. It was a huge sigh of relief for Dixon, as his ever-improving pencils had the opportunity to be in the spotlight for once. Dixon's machinery, which he'd been working on and tinkering with for decades, made him the most efficient of the U.S. pencil makers, especially during a time when portable writing instruments were needed most. In 1866, Dixon patented a wood planing machine that could handle 132 pencils per minute—by far the fastest-producing type in the world.

Finally, after decades of trial, error, detours, and experimentation, Dixon was making money on his beloved pencils. With his health beginning to deteriorate as he neared his 70s, Dixon appointed his son-in-law, Orestes Cleveland, as president of the company and later took necessary measures to incorporate his business as a public company under the name Joseph Dixon Crucible Co. At the time of his death in 1869, his

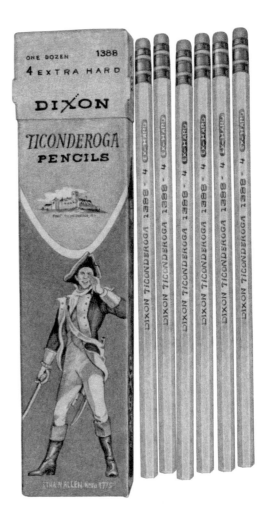

The company's pencil packaging featured Fort Ticonderoga, an important site during the American Revolutionary War.

factory was making more pencils than any other in the world.

The story doesn't end after Joseph Dixon's death. One thing about his company that differs from the others of his time is that it still exists, and his contemporaries did a fine job picking up where he left off.

Steel was also an emerging industry in the early 1870s and U.S. crucible steel, which was

used most notably for the making of suspension cables for bridges, could only be made in a graphite crucible. As a new America was being formed, so was the Joseph Dixon Crucible Company. Following its founder's death, Cleveland carried the business on into a new realm of fame and fortune. Taking what Dixon had started, Cleveland began to build the pencil side of the business by finishing the creation of new machinery and building organized rooms for lathes, planers, painting, and finishing. There was even ventilation for each machine that was connected to air ducts. The dust and debris from the wood-working machine was sucked into the system and then collected and used for fuel. The result was an incredibly sophisticated and clean factory that would help Dixon further conquer the industry. Dixon and Cleveland had learned from the mistakes of Ebenezer Wood, William Munroe, and John Thoreau and were quick to patent and trademark all of their ideas before any member of the public laid eyes on them.

The Dixon factory was even milling its graphite to 99.96 percent purity, which was a far cry from the graphite being employed for pencils only 50 or so years earlier. The reason for this can be attributed to both the technology of the factory and the source of the graphite. In 1873, Joseph Dixon Crucible Company purchased the American Graphite Company in Ticonderoga, New York. The Ticonderoga mine became known for producing graphite with a particularly thin foliation of crystalline graphite, so fine that the product from this mine was *→ This very site was* dubbed "flake graphite." *dedicated as the Joseph* Dixon's most famous pencil *Dixon Memorial Forest* owes its name to this town, *in 1958 and can be* which was built around Fort *visited by all, though it* Ticonderoga during the *has since become a* Revolutionary War. *bit engulfed in greenery.*

After years of preparation, Joseph Dixon Crucible Co. revealed their "new" entirely U.S.-made pencils to the world in the late 1870s. It seems like it was a sort of rebranding by Cleveland to re-establish the company's roots and reintroduce its product to the world. As the company grew, the branding for the Joseph Dixon Crucible Company became more and more complicated as it had evolved into more of a pencil company and less of a crucible manufacturer. For quite some time, a tiny gold crucible was imprinted onto each pencil. The term "American graphite" was even trademarked and used heavily in marketing. Around this time, European pencil companies started establishing subsidiaries in the United States to make pencils for the American market. The Dixon company was outraged by this, as these other companies were calling their pencils "American." From then on, much of the Dixon branding and marketing took on a rather patriotic theme. At this time in history, it's been said that Joseph Dixon Crucible Company was the largest consumer of graphite in the world.

The manner in which the pencil business at Joseph Dixon Crucible Company took off seems rapid, but considering how many years Dixon spent working on his product in the privacy of his home in Salem, it really doesn't come as a surprise. As the century came to a close, the Joseph Dixon Crucible Company was, as Joseph Dixon himself had dreamed, solely a pencil factory. Dixon wasn't the only reputable pencil company in the game anymore. General Pencil Company had set up in Jersey City and many others established roots in New York. The American pencil business was booming. By the end of the 1800s, Americans were consuming about 20 million pencils a year with the average cost of pencils at about 5 cents each.

Throughout the twentieth century, Dixon carried on doing more of the same. They may have been one of the very biggest in the world, but when compared to the rest in their league they didn't take many risks or experiment much further with their products. Sure, after the introduction of the Ticonderoga in the 1910s it was clear that they had it together, but it's a little

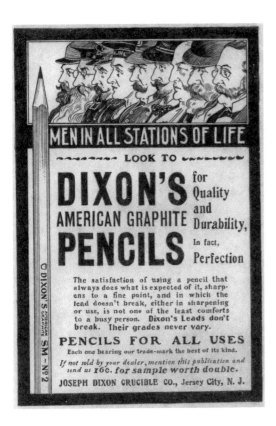

An ad singing the praises of Dixon's pencils
to men everywhere in 1901.

peculiar to ponder it, considering especially the things that were going on within the rest of the pencil empires. Maybe their pencil was that perfect that they thought it was best to leave it alone for another century.

The pencil I consider to be my "gateway" pencil, as one might say, was a Ticonderoga from the very early 2000s that was painted black. My mother heard about them from her friend, who claimed the black ones were somehow better than the yellow, though there certainly wasn't a difference. Having grown up not thinking about the quality of the pencils I was using, this one blew my mind. For the rest of my days as a student it would be my go-to, especially the last of the American-made ones which I'd hoarded.

Dixon pencils aren't made in the United States anymore, nor is the company American-owned, a fact for which we can blame globalization. Even so, just like it was in the 1870s, Dixon branding and packaging is still patriotic. It boasts its history and even makes the claim that it's "The World's Best Pencil." Though the Ticonderoga mine has long been defunct, the one thing that has remained the same is the cedar that the pencils are made from, which very proudly still comes from the United States. You may not find a Dixon factory in the United States anymore, but you can still drive by the old one in Jersey City and see evidence of its glory days. The brick is still painted with the brand name, but instead of finding bustling factory workers and whirling machines, you'll find apartments.

What remains of the old Dixon pencil empire is the humble yellow Ticonderoga. It has a bright green ferrule over its pink eraser. The lead is what we've come to consider to be the standard for a #2 pencil. It's an object we can trust. We know what to expect. It has almost become a caricature of its former self, the humble pencil whose life span lasts forever. Perhaps this is the very object Joseph Dixon aspired to create all along: a pencil for the everyman, utilitarian in its function and perfect in its simplicity. It is the American pencil.

U.S. Manufacturing, German Heritage

The Pink Pearl, the Blackwing 602, and a canary-yellow writing pencil pop up in the colorful story of the great-grandson of Kaspar Faber who combined American innovation with German traditions.

e've covered the earliest pencils in both Europe and North America and have mentioned the effect of German importation in the United States in the 1800s, but I'm afraid that I may have shed an unfavorable light on German pencils for the sake of the American pencil makers who longed for a market all their own. One of the biggest proponents in this (and one of my favorite stories to tell) is that of Eberhard Faber. He wasn't the first to import German pencils but took it one step further by packing his bags and moving to the United States on behalf of his family's business. He permanently made his mark in America by establishing deep roots in New York and building a company that would set the stage for the future of American pencil making.

Second to Dixon, Faber quickly became the most recognized name in pencils in the United States in the twentieth century. Before Eberhard Faber was a household name, he was a descendant of the German Faber family, of A.W. Faber and later Faber-Castell. More specifically, he was the great-grandson of Kaspar Faber, the company's founder.

Though the pencil industry was just getting started in the States in the middle of the nineteenth century, A.W. Faber was already well established in Germany and looking for ways to expand. Eberhard Faber was born in 1822 as John Eberhard Faber and was destined to be a lawyer, but when the opportunity to move to New York presented itself, he left school and jumped at the chance to expand A.W. Faber overseas.

Eberhard was 27 years old when he first moved to New York and though A.W. Faber already had a distributor there, he soon became the sole agent. He set up shop in downtown Manhattan

and imported other German stationery goods in addition to his family's pencils. As we know, most pencils being made in the United States at the time were coming from Boston. One could find a handful of Dixon pencils in New York in addition to a few others, but A.W. Faber, as a trusted and established brand, also had the added benefit of being exotic and foreign. It was all about branding, and to sell pencils having a reputable name was almost more important than the product itself.

By then it was well known that cedar was the best wood to make pencils with, and it had also long been known that the United States had an abundance of it, especially in the south. Eventually, the Fabers got smart and acquired a piece of cedar-rich land in Florida and decided that instead of importing already finished pencils from Germany, it made more sense economically to import the Stein-made cores and assemble the actual pencils in the United States with Florida cedar, and in turn the cedar could be exported to use at the German factory. Petroski in *The Pencil: A History of Design and Circumstance* speculates that this was the Fabers' intention for sending Eberhard stateside in the first place.

The first Faber-owned factory in the United States was built in 1861 on 42nd Street in Manhattan, on the same piece of land where the United Nations now stands. From this point on, the pencils sold in the United States under the A.W. Faber name that were made in the new factory were stamped "Made in the U.S.A."—the very practice that Dixon despised and actively spoke against. They may not have been entirely American pencils, but they were made in America and utilized the same methods and machinery as all the rest in the region. If anything, they were better as they combined American innovation in machinery with the tradition of German pencil making. The conditions allowed the Fabers the best of both worlds and perhaps Dixon was a little envious of the advantage they had.

We must also keep in mind that this was a particularly tricky time to attempt to set up such a business as the Civil War made it not only harder to import pencil cores from Stein and to export cedar, but also because Florida was a Confederate state and getting the cedar shipped north proved problematic.

The bad fortune didn't end with the war, as the A.W. Faber factory in Manhattan was destroyed in a fire just over 10 years after opening. Eberhard had wanted to set up the new factory in the borough of Staten Island, where he lived with his family, but instead ended up buying three existing buildings in the rather industrial Greenpoint neighborhood in Brooklyn.

→ Most of the American Faber family built grand homes and lived on Staten Island. Most of these houses have since been demolished, though the Faber Park and Pool still stands in their old neighborhood as a public monument to the family.

When Eberhard Faber died in 1879 at the age of 57, he had established an empire. The cause of his death was mysterious, though his bizarrely detailed *New York Times* obituary told of him traveling to Germany and back to seek help from numerous doctors. It goes on to detail that "his disease was of long standing and seems to have completely baffled the doctors." He was buried at the Greenwood Cemetery in Brooklyn not far from his competition Joseph Dixon, who died 10 years earlier. In the cemetery's archives is a letter written preceding his death instructing the cemetery to open his grave for his children—written and signed in pencil, of course. If only he'd known what would eventually become of his name.

Though we know little about Eberhard Faber himself, the story of his name and his family really starts with his children. He left behind his wife, Jenny, who was also from a prominent Bavarian family, as well as three daughters and two sons. Tasked with taking over the business, sons John Eberhard II and Lothar W. had plans of their own. As mentioned in the history of the Faber family, it was these two brothers who decided to incorporate their business as their own, independent from A.W. Faber. It seems the Fabers took this family feud to the grave as no one knows quite what happened. Whether it was an amicable split or not, in 1898 Eberhard II and Lothar W. officially divorced the family business and changed the name to E. Faber Pencil Company. Still operating from the same Greenpoint location, they started making pencils with the new name on them. Around the same time, they also established Eberhard Faber Rubber Company in Newark, New Jersey, which primarily made rubber erasers and rubber bands.

The more exciting part of the saga began in the early twentieth century when the Faber brothers started making a name for themselves. In an introduction in the 1892 catalog, Eberhard II made a bold promise to "manufacture perfect goods only." The formation of the new Eberhard Faber Pencil Company didn't totally eliminate A.W. Faber, as there were still agents importing the German goods into the United States. By the early part of the century, the American pencil industry was controlled by the "Big Four": Eberhard Faber, Dixon, American, and Eagle—all of whom had set up shop in or around New York City. Finding the technique and technology to make near-perfect pencils was no longer the problem, but rather the race to stand out posed a bigger threat to pencil makers. A successful pencil not only had to be of terrific quality, but also special in some way.

→ Of the "Big Four," all of which were originally family-owned, only the Weissenborns of the American Pencil Company and the Berolzheimers of Eagle Pencil Company are still making pencils.

Most of the early Eberhard Faber pencils were made well and simply branded. About 10 years into the twentieth century, pencil models began to be named outside of their brand name and model number—usually with a name that had to do with the heritage and preferences of the pencil maker. Eberhard Faber Pencil Co. started to grow. It expanded its factories to Germany, Argentina, and Canada, though the primary factory remained in Greenpoint.

The first of the more creative Eberhard Faber pencil models is one that is still perhaps its most recognizable. The Eberhard Faber Mongol 482 came to be in the early 1910s. It was painted yellow and had a ferrule that was a dark metallic gray. After a few years in existence, the ferrule became black with a thick gold stripe through the middle—a feature that became a widely recognized trademark of the Mongol, as well as its distinctive typeface. The truth about the Mongol's name isn't really known. A very early example of the packing is a yellow-gold box with brown printing where some of the text is written in a rather racist, fake brushstroke font.

Also pictured on the box is a portrait of a Chinese man. The name may be related to a theory about the yellow color of a pencil, which has been tied to a claim that the best graphite in the 1800s came from China, where the color yellow is traditionally associated with royalty. There are a number of disputes against this claim about the origin of the yellow pencil as well as another explanation about the Mongol pencil that comes straight from a Faber descendant. Sean Malone, historian of the Blackwing 602, learned from Eberhard Faber IV himself that the pencil was instead named after John Eberhard's favorite soup, Pureé Mongole.

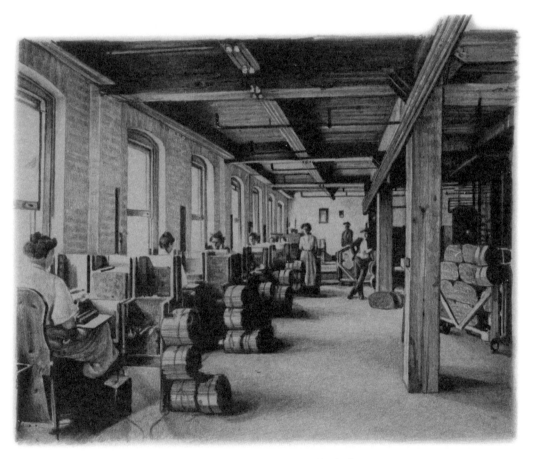

One of the starting points for a pencil-making family saga: Eberhard Faber's Greenpoint factory in New York.

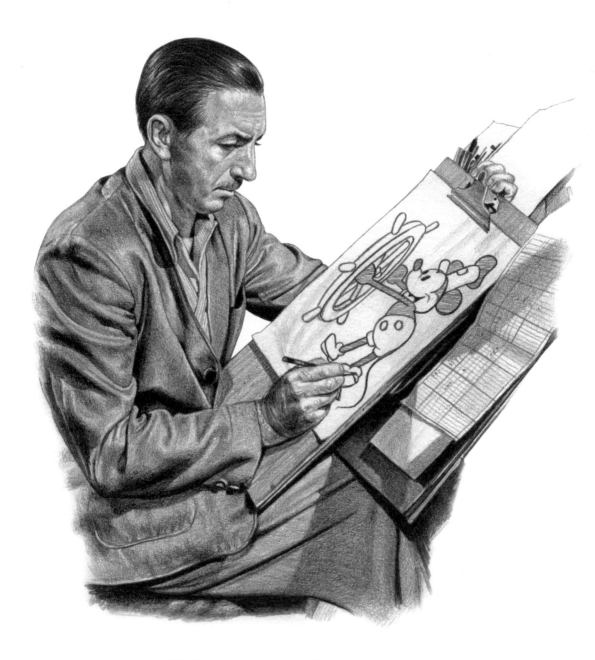

A favorite of animators, including Walt Disney, the Blackwing 602 was one of
Eberhard Faber's prime products in the middle of the twentieth century.

What we do know for sure about the Mongol is that it long remained one of the most recognized "general use" pencils. It rivaled the Dixon Ticonderoga and the Venus Velvet as the most iconic yellow pencil, and was successful in great

→ Pureé Mongole was a fashionable soup of the late 1800s and early 1900s. It is essentially creamed split pea soup with carrots and other root vegetables, spiced with curry, basil, cloves, and turmeric.

part due to its packaging design and clever advertising. Many different versions of it existed, branded for different uses, including the Mongol School Pencil, the Mongol Fine Writing pencil, Mongol drawing pencils, Mongol colored pencils, and the Mongol Stenographic pencil (my personal favorite), which was smaller in diameter, firmer in hardness, and sharpened on both sides for efficiency and ease of use for court reporters, secretaries, and stenographers.

Shortly after the Mongol came the Van Dyke, which was widely known for a number of things, including its position as the first quality drawing pencil in the Eberhard Faber catalog that was made in a variety of degrees of hardness—18 to be exact. The pencil was named after the Dutch artist Anthony van Dyck. It was introduced in the 1920s, and once it gained notoriety it was redeveloped to feature two very unique characteristics. First, it contained "Microtomic lead," which was marketed as including high-density graphite with smaller particles, so it was smoother and less smudgy. The second and perhaps most noteworthy feature of the Van Dyke was its flat ferrule on later models that were marketed for more general use. Until the Van Dyke, ferrules were always round. In this case, the part of the ferrule that attached to the pencil was round and as it was molded off, the pencil took on a flat, rectangular shape that held a small removable clamp that held a red rubber eraser. The idea was that not only did the flat shape of the ferrule help prevent it from rolling off of a table, but the eraser was a more useful shape and was replaceable since it wasn't glued into the ferrule.

Included in the text of a very early Van Dyke advertisement is the quote "Europe invented the pencil, but America perfected it." From the first prominent German-American pencil company, especially one who claimed to be "The Oldest Pencil Factory in America," this is a bold but honest statement, one that this particular era in pencil history could justify. Though Europe was still producing fine pencils, their process, marketing, and design hadn't evolved in a way that was even close to matching that of the United States. The American Fabers, if anything, were brilliant at not only making quality products that challenged what that very statement meant, but also at taking it to the next level and convincing the American public that their pencils were the very best, regardless of whether they were or not.

With the introduction of more specific types of pencils, Eberhard Faber II became frustrated with the way they were selling. Most stationers sold only a couple of types from his catalog, though they were constantly churning out new models for different purposes and different price points. Eberhard Faber started putting together very specific product catalogs detailing exactly what each pencil was made for, including all of the relevant information—an education of sorts for their stockists. This included beautifully made sample kits and product cabinets, with special places made to hold each type of pencil. Though this new sales strategy helped give exposure to more types of products, there were still strong favorites. By the 1930s, the most popular items were eraser-tipped pencils, untipped pencils, and copying pencils, in that order.

The success of the fancy new Faber pencils had the company on a roll. That is, until the Great Depression hit. The Eberhard Faber Pencil Company was certainly not immune to the tragic effects on the economy. They had to let go of 30 percent of their workforce and the demand lessened greatly. Their new strategies for marketing had to be re-evaluated and scaled back. One particularly important thing came of this period—a

Blackwing fan Vladimir Nabokov, who used the
pencil for drafting out his novels on index cards.

part of the ferrule. The back of the pencil was
stamped with the words "Half the Pressure, Twice
the Speed"—a tagline that pointed to one import-
ant feature of the pencil: the inclusion of wax in
its core. The 602 contained a rather high amount
of wax, more graphite, and less clay, which made
it write like a pencil of 4B hardness, but with a
unique glide. The theory was that it required half
the pressure to make the same mark and could be
used faster for the benefit of writers.

The Blackwing 602 was indeed a great pen-
cil, and without a doubt one of the most legend-
ary. What makes it so renowned is not necessarily
the pencil itself but the people who were famous
for using it. Walt Disney and his animators were
known to love the Blackwing and considered it to
be a prime pencil for animation. It's also credited
as being the favorite of Stephen Sondheim, who
appreciated its darkness for writing music. The
list goes on to include Quincy Jones, Vladimir
Nabokov and many others, though one Blackwing
user stands out beyond the rest: John Steinbeck.
Steinbeck is likely the person whose legacy for
using the Blackwing has promoted its popu-
larity long after its discontinuation. Famously,
Steinbeck was quoted as saying, "I have found
a new kind of pencil—the best I have ever had.
Of course it costs three times as much too, but it
is black and soft but doesn't break off. I think I
will always use these. They are called Blackwings
and they really glide over the paper." Though we

→ Within the modern pen- don't know exactly which
cil community, a pencil works Steinbeck wrote, he
is considered to be in was a notorious and serious
"Steinbeck stage" when pencil user and only used
it reaches this length, his pencils until the ferrule
which varies depending sat in the crux of his hand,
on the size of your hand. at which point he would
pass them on to his son who also went on to be-
come a writer.

Whether or not we owe the glory of the
Blackwing 602 to Steinbeck or to the pencil it-
self, it has become one of the very most collect-
able on the market. Older versions have been

pencil known as the Blackwing 602, a bold move
for the Fabers. It was rather controversially in-
troduced in 1934, during a period of time when
the last thing America needed was a premium
writing pencil.

The legend surrounding this pencil is im-
mense and also widely known. Early Blackwings
looked similar to the newly revamped Van Dykes.
They featured an almost identical version of the
famous ferrule and were lacquered in a dark,
shiny, pearlescent gray. To distinguish it from its
predecessor it had a gold band around the lower

known to sell for upwards of $100 each on eBay, and though there have been claims that other Eberhard Faber models write the same, loyalists still believe that nothing will ever come close to the original. Writing with a Blackwing 602, more than any other pencil, feels like an event—something like a rite of passage for a pencil obsessive. When they are sold in my shop I always encourage the customer to sharpen it at least once and to use it for special occasions, because most of the pleasure of owning it comes from knowing what it feels like to write with it as much as it comes from the history.

One could say the middle of the twentieth century was Eberhard Faber's prime and their greatest hit was the Blackwing 602. By this time, more pencil companies were popping up in the eastern United States, and though most of them weren't around for long, they did make the industry fiercely competitive and diluted the influence of the Big Four. Eberhard Faber remained one of the largest and went on the make more legendary products, including the eraser we still know as the Pink Pearl. Eventually, the Van Dyke pencil was given another makeover and renamed the Microtomic. The Mongol continued to evolve into a school favorite and the Blackwing dominated the writing pencil sector. It almost seems that once Eberhard Faber perfected its signature products, that was it—nothing as remarkable as the Van Dyke, Mongol, or Blackwing came along in the periods after. By the 1980s the pencil industry was starting to experience what seemed like a mass consolidation. Factories began to close or were bought by others, and Eberhard Faber fell victim in 1987 when it was bought by A.W. Faber-Castell, almost 90 years after its incorporation as an independent company. The irony of this may or may not be significant, but it's almost as if the American Fabers had run away for a century, only to return home eventually.

Fortunately for the Blackwing, it made the cut when Faber-Castell took over. Blackwings remained generally unchanged apart from the gradual and slight evolution of the graphite core, which had already been happening for decades. Faber-Castell was bought by Sanford in 1994, and around the same time the machine that made the ferrule clips, the ones that held the eraser in place, was broken and never fixed. Faber-Castell continued to make the Blackwing 602 until the back stock of ferrule clips ran dry in 1998. When Faber-Castell chose not to continue with the Blackwing 602, its fans frantically hoarded the last ones.

Much of the history of the Eberhard Faber Pencil Company has long been forgotten, but one can still find pencils of the same names and designs by other current pencil makers. The Mongol 482 is still the pencil of choice in Latin America, though now it's made by Papermate. The Pink Pearl, also made by Papermate, is still a staple for back-to-school shopping lists year after year. Even the Blackwing 602 has seen a revival by the California based company Palomino, which has brought to light the story of Eberhard Faber for a new generation of creatives.

Like the old Dixon factory, the Eberhard Faber complex in Greenpoint has now been converted into condos and studios, though if you look closely towards the top of the main building you can still spot the art deco–style yellow tile pencils flanking the industrial brick facade. Watch a period television show or a movie from anywhere between the 1940s and 1970s, and it's very likely you'll spot an Eberhard Faber pencil. Traces of the old Eberhard Faber empire are scattered all over American culture and the fame of the Eberhard Faber Pencil Company and the family at the helm will always be an important part of pencil history. Their products brought a certain playfulness to the pencil and gave it a life as an object that was not just utilitarian, but also special and even sometimes glorified. Long gone are the days when a pencil could truly be considered innovative, but the Fabers made their mark in America for taking what was known, shaking it up, and giving us exactly what we never knew we needed in such a seemingly simple object.

Shades
of
Gray

Ever wondered what the H, B, and F emblazoned on your pencil stand for? Here's pencil hardness and the grading scale explained—as much as possible, given the unconfirmed nature of its origin.

We've grazed the subject already, but it's time to talk about the evolution of the numbers and letters that grace the ends of your pencils. I'm talking about the pencil-grading scale, a complicated system to mark the hardness of a pencil. Knowing that the main ingredient in a pencil's core is graphite, how does one find out just how much of this the pencil contains? And what difference does it really make?

Pencil hardness determines one thing: the ratio of clay to graphite in a pencil's core. If the pencil has more clay and less graphite, it is considered harder. Typical characteristics of a hard pencil are that it is less smudgy, has better point retention, and makes a lighter mark. A softer pencil will have more graphite, less clay, and will be darker, smoother, smudgier, and will usually wear down more quickly. A #2 pencil or an HB pencil is not only the grade we're most used to finding on our general use pencils, it's also the very middle of the scale. Useful, as it's pretty well understood internationally what an HB is roughly supposed to feel like. If you are left-handed, you may prefer a harder pencil because your hand won't smudge it. If you are an artist, you might prefer a softer pencil because the high graphite content will give you more freedom to blend and find line variation. If you're an architect, you'll probably want a very, very hard pencil to get perfect, sharp lines. There is a whole world beyond the #2/HB pencil for a whole list of pencil uses. The importance of the pencil-grading scale is something I can't emphasize enough. It is a common misconception that drawing pencils are the only ones that come in different grades. Not only is this untrue, but also, if you think about it—is a drawing pencil not the exact same thing as a "regular" pencil apart from the variety of hardnesses available? In my world, there is no such thing as a "drawing pencil" or a "writing pencil," there is just "the pencil."

First things first: the pencil-grading scale is not at all universal. There is no standardized formula for how a pencil of a certain grade is meant to feel, nor has there ever been. The user of a pencil cannot expect, for example, an Indian HB to feel the same as a Japanese HB. The purpose of the grading scale is for general reference, as well as to grade pencils in relation to the others in that particular range. At one point in history, the National Bureau of Standards attempted to address this conundrum with no success. This is one of the most intimidating things for new pencil enthusiasts: if you hate a pencil, is it because you just hate the pencil or because you've chosen the wrong hardness? I, for one, have soft taste in pencils. That said, I also write with a heavy hand—something that is not conducive to a softer pencil with lesser point retention. For that reason, I prefer what is a sort of "unicorn" of pencils: a soft pencil that doesn't smudge or wear down quickly. This exact object doesn't really exist, but I've found a few that come pretty close.

We can credit our original pencil hero, Nicolas-Jacques Conté, for making the grading scale possible with his mix of powdered graphite and clay. Can you imagine trying to vary the hardness of a pencil using gum arabic and spermaceti? Clay strengthens the graphite but also makes it variable. There is no other ingredient one can use to replace clay for this particular purpose. After the materials, much of the history of the grading scale is really the stuff of myth. There are two main accounts that we can consider to be true: one that tells of a pencil maker putting his own stamp on his work and another of a less-enticing practice of utility. Either way, in the United States, pencils are usually graded on a scale of 1 to 4, whereas everywhere else they're marked on a scale of numbered Hs and Bs. This is just one more example of how Americans tried do it on their own in the nineteenth century, though in this case, the impact was more confusing than revolutionary.

Opinions on which theory explains the H and B designations are split mainly between two stories. What we do know for sure, though, is that the grading scale itself is fixed. HB is the middle grade, and as the grade gets softer, it goes from B to 2B, 3B, 4B, 5B, etc. As the pencil gets harder, the scale goes from F to H to 2H, 3H, 4H, and so on. The whole thing is pretty easy to understand—except for that seemingly random F. You'd think that this sneaky F would help to figure out where the whole thing came from, but this isn't the case, as just about any account of its origin can justify it.

When Conté developed his method for making pencil cores, he was the first to use the 1 to 4 scale. We can assume that Thoreau didn't know about this when he started using the exact same scale shortly afterwards in America, though there is evidence to support that in addition to grading the pencils by number, the Thoreaus also used S and H for soft and hard. Other than that, we have H and B, the scale that has always been used and preferred by European pencil makers.

The first theory comes from Nuremburg, where it is said that A.W. Faber made the first poly-grade pencils in the late 1830s. These pencils were graded in a range from HHH to BB (so essentially, 3H, 2H, H, HB, B, 2B). It is generally assumed that these letters meant H for hard and B for black or bold. Of course, this makes a whole lot of sense. Another similar theory says this comes from the Brookman pencil company in London, who used the same scale. This claim doesn't seem as reputable as being the first, though, as it would have been the early 1900s, decades after Faber had begun making poly-grade pencils with the same numbers. Where the F came in exactly, no one knows for sure, though following these theories it is often explained as meaning "fine" or "firm."

As we know, the Hardtmuth family of L. & C. Hardtmuth Pencil Company is known for having made many innovations in pencils in the nineteenth century; however, most of them have been

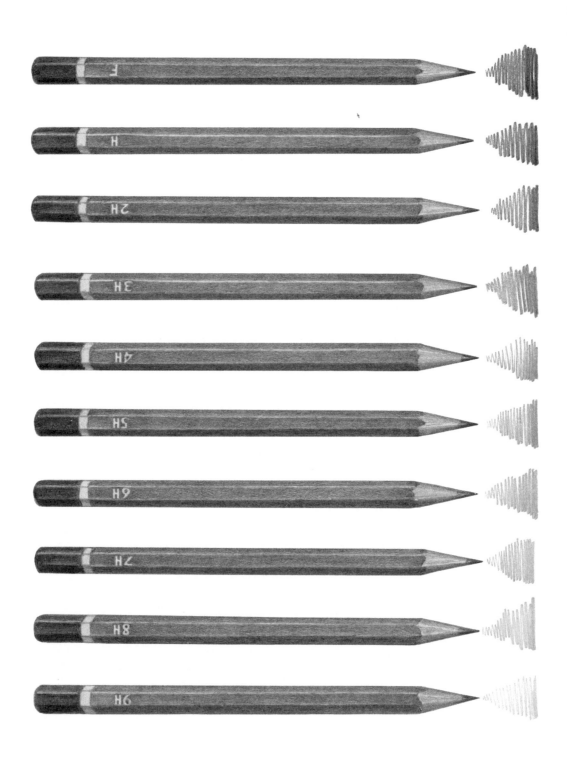

Hard pencils (F and H) contain more clay and less graphite and so are lighter and scratchier, while soft pencils (B) contain more graphite than clay and so are darker and smudgier.

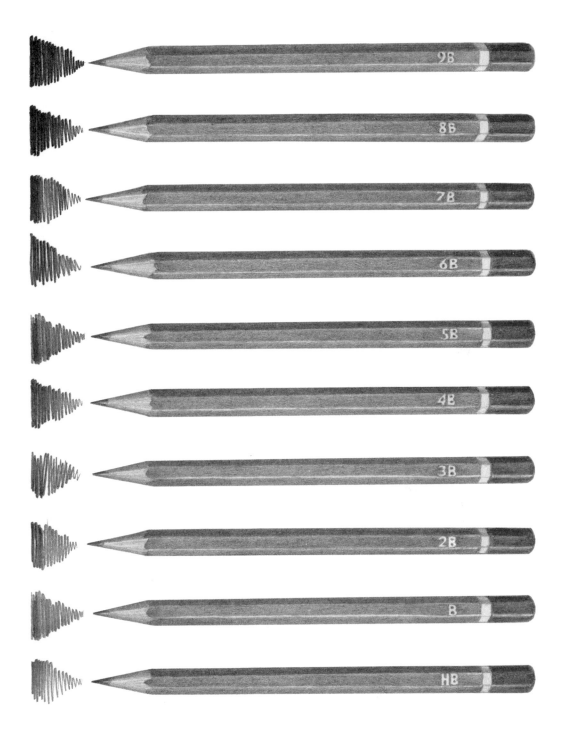

discredited, as there isn't significant proof. From Conté's clay, to the explanation of yellow pencils, to the modern grading scale—the Hardtmuth pencil company is often written off as a side note in pencil history for having "maybe" discovered a plethora of things. In the instance of the pencil-grading scale, this is the story I choose to believe, based on the timeline of when all of these things approximately happened and the way the letters so perfectly stand for the words involved. Perhaps I'm a bit biased because I think the Hardtmuth's haven't been paid their due in documented pencil history; however, the truth is that it very well could have been just another appropriation of the meanings of the H, F, and B.

Towards the end of the nineteenth century, the Hardtmuth pencil company introduced a pencil called the Koh-i-Noor 1500—a pencil that's credited for doing many different things. It came in a remarkable 17 grades, far more than anything else on the market at the time. According to Koh-i-Noor Hardtmuth's history, the H stood for "Hardtmuth," the B stood for "Budweis" (the name of the town in which the pencils were made), and F stood for "Franz," the member of the Hardtmuth family who came up with the idea. Early examples of Koh-i-Noor 1500s are marked with a number before the letter, whereas German pencils just had a series of HHHH or BBBB. Perhaps we can assume it was Hardtmuth who first consolidated all of the letters, though I'm a little surprised that this didn't happen sooner.

What is very likely is that these things were all discovered by different people around the same time, with no knowledge of each other, and there is no untrue story or no definite first—as is the case with most of this history. We can, however, be grateful that there's a universal system

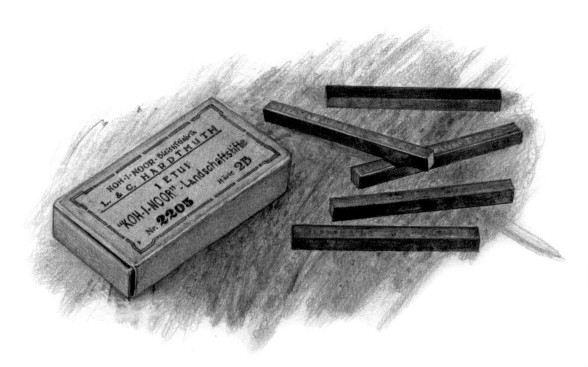

The innovative Koh-i-Noor Hardtmuth range has expanded, running to graphite sticks and, today, to all manner of office supplies.

for understanding pencil hardnesses. Though it's not consistent, if the grading scale hadn't been established so early in the history of poly-grade pencils, then a universally understood method of expectations for pencil hardness would likely be an even more blurry subject than it currently is.

Every country in the world uses the same scale, apart from the United States, which uses a number system. The U.S. *→ Odd examples of pen-* hardness scale is set up so a *cils with fractions in* #1 is a B, a #2 is an HB, a #2 *the grading scale include* 1/2 is an F, and a #3 is an H. *the Dixon Ticonderoga* Though the use of this scale *Thinline in a #2 6/10,* is in a minority on a global *the General's Badger in a* scale, there was once a time *#2 2/4, the Blaisdell Ben* when the numbers were not *Franklin in a #2 3/6, a* only used to grade pencils *Ruwe Pencil Co. in a #2* but also to determine wheth- *4/8, or an Eberhard Faber* er a pencil was a "writing" *Mongol in a #2 3/8.* pencil, as U.S. "drawing" pencils were given the H-B scale. Not just that, but the fractions used to be a lot more complicated. For some reason I can't explain, it was fashionable in the mid-twentieth century to describe an F grade writing pencil not as a #2 1/2 but as a #2 4/8 or even a #2 5/10. What could the motive have been for giving the pencil grade a divisible fraction? Maybe it was a branding move, or some sort of trick, like when stores price things at 99 cents to make the buyer feel like they're getting a better deal—maybe by using larger numbers it makes the user think it's closer to a #3 than a #2. In *The Pencil: A History of Design and Circumstance*, Henry Petroski makes the claim that this was actually because of trademark infringement. This might be the most likely conclusion: that even the fractioned numbers were owned by somebody. Eberhard Faber Mongols were amongst the first to use fractions, but they eventually began labeling the #2 1/2s as Fs, even though the rest of the range was numbered. Was this because they thought the F was less confusing for consumers than a fraction? This is another thing we don't know for sure, but if you were a fan of harder writing pencils in the middle of the century, then you certainly didn't have an easy time decoding them.

Fractions and numbers aside, there's a bigger problem with the pencil-grading scale that most don't realize. As I mentioned earlier, the same system of labeling may be universal, but the ratio of graphite for each grade certainly isn't. The one instance where this seems to be a particular problem is in standardized testing in schools. A #2/HB pencil is very strictly required—a rule which seems redundant now since test-scoring machines are advanced enough to read just about anything these days. One could use an HB from Germany and it would feel like an American *→ When it comes to the* H, or an HB from Japan that *U.S. grading scale, a num-* would feel like a B or 2B. *ber isn't always enough.* This is where pencil using *It's common to find a #1* becomes complicated—one *also marked as "extra* must learn the nuances of *soft," #2 marked as "soft,"* grading by country. *a #2 1/2 as "medium," a*

Since the ground- *#3 as "hard," and a #4 as* breaking Koh-i-Noor 1500, *"extra hard." This gives* graded pencils have come *a little more clarity for* a long way. Mitsubishi of *the average office-supply* Japan makes a 22-grade *consumer.* range for their premium Mitsubishi Hi-Uni that runs from 10H through to a seemingly impossible 10B, which is nearly pure graphite. Though this range is the widest on the market, most drawing pencils usually come in 18 to 20 different grades.

All of this considered, the modern pencil user is much better off choosing pencils by feeling rather than grade, as the grades really only stand as a marker—not a perfect indication of the actual hardness. As there are many more graphite resources now than there were when the system was developed, the chances of a pencil of the same grade feeling different are even higher. So, 2B or not 2B—perhaps the most lame pencil joke there is—might actually be a valid question.

Poster advertising the fair where
the Koh-i-Noor 1500 made its
debut, alongside an iconic tower
designed by Gustav Eiffel.

The *Pencil* and the *World's Fair*

A little yellow gem of a pencil with one end dipped into 14-carat gold, the Koh-i-Noor 1500 was unveiled by L. & C. Hardtmuth in Paris in 1889. It was set to become a trendsetter.

We're a little bit spoiled today because with just the click of a mouse or swipe of a finger we are exposed to everything that is new in the world. In the nineteenth and twentieth centuries, long before the world wide web, the main stage for the introduction of the new and innovative was without a doubt the World's Fair. It stood as a trade show of sorts for every trade that existed, with emphasis on showcasing development in engineering, science, agriculture, and architecture. The event that inspired the whole concept was the French Industrial Exposition of 1844 in Paris, though the first widely recognized World's Fair was the Great Exhibition of 1851 in London—the same exhibition where A.W. Faber made its grand debut. It was Prince Albert's idea to host the event and for it he built the Crystal Palace—a grand iron and glass building situated in Hyde Park with nearly a million square feet of exhibition space. The magnitude of the Great Exhibition spawned the regularity of World's Fairs and set the tone for all the exhibitions to come.

World's Fairs still happen today, though their importance has since died out due to the

ability to share information and innovation in more efficient and cost-effective ways. The first few World's Fairs were sanctioned differently, but since the founding of the Bureau International des Expositions (BIE) in 1928, official expositions have to be approved to be considered "registered" as World's Fairs. Past World's Fair themes of the past have been divided into three groups, changing along with the interests and needs of the global economy. From 1851 to 1938 the theme was industrialization, from 1939 to 1987 the focus was on cultural exchange, and from 1988 to the present is the period of national branding.

The great World's Fairs of the past were all part of the industrialization period. After the Great Exhibition of 1851 they only became larger, more elaborate, and more inclusive of all nations and trades. Think of a trade show as we know them today, add the idea of an amusement park and the magnitude of the Olympics—that's essentially what a World's Fair was. They existed as much for entertainment as they did for education and sales. For each country involved it was a competition of sorts to show off their industrial advancements and national pride. We'll never know such an event as we consume news and information in real time in the twenty-first century, but we can only imagine what a spectacle it must have been to have it all condensed within a six-month period once every five or so years.

This takes us to the Exposition Universelle, which took place in Paris in 1889. This edition of

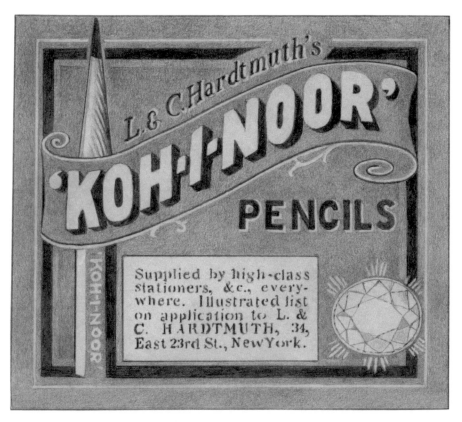

The Koh-i-Noor branding featured a diamond, a symbol of quality and perhaps even a small reminder of graphite's carbon base, which it has in common with the gem.

the World's Fair is most known for the debut of the Eiffel Tower, which was constructed as the entrance to the exhibition. It was scheduled to coincide with the hundredth anniversary of the storming of the Bastille, an event that was memorialized heavily at the fair. Two of the main attractions were the Negro Village, a display of 400 indigenous people (a trend that has thankfully been universally criticized for its racism since) and a Wild West show that included sharpshooting phenomenon Annie Oakley. This was also the exhibition in which L. & C. Hardtmuth, the Bavarian pencil company, debuted their fabled Koh-i-Noor pencil for the first time, which was painted a shocking yellow and featured Hardtmuth's new, advanced *→ The Koh-i-Noor logo still* grading system. The Koh- *includes a diamond as a* i-Noor was named for the *small homage to the origin* eponymous diamond, which *of its namesake pencil.* is now one of the Crown Jewels of England. The pencil was praised by Queen Victoria, probably because of its grandeur, but likely also because it was she who possessed the diamond that inspired it.

What made the Koh-i-Noor pencil extraordinary was a number of things. Of course, the range of grades was the first, as it was by far the widest available at the time. They were also sold for three times the price of anything on the market and packed in beautiful metal boxes to reflect the quality of the pencil. One other particularly notable thing set it apart from the rest of the world's pencils. The pencil was lacquered an unheard of 14 times in rich yellow-gold paint and then dipped on the end in 14-carat gold. To put this in context, this was one of the first, if not the first pencil to be painted as a design choice, not as a necessity. Pencils of the nineteenth century were almost always unfinished, as a way of showing off the quality of the wood. They were usually only painted to conceal imperfections. Until the Koh-i-Noor, a painted pencil meant that it was likely of lesser quality. All of this considered, Franz Hardtmuth's precious pencil was viewed as

being extremely daring and rather controversial. The introduction at the World's Fair in Paris in 1889 helped L. & C. Hardtmuth make their name as a fierce competitor in Europe, but it wasn't until a few years later that another World's Fair helped them to make an even bigger mark on a more global stage.

In 1893, the World's Fair came to the United States, to the midwestern city of Chicago. Much to the surprise of the magnates of American industry who bid to host the fair in their respective cities, Chicago won over New York, Washington D.C., and St. Louis. The significance of having such a huge event in Chicago resonated with the city in a particularly profound way as it was 22 years after most of Chicago was wiped out by the Great Chicago Fire. It was a way of showing the world that they'd recovered and were ready to be recognized as a modern *→ A cow was allegedly to* city. The event also marked *blame for the fire that* the 400th anniversary of *took out more than 17,000* Christopher Columbus's *structures in the city.* voyage to the new world, which was commemorated by titling the fair the World's Columbian Exposition. The centerpiece of the fair, like the Eiffel Tower in Paris, was a long reflecting pool to represent Columbus's journey. In collaboration with Spain, Chicago had scale replicas of Columbus's three ships made that sailed across the Atlantic for exhibition. Some 200 mostly temporary buildings were erected for the fair and a total of 27 million people attended in the six months it was open, just over one-third of the population of the United States in 1893.

It was the most-attended fair to date and with good reason. Among exhibitors were inventors Nikola Tesla, Thomas Edison, painter Mary Cassat, and Edward Muybridge, who debuted his zoopraxiscope in what is considered to have been the first commercial cinema. The first moving sidewalk was constructed to help visitors travel the immense grounds, though it was different than the ones we find in airports today. One side was fitted with seats and the other with

room for walking. Another mechanical marvel was the original ferris wheel, designed by George Washington Gale Ferris Jr., which was the largest attraction at the fair. A number of more quotidian items made their debut as well, including the zipper, spray paint, and the dishwasher.

With the participation of 46 nations, it was the first World's Fair to be organized by national pavilion in addition to setting up pavilions for different trade groups. The fair was a huge win for the United States, who had also hosted a flop of a World's Fair in the 1870s in Philadelphia. It was Chicago that ushered in a new era of American industry and international respect. The beautification of Chicago by building the "White City" and installing elaborate landscape architecture (thanks to the legendary Frederick Law Olmsted) paved the way for modern city planning and the City Beautiful movement that encouraged American cities to enhance their urban landscape.

→ One of the biggest attractions at the fair was a guerrilla performance of Buffalo Bill's Wild West, which was not sanctioned by the fair's organizers. Buffalo Bill had originally proposed the show to the committee and after scoffing at the commission they required, retracted his interest. His response was to just show up and do it anyway.

Amongst all the excitement in Chicago, the public once again met L. & C. Hardtmuth's famous Koh-i-Noor pencil. It was a great success in Paris, but exhibiting it in America exposed it to a much wider demographic. It was such a hit that after the fair ended, the pencil was exported to the United States in such a high quantity that the company decided it would be incorporated in New Jersey, where they eventually opened a factory for stateside production. Following the lead of the great German companies before them, the Hardtmuth family recognized that high import taxes, especially during wartime, meant that the smartest way to do business with the United States was to set up a subsidiary company. Following the success of the yellow pencil, the company's name was changed from L. & C.

Hardtmuth to Koh-i-Noor Hardtmuth, the name under which the company still operates today.

The importance of all of this lies within one fact: the Koh-i-Noor pencil and especially its introduction to the States is credited for popularizing the color yellow as the pencil color. Marketed as "The Gem of Pencildom" amongst other titles claiming its superiority, the Koh-i-Noor was considered to be the best of the best. Pencil makers in the United States took note and started painting their pencils to mimic it. One of the first examples was the Dixon Ticonderoga, a pencil whose reputation for being yellow now precedes that of the Koh-i-Noor. It is safe to say that the Hardtmuths are to be credited for making it not only acceptable but also fashionable to lacquer a pencil, a practice which has become common for just about every pencil manufactured since.

Of course there are conflicting stories about the origin of the yellow pencil. The most believable claim is that the best graphite in the world during the nineteenth century was coming from China. As Chinese cultures associate royalty and respect with the color yellow, it was commonplace to paint a pencil containing graphite from the Orient yellow to mark its quality. The Koh-i-Noor pencil was made with Siberian graphite so it's completely plausible that the connection between the graphite's origin and the importance of the color yellow informed L. & C. Hardtmuth's decision.

Another theory, as explained by Petroski in *The Pencil: A History of Design and Circumstance* ,tells the story of a pencil maker who sold his pencils to an office, the pencils painted yellow and green. The employees of this unnamed office complained that the green pencils weren't as smooth and sturdy as the yellow ones, which caused the pencil maker to respond by painting all of his pencils yellow. Even though there's little proof for any of the claims, the association with China became the most commonly accepted reason for the color, especially after Eberhard Faber named their yellow pencil "Mongol" and Eagle

80

The yellow trendsetters and followers: Eberhard Faber's Mongol, Hardtmuth's Koh-i-Noor, Caran d'Ache's Technograph, and Eagle's Mikado.

Pencil Company named their competitor "Mikado."

We can ultimately chalk all of this up to legend, but the fact still stands that the Koh-i-Noor and its wild popularity in the still-young and impressionable American market set the trend for yellow pencils at the start the twentieth century. One small idea presented in the right place and the right time spawned a tradition over a century old. The yellow pencil is still a specifically American icon, and though it might not be an indicator of quality as it once was, it remains an identifying factor for a pencil.

→ Most early American yellow pencils were not the bright hue we know now but a more subdued, deeper yellow. The majority of painted pencils in the late 1800s/early 1900s were painted dark colors, so even a dull yellow was wild in comparison.

Had it not been for the World's Fairs of the nineteenth century, knowledge of such innovations likely would have taken much longer to be shared worldwide. The money, time, and resources poured into these events were not just astronomical but extremely important as the grand scale allowed for such huge attendance that the spread of innovation was inherently simplified. It was the beginning of global industrialization and it was nothing short of a spectacle.

Succeeding World's Fairs of the twentieth century offered the same sort of experience to the public and allowed the event to evolve to be the premiere world stage for the industrial age. L. & C. Hardtmuth wasn't the first pencil company to find success after presenting their wares at one of the fairs and was certainly not the last. Following in their footsteps, Caran d'Ache of Switzerland made its debut the same way a couple of decades later. Making a splash in the world economy in the nineteenth and early twentieth centuries may not have been as easy as it is today, but the World's Fairs put it within much better reach.

THE

20th

CENTURY

Two world wars provided the framework for the global pencil industry in the first half of the twentieth century by posing challenges and providing chances for innovation. Numerous new factories opened to meet the growing demand for pencils, each with their eyes on the future. With the First World War, pencil demand skyrocketed, as the need for easy writing tools meant millions more pencils went into production and the copying pencil, made with aniline dye, became an essential tool.

The aftereffects of the war and of the Great Depression forced the pencil industry to think about how they might move forward should the same happen again. Newcomer Caran d'Ache of Switzerland developed the first clutch pencil: a reusable, woodless, and more sustainable alternative to traditional wood-cased models. The pencil giants of the United States, nicknamed the "Big Four," also started making plans of their own, which proved useful with the arrival of the Second World War, when trade lines were cut off and metal shortages were a serious cause for concern. By the time the conflict was over, most pencil makers had become accustomed to making their goods with alternative materials. The middle of the century offered opportunities to explore the ways pencils could be made differently with newly acquired machinery and skills to help. The pencil was experiencing its moment. As the race to beat the competition became increasingly fierce, it was advertised extensively. But by the end of the century, with new inventions to replace it, and the effects of globalization, the pencil was once again in need of a serious overhaul.

The Russian-French cartoonist Emmanuel Poiré (1858–1909) worked under the pen name of Caran d'Ache. The pencil company used his name and adapted his signature for branding.

Swiss to the Core

Switzerland's reputation for quality extends right down to writing instruments— something this company makes using its heritage to the full. Combine that with a mechanical classic and you have a brand with a special place in history.

The tradition of European pencil making has deep roots with a number of legendary companies. Faber-Castell, Staedtler, and Stabilo of Germany, Fila of Italy, Derwent of England, Conté of France, Viking of Denmark, and Caran d'Ache of Switzerland—the list goes on. The latter is one of the youngest of the bunch, but one with a particularly important and fascinating heritage. While the rest were spending time perfecting their decades-old pencils, Caran d'Ache was busy trying to make their mark on the pencil world in a more modern capacity: through branding and development of new products. While now a well-known and celebrated company, they quietly innovated a number of products through the twentieth century. With these, which were made popular by a friendly approach to design and marketing and excellent quality, Caran d'Ache paved the way for a new wave of writing and art materials.

Switzerland's only pencil factory was taken over in 1915 by shareholder Arnold Schweitzer. Based in the city center of Geneva, the factory was originally called Geneva Pencil Factory (or "Fabrique Genevoise de Crayons" in French) and later briefly Fabrique de Crayons Ecridor (or Ecridor Pencil Factory), which went by FCE for short. Thirty-five-year-old Schweitzer was a man of many industries and was interested in giving the company a much-needed reboot to keep it fresh and relevant. Prior to his ownership, the factory was making a small range of products with not much to distinguish them from companies doing the same in other parts of Europe—apart from the fact they were Swiss-made. This meant a certain level of quality

was assumed. The drawing and colored pencils they made were marked with the brand's icon: a small foil-stamped key. Caran d'Ache was well placed for an update.

For the better part of the two decades, Schweitzer applied his skills as a businessman and creative mind to getting the factory up to speed and in 1924 renamed the company Caran d'Ache. During this period of time, just about every pencil company operating worldwide was named for the founding family or for something of a patriotic nature. Schweitzer's name choice was peculiar and daring in comparison because it wasn't derived from words in the French or English language, or the name of a related person, but from the pseudonym of a famous cartoonist.

Emmanuel Poiré was a nineteenth-century Russian-French satire cartoonist known for his funny and politically controversial cartoons, which were published regularly in the popular French newspaper *Le Figaro*, among many others. His pen name, Caran d'Ache, was a Franco-fied version of the Russian word for pencil, *karandash*, which is pronounced the same way. Poiré died in 1909, but Schweitzer carried on his legacy through the pencil company and even adapted his iconic signature for the branding. This wasn't a decision that was meant as a tribute to the artist, who was still very famous in French-speaking countries. Instead, it was an inspired branding move. Schweitzer wanted to give the company a modern look and by incorporating an already recognized name—a playful one at that—his intention was to ride on the popularity of Poiré as a selling point. According to Caran d'Ache, Schweitzer respectfully paid royalties to Poiré's

[ABOVE] **Finishing pencils by hand in the Caran d'Ache factory.**
[OPPOSITE PAGE] **The Fixpencil then and now. This clutch pencil has a simple look and a clever mechanism, and in its new guise it's still a favorite for draftspeople today.**

widow for use of the pseudonym. The association with Poiré elevated the brand to one that could be more easily related to and more trusted.

After the great rebranding of the Geneva-based firm and in the tradition of European brands, a formal introduction was made at a World's Fair: the 1929 Barcelona International Exposition. In the Swiss Pavilion, Caran d'Ache presented an enormous framed board with examples of every product in their line fanned out spectacularly. The whole thing was the size of a large wall—and is a display that still hangs in the entrance of the Caran d'Ache factory (though it's

multiple types of colored pencils, erasers, and other tools are also pictured. The spectacular display and the exposure at the fair ushered in a new era for Caran d'Ache, gaining them a new audience for the debut of the Fixpencil, which followed shortly after and would change the game for the fledgling Swiss pencil maker.

The Fixpencil project was commissioned by Caran d'Ache with the aim of creating a pencil that was reusable and sustainable should another world war strike and resources for wood pencils become scarce. This was a serious concern following the Second World War when cedar

since been altered), greeting visitors and employees with a daily reminder of the brand's heritage. The main item on show was the Technograph pencil, with its rich yellow lacquer and bright gold foil lettering. As the flagship pencil, it came in a number of hardnesses and has always been the pride and joy of Caran d'Ache's range of graphite. When it was first introduced, it was a competitor in design and function with the ever-popular Koh-i-Noor 1500, but had the advantage of being marketed not just as a drawing pencil but as an everything pencil. A range of rectangular carpenter's pencils (including an unusually long one, which has spawned many conversations about its purpose),

→ The Barcelona International Exposition of 1929 is most known as the first "modern" World's Fair, specifically for art and architecture and the ushering in of the Bauhaus and art deco movements.

shortages were a very real threat to the European pencil industry. The original Fixpencils, developed by Swiss engineer Carl Schmid, featured a patented propelling mechanism that held the lead—2 millimeters (1/16 inch) in diameter, about the same as that of a wood-cased pencil—inside its body. With a push of the button on the end of the pencil, the propelling tip would open and allow the lead to emerge. Though the original intention of the pencil was to serve as a more reusable and economical alternative to its wood-cased counterpart, draftsmen took up using the Fixpencil and still use it today. It was later known as a "clutch" pencil—a type that has since been replicated by many a pencil maker—and was the first version of this particular sort of lead holder, a sophisticated one that has become a legend of function and design.

Bonne Mine, the cartoon figure that gave Caran d'Ache's advertising some character and a little edge.

At first, Fixpencils were made with a no-frills, unfinished metal barrel in a hexagonal shape. That evolved to a sleeker version of the original, made with coated aluminum and a simple pocket clip attached. The same design is still used as the framework for most of Caran d'Ache's mechanical pencils and ballpoint pens and has taken on many forms over the years. At one point, it even featured an adjustable calendar on the barrel. In 2005 the Swiss postal service recognized the Fixpencil as an icon of Swiss design by putting it on a postage stamp. For this outing Swiss Post used a very surrealist image of a single Fixpencil floating over a perfectly arranged sea of erasers.

The 1920s was a big decade for Caran d'Ache, and not just for products but also for advertising. It was during this time that they created the Bonne Mine character for their print ads. He's a personification of a pencil with a comic,

almost creepy, face instead of a ferrule or eraser. The name translates to "good face" or "good lead" in English, which could be interpreted as a sort of pun. The quirkiness of the ads was something new to pencils—they'd never been sold with a regularly appearing invented character before. This example was very likely a reference to Poiré's legacy and an ingenious move on the part of Schweitzer and his unconventional marketing scheme. Ads were important to Caran d'Ache, though their approach was drastically different to their competitors'. Their simple, fun, and colorful ads were beautiful works of graphic design instead of salesy pitches for innovation and superiority. Throughout the history of the design of Caran d'Ache products (apart from their fountain pen—which we'll get to later), less has always been more, with modernity being the most crucial component.

Following the introduction of the first round of new products, Caran d'Ache didn't stop coming up with more. The next bright new thing came in 1931, when they introduced their most advanced range of colored pencils yet: Prismalo, the world's first water-soluble colored pencils. At the beginning of the twentieth century, colored pencils were still an item very much in the process of development. They were a relatively new idea, and proved difficult to manufacture because of their fragility and the cost of pigment. Another complication came with the lightfastness of the pigment; this was important because it made the pencils sustainable as an artists' material. They also had to be uniform in drawing quality. As any painter knows, not all pigments behave the same way. As the first makers of premium colored pencils, Caran d'Ache were tasked with finding the right formula to make each color feel the same and perform similarly to the rest, despite differences in the physical characteristics of certain hues.

→ *"Aquarelle," "water-soluble," and "watercolor" are labels put on pencils that are soluble with liquid. They all perform the same function despite their different names.*

Colored pencils generally consist of pigment in the place of graphite and oil or wax in place of clay. The latter two ingredients serve the purpose of making the pencil smooth and easily blended as well as for binding the pigment into a solid form. For water-soluble colored pencils, this is problematic because most oils and waxes aren't soluble. The pencil must feel like a pencil (not a watercolor paint cake), but be able to be applied like paint with the addition of a liquid. The Prismalo offered artists a sort of hybrid of the two mediums. The translation of this method to traditional pencils a little later on allowed for a similar experience with graphite. This pencil, the Prismalo, is, even in the twenty-first century, still one of the crown jewels of Caran d'Ache.

The heritage of Caran d'Ache is deeply rooted in wood and graphite, though the range of wood-cased pencil products has always been kept to a minimum. The cores of Caran d'Ache pencils have been used in other designs and forms, but at the heart of all the pencils made is a dedication to simplicity. They're made from water, graphite, and kaolin clay, just like the insides of other pencils, but the difference lies in the treatment of the most important ingredient. The graphite in a CdA pencil comes from three different sources in three different countries, which allows for a unique and specific combination. Depending on where graphite is sourced, its purity, consistency, and color can vary, and those minute nuances make all the difference in the way the pencil feels. By combining a few different types, a particular texture can be achieved— something that is certainly noticeable in the pencil's smoothness, darkness, and ability to be fairly smudge-proof.

As Caran d'Ache became known for their high-end pencil products, the market wanted more. By the 1970s, Caran d'Ache was making a few other things for which they are well known today. The first being the Neocolor pastel—a heavily pigmented wax pastel that was later made in water-soluble form to satisfy the needs of teachers and parents. A small but important detail of the pastels was that the paper wrapper that was glued around them to protect hands from an oily mess is scalloped on the edge so it can be torn off as needed in strips—a feature that makes so much sense yet is still unique to

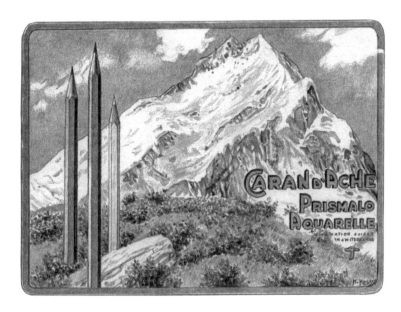

The world's first range of water-soluble colored pencils, Prismalo, featured an emblem of its Swiss heritage on the tins: the Matterhorn.

Caran d'Ache. There's even a Fixpencil-esque holder made for them to fit into.

Following the first foray into non-pencil artists' supplies came pens, the natural move for the company. After the popularity of the Fixpencil, a luxury range including mechanical pencils was created. Named the Ecridor after the original factory, the collection was made from carefully engraved fine metals. The first ballpoint pen came in 1953 under the Ecridor line, with the 849 ballpoint pen following shortly after. In keeping with the Swiss tradition of making finely tuned high-end accessories, Jacques Hubscher, the third-generation owner, introduced CdA's first fountain pens. Certainly this was a decision made to stay competitive with other European brands; however, it also launched the brand into a new tier. Not only did this help Caran d'Ache break into different markets, it also allowed them more room to play with design and meant they could call themselves a luxury brand.

From the very beginning, heritage and nationality were a big part of Caran d'Ache's identity. The tins the pencils were, and still are, packaged in feature scenes of the Matterhorn or of Swiss plants and other landscapes; the brand's entry-level pencil is called the Edelweiss, after the national flower, and the current factory stands in a landscape of trees and wildflowers, with a view of the peak of Mont Blanc. Caran d'Ache seems to have perfected the art of reflecting a patriotic attitude towards manufacturing without being ostentatious. When they can be, all of the products are branded to represent and celebrate their national heritage.

→ In 1993 Caran d'Ache was put into the Guinness Book of World Records for making the world's most expensive pen: the Modernista Diamonds, a fountain pen completely covered in diamonds that sold for $265,000.

These days, CdA are, of course, still run from Switzerland, though they've long outgrown their central Geneva factory. The corporate offices and factory are all in the same building now and the machines on the factory floor were specially engineered just for Caran d'Ache products, every one of which is made locally, mostly all under the same roof, or at the very least somewhere else in the country—that is, everything but the tiny ball that goes into the tip of the ballpoint pen (those are made in the United States). In recent years, Caran d'Ache introduced the Swiss Wood pencil, which is made from beech wood from a forest in Jura, Switzerland. The pencil is finished naturally, smells of brown sugar, and the end is dipped in bright red lacquer and has a small red cross for the Swiss flag painted on it.

Under Carole Hubscher, the fourth generation of family owner, CdA have brought the classic brand into the twenty-first century, introducing increasingly more unique products and utilizing friendlier marketing and exposure. Their interest in pencil development is ongoing and has adapted to the demands of the twenty-first century: In addition to the old standbys is a pencil with a stylus attached to the end instead of a ferrule and an eraser. One of the most sought-after and beautiful pencils of more recent times is an annually released limited-edition set of four pencils, each piece made entirely from fine and sometimes strange-looking types of rare wood from all over the world.

My personal connection with the brand runs deep and has much to do with why I've devoted my career to pencils. When I was six, my mother brought home a set of 18 Prismalo colored pencils for me from a trip to Italy. They were my most prized possession—that is, until they went mysteriously missing, only to be found hiding in my mother's desk years later. She eventually admitted to borrowing them without asking and subsequently losing them but their rediscovery was a reminder of just how lovely they were. As a reckless child, it was

→ Over the years, Caran d'Ache writing instruments have ended up in a number of interesting places, including on the NASA space shuttle Discovery and in the hands of world leaders at the Geneva Summit in 1985, where Ronald Reagan met Mikhail Gorbachev for the first time.

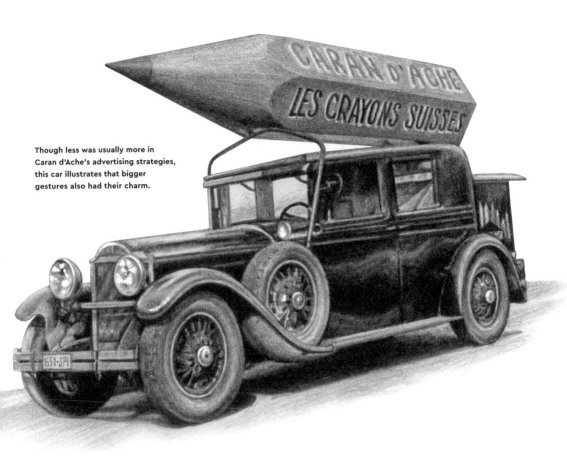

Though less was usually more in Caran d'Ache's advertising strategies, this car illustrates that bigger gestures also had their charm.

the first object that I remember wanting to take care of, something I did so well that I still have them intact and only about half-used 19 years later. The brand was one I previously knew only from the logo on the tin of the Neocolor II pastels that my friend Alice and I used, dipped in water, to paint each other's faces. The newness of such a material was both perplexing and exciting to me, and led to the Neocolor pastels always having a special place in my supply box throughout art school.

Shortly after entering the pencil industry, I was invited to visit the factory in Geneva. To me, this was like visiting pencil nirvana. The whirling of the enormous equipment and the smell of fresh colored-pencil sludge is a like an explosion of sensory experience. To see how a mess of organic materials ends up as a perfect, contained product

is something of mechanical wonder. Visiting, you get the feeling that everyone who works there has been there for a long time and a certain amount of pride is taken in what they do. Each employee has a different story to tell. One that I've been told is the tale of a woman whose uncle was a highly decorated Second World War Air Force pilot whose life was saved during combat by a small metal pen in his pocket. After his death, the niece found the fabled pen, only to discover that it was made by Caran d'Ache. It's not just about the company's heritage but the objects' places in the homes of others. My own Prismalo pencil tin is something that I'll pass on through my family for generations as an heirloom of my passion for wood-cased pencils. It contains ephemeral, simple things but the scratches, pigment residue, and dents that accompany them tell my story.

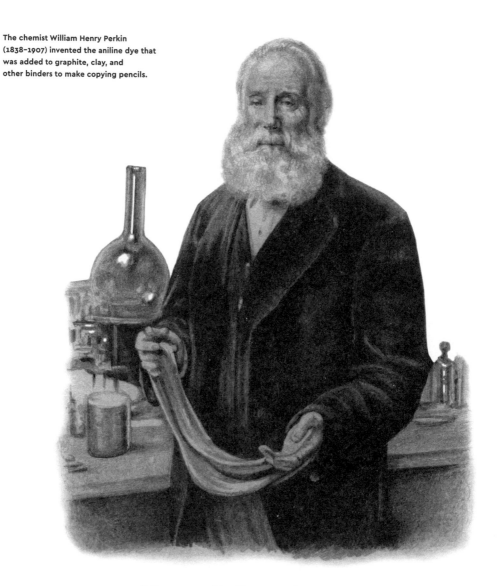

Double Type

Most famous for its use during the First World
War, the copying pencil may have had a short-
lived period of acclaim, but its existence has left
an indelible mark on history.

By the start of the twentieth century, the graphite pencil was pretty well perfected and pencils of other varieties, including colored pencils and pencils for specific uses, were beginning to appear on the market. One pencil that had a particularly profound impact was the copying pencil, or indelible pencil, as it was often known. This pencil went against the very nature of a pencil—it wasn't erasable and was rather brittle and hard. It was expensive, harder to make, and required special attention while sharpening because of its fragile core. You might wonder what the purpose of such a pencil was, but the key is in the added ingredient: aniline dye.

Let's take a step back for a minute and focus on this very unique and important additive. Aniline dye is known outside of the context of pencils for being the first synthetic dye ever discovered. It came about from an experiment by 18-year-old budding chemist William Henry Perkin in 1856. Perkin was invested in trying to chemically recreate the naturally occurring quinine, which was a pro- *→ This is the same quinine* phylactic derived from the *that is used in small* bark of the cinchona tree. *amounts in tonic water* Quinine's principal purpose *to give it that distinctive* was for the treatment of *bitter flavor.* malaria and was very valuable and increasingly in demand. By working with a coal tar derivative and a few other compounds, Perkin noticed a dark residue at the bottom of his test tube. After studying that residue, he realized that it stained cloth a bright purple, a hue that he named "Tyrian Purple." This purple, later renamed "mauve" (short for its chemical name mauveine), was significantly more vibrant than the natural dyes of the time. The actual molecular structure of mauveine remained largely unidentified for over a century, but was made by dissolving aniline, o-toluidine, and p-toluidine in sulfuric acid with the addition of potassium dichromate. The color didn't garner much attention immediately, partly due to skepticism, until Queen Victoria wore an elaborate dress dyed entirely in Perkin's purple to her oldest daughter's wedding. The rich mauve quickly became fashionable among the wealthy and was also deemed a suitable alternative to black for mourning, which likely attributed to its widespread popularity thereafter.

During the same period of time, the earliest forms of carbon paper were being experimented with. This consisted roughly of a piece of paper, which was inked on one side, sandwiched between two other sheets of paper. A metal stylus was used to write on the paper, as it was firm and left a mark strong enough to make the transfer. The newly discovered aniline dyes were quickly adapted for carbon paper, copying presses, and typewriters because they created a much sharper mark than ink. Long before Xerox machines and scanners, this was the pinnacle of innovation in the duplication of documents.

By the 1870s, it was standard business practice to make copies of all documents, making letter-copying books and copying presses important fixtures in any workplace. The letter-copying book was essentially just a book bound with hundreds of leaves of tissue paper. One could slip a document written in a special copying ink underneath a sheet of tissue with an oiled piece of paper on both sides, to avoid getting ink or water on the rest of the pages in the book. The tissue was then moistened with water and the book was pressed using a heavy iron copying press so the ink would transfer onto the tissue. This sounds like a lot of work to get a copy of a document but it was really the only way.

Coinciding with the peak of the letter copying book's popularity was the inevitable invention of the copying pencil. There is no evidence to indicate when exactly it was introduced or by whom, but we do know that it was roughly around 1870. This pencil was made with Perkin's aniline dye in addition to the usual graphite, clay, and occasional addition of another binder. Copying pencils were always made to be medium, hard, or very hard—never soft.

Because copying pencils needed to be non-erasable and smudge-proof, it was to the user's benefit to include more clay and less graphite. It had the permanence of copying ink but was less fussy to use. The hardness of the pencil also allowed it to be used instead of a metal stylus with carbon paper as well.

→ Copying pencils are often also referred to as "indelible pencils." The terms are generally interchangeable, though the word indelible generally refers to the use of silver-nitrate in the pencil core.

Most famously, copying pencils were used during the First World War for the drafting and signing of documents, as it was the easiest, most portable writing instrument that could leave a dark mark. Of course, it didn't hurt that copies could then be made. This period of time in the early twentieth century marked the height of the copying pencil's popularity and usefulness. By the time the Second World War struck, the ballpoint pen had been invented and the copying pencil started to become obsolete. Some of the most famous models of the era were the Eberhard Faber NoBlot, which boasted "A Bottle of Ink in a Pencil," and the Mephisto, which was made by Koh-i-Noor Hardtmuth in the United States. Just about every pencil brand in the United States had their own type of copying pencil, many of which were exported to other countries, especially to England during the war. The one thing that remained similar with all of them was the blue-violet mark they left behind.

Wartime copying pencils may not have been a necessity for very long, but many other uses kept the copying pencil alive for centuries. Railway conductors were known for keeping them tucked behind their ears for use when completing en-route paperwork. In India it was once required by law to wrap parcels in calico when being sent as registered mail. Indelible pencils were used to address the parcels, dipped in water and then written with. Fountain pen nibs got caught in the weave of the fabric more easily, so the pencil alternative was widely preferred. One article in the *Free Lance–Star* newspaper published in December 1919 tells of U.S. President Woodrow Wilson using a copying pencil for the first time to sign some pardon warrants because it was easier to use than ink in a reclining position. He'd suffered from a debilitating stroke just months prior and had limited ability to go about official business. For the most part, indelible pencils were accepted for the signing of important documents. Even today, indelible pencils are used for voting in elections in Italy where paper ballots are still used.

Despite the usefulness of such a pencil, the copying pencil had its drawbacks. The main one being that they were eventually discovered to be hazardous to one's health. Because of the chemicals used in the dye, they were highly toxic and since they were soluble, the practice of licking

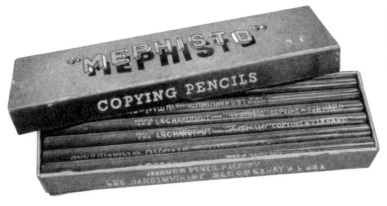

One of the well-known models of copying pencil during the First World War: the Mephisto. It was made in the U.S. by Koh-i-Noor Hardtmuth.

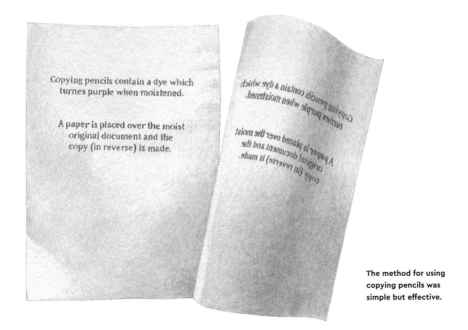

Copying pencils contain a dye which turnes purple when moistened.

A paper is placed over the moist original document and the copy (in reverse) is made.

The method for using copying pencils was simple but effective.

the pencil tip was common when writing with them. Symptoms if ingested were minimal and usually temporary, but if the skin was penetrated with a copying pencil, especially a wet one, the results were more severe. Liver and kidney damage, necrosis, carcinoma, eczema, and a number of other, more minor ailments could occur with frequent exposure.

Eventually, the copying pencils that were still being made were adjusted to be healthier for the user, which was especially easy with the discovery of more types of safe synthetic dyes. Their permanence, effectiveness, and potency were lessened through the removal of traditional aniline dye, which may have contributed to the decline of their popularity. Despite all of this, in the decades preceding the invention of more advanced copying devices, they did still have their place in office pencil cups. In more modern times they are often used for sketching out the lettering for a sign, as the whole background can be painted over it and the pencil's ink will bleed through, indicating where the design is to be painted.

By now, the need for copying pencils has largely died out and few are still being manu-

factured. They can be found, though most of the iconic models of the early twentieth century have long been out of production. The idea of a permanent pencil is a romantic one—the ephemerality of a pencil mixed with the permanence of ink makes it a prime choice for the nostalgic writer. A vintage copying pencil is generally my instrument of choice for writing letters, as it doesn't smudge like a regular pencil and makes a longer-lasting mark. I learned by accident that spraying indelible pencil with hairspray—a practice commonly used to set pencil marks—causes a strange reaction between the chemicals in the hairspray and the chemicals in the dye, turning it a very permanent, very strange bright green.

Though you might not find a great amount of practical use for a copying pencil now that we have easy access to such a spectacular array of permanent writing solutions, they still have their charm. Perhaps the copying pencil is the antithesis of what we expect a pencil to be, but an ink/pencil hybrid has yet to find a better match (I'm talking to you, liquid graphite pens). I dare you to try to sign in copying pencil next time you're handed a document and a pen—at least you'll know how to defend yourself.

Material Shifts

During the Second World War, supply shortages, strict import regulations, and a new political climate led to rebranding, new color mixes, and even plastic and cardboard ferrules.

The end of the pencil's new incarnation: Dixon's Sergeant 704 with its varying ferrules.

The pencil industry survived the First World War and the Great Depression, supporting the increased demand and adjusting to changing economic environments. This, however, was nothing compared to what was to come with the Second World War. Shortages of crucial materials, the halt of most world trade, and a lack of skilled workers hindered the industry tremendously, though demand remained steady, if not greater than it'd ever been. Pencils were still the most-desired portable writing instrument. Fear of the impending war led pencil companies to prepare in the years prior to the conflict, though the actual issues that were to come were widely unforeseen. During one of the darkest periods in world history, the pencil, in all its simplicity, remained a hero.

The first of the problems began with the basic supplies needed for pencil manufacture. The precious Chinese and Sri Lankan graphite couldn't be imported, limiting pencil makers in the United States to the use of graphite from only their own continent—mostly from places such as Mexico, Canada, and New York. Though local graphite was less pure than that acquired from Asia, it was good enough to make pencils that were only slightly inferior. There was the same issue with clay, which could not be obtained from Germany and was replaced with South American clay. Wood was another story—red cedar, the preferred pencil wood, was already becoming scarce, regardless of the political climate. As European companies could no longer get their cedar from the superior U.S. farms, alternatives were used. Even in the United States, red cedar was used in limited supply because reforestation wasn't something practiced as efficiently as is done today. Since everything but wood was imported for the making of American pencils, the booming U.S. pencil industry was arguably hit *→ The pencil's name was borrowed during the Second World War for the "pencil detonator"—a time fuse that resembled a pencil made to be connected to a detonator. This was also known as a "time pencil" and used heavily in combat.*

the hardest, though these limitations offered an opportunity to improve by creating an entirely American-made product—something that would later become a point of pride.

For a long time, certain materials from certain places were considered to be the best for the making of pencils. Though technology advanced year by year, offering the opportunity to better utilize lesser versions of the materials, manufacturers still stuck to what they knew. The strict but necessary regulations on importing goods during the war gave pencil makers a much-needed push to develop ways to make their products just as great, but with more sustainable resources.

One shortage that is perhaps the most physically noticeable and most talked about regarding Second World War pencils involved a material that wasn't entirely necessary for the making of the object—the natural rubber for the attached erasers. By the time war struck, the ferrule and eraser combination had already secured its place on the majority of the pencils being made in North America. Born out of convenience, it was what the American public had become used to and a shortage of supplies wasn't going to deter pencil makers from continuing to make their pencils this way. For a start, the rubber that the erasers were made of came from outside of the United States (mostly India), so, as it became increasingly difficult to import, alternatives needed to be found. Substitute eraser materials had previously been developed, though not widely utilized—the war created an environment ripe for work on such new technology.

The bigger problem, however, was the ferrule that was needed to attach the eraser. Brass and aluminum from the western part of the United States had long been used for ferrules, but like so many raw materials, they were strictly regulated and rationed. Metal supplies were cut off completely from the pencil industry at the start of the war. Fortunately pencil companies like the American Lead Pencil Co. in New York had already started working on a more sustainable

option for their popular Velvet and Venus pencils. The solution: plastic and cardboard—both of which were abundant and easily adaptable.

Unlike wood, graphite, and clay, which could easily be substituted with the same thing from a different place, *→ Plastic and paper ferrules are characteristics* plastic and cardboard required major development *that only lasted through* and changes to production *the Second World War* machinery. Plastic ferrules *and so are an easy way* mimicked the same shape *to identify a pencil from* and general design of their *that era. Bic currently* metal counterparts—a thin *makes a pencil with a re-* tube with some sort of band *cycled plastic ferrule,* around it. Paper ferrules *but it seems to be the ex-* were roughly the same, but *ception to the rule,* fashioned out of dense cardboard and rolled into a slightly chunkier version. Despite the production difficulties, the use of the two materials allowed pencil designers to get creative. While previously limited by the properties of metals, designers could more easily alter the appearance of the substitutes, which could be one-colored, multicolored, and in the case of card-board, printed on. Cardboard ferrules could even be used as a canvas to print super-tiny advertisements on. Plastic, however, was slightly more limiting, as it was made in mostly basic colors like green, red, or blue, and sometimes black—still a significant difference in look from what the consumer was used to with their favorites, though. The Eberhard Faber Mongol was given a new look with a black ferrule with a yellow band, and most famously, the Dixon Ticonderoga's ferrule was a bright green with a yellow band—looks that would both be adopted permanently when metal was available again. If anything, the shortages inadvertently gave the pencil makers of the United States an opportunity to redefine their branding and identities.

Changes in brand identity didn't stop with the new ferrules. The war heightened the need for social and political sensitivity and product names and branding were altered to accommodate the political climate. This mainly applied to American pencils branded with racist names and images that referenced Asia as the origin of the graphite. Immediately following the bombing of Pearl Harbor, Eagle Pencil Company changed the name of the Mikado, their most popular pencil, to Mirado—the meaningless (at least in English) name it still goes by today. Advertising for pencils was also on the rise. With the increased need and decreased number of foreign competitors available, print ads were more important for making the public aware of alternatives made on local soil. Though some companies used imagery from the war to sell their pencils, most refrained and focused on the benefits of their product. By the end of 1942, 1.25 billion pencils had been sold in a year in the United States.

For the most part, the pencil industry made the transition and adjusted to the changes pretty seamlessly. As the years passed and the war continued, more rules, apart from those already established for the use of materials, were put in place. In 1943 the War Production Board limited the national production of wood-cased pencils to 88 percent of the amount consumed four years prior. This wasn't necessarily because materials were scarce, but rather because of the man power needed to make, transport, and distribute the product. As the war continued, it became clear that the most valuable resource was labor. As in many other American industries, vast numbers of women were trained and put to work to replace the men who were either enlisted in the military or needed more elsewhere. For the Big Four of the American pencil industry, this meant that their workforce was reduced to about 3,000 employees on average, three-quarters of which were women.

Overseas, things weren't much easier. England was particularly strict and limited their output even more than the United States. While American ferrules were getting a makeover, Great Britain forbade any of the pencils being

YOUR AMMUNITION

Typewriters, pencils, pens, paper clips, rubber bands, adding machines, staplers, paper, carbon paper, etc.

DON'T WASTE IT!

Second World War poster asking people to keep an eye on their stationery usage.

made on their turf from featuring any unnecessary frills or finishing. Rotary pencil sharpeners were even banned because they wasted too much precious wood and graphite. I'm not sure that using a sharpener versus sharpening with a knife actually salvages more material, but perhaps one was more likely to engage in frivolous sharpening if it could be done easily.

→ The first mechanical pencil factory in England, founded by co-inventor of the object Sampson Mordan, made a beautiful collection of pencil and lead holders until the factory was bombed during the London Blitz.

None of this was without controversy. The biggest scandal in the United States involved the newly established division of L. & C. Hardtmuth in New Jersey. In the early 1940s, they imported an enormous supply of pencil leads made in Germany and the Czech Republic right before the international shipping lanes were closed. This, though questionable in its values, was perfectly legal. The problem was that the pencils made with these imported cores were advertised as entirely American-made pencils. Given that L. & C. Hardtmuth was one of the few European companies that was operating as a stateside subsidiary and was also one of the newest, this did not go over well with the pencil companies of the Northeast who had been making do with inferior local materials to stay in business for the duration of the war.

When the war finally ended in 1945, the American pencil industry bounced back rather gracefully and sales remained steady. The same cannot be said for the German and Japanese industries, whose pencil industries were bruised the most by the aftermath of the war and required more time to recover and start exporting again. All things considered, and with all of the horror of the war in the past, the six years of conflict provided an unfortunate—but ultimately beneficial—learning experience for pencil makers worldwide. The great need for ingenuity provided for many advancements and changes that challenged the ways of making a product that was not only useful but also able to evolve with political and economic upheavals.

Meaningful
Endings

Made from anything from brass to aluminum, and fancy or functional, the little ring that attaches to the eraser onto the end of a pencil has its very own history and national identity.

errule. It's a peculiar sounding word that we've already discussed and which describes the metal (or otherwise) cylinder that holds an eraser on the end of the pencil. The definition of the word, first used in the 1610s, is "metal cap on a rod." It was derived from the earlier word _verrel_ and from the spelling of the Latin word _ferrum_, which means "iron."

While Hymen Lipman may have invented the idea of having an eraser attached to a pencil in the mid-nineteenth century, it was the pencil makers of early twentieth-century America who perfected and popularized it. The ferrule not only added a design flourish to the pencil,

→ The word "ferrule" is used to describe other things as well, including the thing on the end of shoe laces that keeps them from unraveling, the piece of metal that attaches the head of a golf club, the cap on the end of a cane or umbrella, the metal that holds bristles onto a brush—the list is nearly endless.

it also made it more convenient for those who prefer to hide their mistakes. You might even say that the weight of the added objects on the end makes a pencil more comfortable to hold and use (I am certainly of this belief, though I usually refrain from actually using the eraser). It also allowed the pencil to be a singular object. One can carry just their pencil and not need anything else to accompany it, besides maybe a penknife for sharpening. What's especially nice about the ferrule, though, is its way of giving the pencil an added sense of identity. So many pencils can be identified solely by the characteristics of their ferrule, characteristics that precede that of the actual pencil.

The earliest ferrules were usually made of brass, which was often polished to a bright sheen and sometimes tinted or painted. Originally, ferrules were long—about 2.5 centimeters (1 inch) compared to the 1.3 centimeters (1/2 inch) of a modern standard ferrule. Though a little excessive, the earliest ferrules, mostly from the late 1800s and early 1900s, are, in my opinion, the most beautiful. They weren't simply a cylinder of lumpy brass but were instead laden with tiny grooves—elaborate details, the purpose of which

seemed to be only to make the pencil more desirable. Eventually, as more pencils became eraser-clad, the ferrule became standardized. Most ferrules were short, shiny, and with small punctures that were responsible for gripping the pencil and the eraser. Some were nickel, and rarely were they decorated. There wasn't much to them, but they did the job. In 1934 the National Bureau of Standards even set up a list of very specific guidelines for how the ferrule and the pencil itself were meant *→ Among the American* to be made in order to re- *pencil standards of the* gulate competition and cre- *1930s was one that limi-* ate a fair business environ- *ted the color yellow to* ment. These standards in- *use on "high-quality 5-* cluded certain eraser/fer- *cent pencils" only.* rule combos and regulations on pencil length, size, price, etc. The guidelines went as far as to specify which color erasers were to go with which types of ferrules. These rules, by and large, weren't adhered to, as they made things more difficult and more expensive for smaller pencil companies and seemed ridiculous to the larger ones. Needless to say, they didn't stick around for long. As ferrules started being produced by outside companies who made only a few styles at fixed prices, the problem of the fancy ferrule became redundant.

Regulations were attempted partly because pencil ferrules were becoming increasingly decorative. The Eberhard Faber Van Dyke was among the first non-standard ferrules, with its long, flat, black version. The first ones even had instructions for how to use the removable eraser engraved on them. To the Van Dyke's credit, the elaborate eraser quickly became fashionable. Dixon started making ferrules that didn't enclose the eraser but rather had a little decorative fixture on the end that held a squarish, paddle-like eraser. Another popular style adapted by different manufacturers featured an attachment that was larger than the diameter of the pencil and looked sort of like a small bowl that held the eraser off the end of the pencil.

Apart from the plastic and cardboard versions during the Second World War (which didn't stick around afterwards), ferrules were made in more or less the same way—carefully crafted from brass and nickel—until 1964 when J.B. Ostrowski patented the aluminum ferrule. Though aluminum was less expensive than brass and nickel and had been experimented with before, it was ultimately deemed too soft and susceptible to disfiguring. On Ostrowski's new ferrule, small vertical ridges were created with one or two horizontal bands across them for support. This made for a significantly stronger and less expensive ferrule and was adapted for most American pencils. The new aluminum ferrules were easier to make, lighter in weight, more economical, and also easier to personalize.

Though the Eberhard Faber flat-ferruled pencils were mostly still made from brass, aluminum became the metal of choice. As for the design—the necessary band on the new ferrules became an opportunity for a paint job. Many older pencils' ferrules had been banded with brass, but this band served more as a design feature and less as a functional component of the ferrule. Since its beginning, the Eagle Mirado had had a red band, a trait that the company even went as far as to patent. The General's Semi Hex had also had a painted band, though theirs was lavender and later changed to a true purple. The Dixon Ticonderogas became bright green with two yellow bands, the Venus Velvet had a light blue band, and *→ When collecting vintage* the Eberhard Faber Mongol *pencils with odd ferrules,* was black with one thick *don't try to use the erasers.* gold stripe, though this had *They do have a shelf life* been implemented long be- *and will probably be* fore the aluminum ferrule *oxidized and hardened.* became common.

The specifics of a pencil's ferrule could even be considered the pencil equivalent of a watermark. They were the part of the pencil that, even more than the text printed on it, was an indicator of make and quality. Advertisements

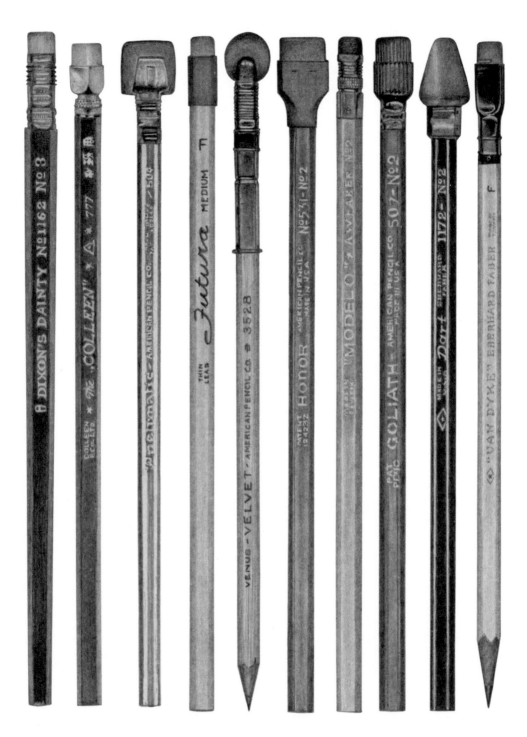

All the fun of the ferrule: A selection of twentieth-century pencil endings, including the Dart [SECOND FROM RIGHT] by Eberhard Faber.

often mentioned it when explaining how to find their pencils in a shop. A few short-lived but especially inventive ferrules were made by Eberhard Faber, including one for a pencil called the Dart, which had an eraser that looked like that—the tip of a huge dart—and looked strangely misshapen once used. They also very briefly sold a variant of the Mongol that had an eraser wheel attached to the end, just like a mini version of a typewriter eraser. Dixon also did a few of their more popular pencils in a version that appears as if a round disk-like eraser is fitted over a metal protrusion at the end of the ferrule. Though mostly decorative, the disk-shaped eraser must've been useful for precision erasing, but likely little more than that. The novelty of these pencils wasn't enough to justify the cost of manufacturing them, but they're amusing examples of how pencils developed in the twentieth century.

Much to my continuing disappointment, ferrules aren't nearly as inventive now as they once were. Very few pencil companies make their own ferrules today, and, if you look closely, all ferrules are more or less the same. Any model that once had a defining feature probably still does, though it has likely been cheapened by current manufacturing standards. Perhaps less competition has made pencil manufacturers reconsider the need for pouring money into pretty ferrules. To my knowledge, Palomino's reproduction of the Blackwing 602 is the only example of a unique ferrule still made, and even so, it's not the same as it once was.

The main selling point of the elaborate ferrules of yesteryear was that they held more eraser, while a common complaint about their modern counterparts is that they don't hold enough eraser to be useful. If you've ever been a math student, you'll know this to be true. Constant erasing leaves you with half a pencil and an empty ferrule sitting useless on the end. This is where eraser caps come in. Although these had been around in one form or another since the late 1800s, they were popularized sometime around the middle of the century. The classic is the Arrowhead, with its smooth pink rubber and double-walled lining to prevent splitting. It was originally sold by Eberhard Faber and was made with the same eraser formula as the infamous Pink Pearl.

Why the tradition of ferruling a pencil has become so American, I can't be so sure, but for as long as pencils are being sold and made in the United States, they will have ferrules. The invention was made in America and developed in America. Though it was never really adapted by the European market (because "Europeans don't make mistakes," as the pencil joke goes), it is an identifying mark of an American-made pencil—or at least one of a pencil made for the American market. Along with the dying tradition of painting the barrel yellow, the ferrule might actually be one of the last remaining pencil Americanisms.

Electrographic
Pencils

With the advent of test-scoring machines came the need for new forms of graphite. This, of course, led to new forms of pencils—ones with thick, dark, smudgy cores.

As a person who owns a pencil shop, there's one particular pencil type that I am always asked to explain. These pencils are ones that are described with words like "mark sense," "test-scoring," or "electrographic." Undeniably, they have the most scientific names and often the most scientific designs. There is certainly science involved, because these pencils, more times than not, contain a type of graphite that is created by science, not nature. They are unique in a number of ways, not only in their composition but also in their quality of writing. They're among the favorites of many serious recreational pencil users, though not necessarily because of their intended purpose.

In the early 1930s, a teacher by the name of Reynold B. Johnson pioneered the first automatic test-scoring machine, which was then purchased by computer giant IBM, who hired Johnson to work for them as an engineer. This

→ Reynold B. Johnson, during his time working in computer technology, invented the videocassette tape and is recognized as the "father" of the disk drive.

machine looked like a desk of sorts, into which completed test sheets—the answers marked in pencil on the multiple choice bubbles—could be inserted. Inside the processor was a contact plate with individual prongs for each of the questions that could detect the electric current conducted by the graphite of a pencil mark. Through this, the machine could read if the answer was right or wrong and therefore tally the score of the test. These were the very first standardized, electronically graded tests.

The initial commercial use of the test-scoring machine was by the Educational Testing Service—the world's largest nonprofit educational testing assessment organization. A vast majority of the standardized tests used in schools in the United States and around the world were created and administered by the ETS and the IBM 805 Test Scoring Machine, making the process of grading exams faster, easier, and less prone to error. Test scoring is the most known use for this sort of technology, but the term "electrographic" applies to other fields as well. An electrographic pencil with a punch card was also used widely by

IBM Test Scoring Machines
Make Test Results Immediately Available

INTERNATIONAL BUSINESS MACHINES CORPORATION

Offices in *Principal Cities*

Test-scoring machines and their natural partners—electrographic pencils—
were launched commercially in 1937 and used mainly in schools.

Autopoint's spiral pencil from the 1960s. These were almost duplicates of Dur-O-Lite's, as their patent expired in the 1950s and anyone was allowed to produce them.

telephone companies from the 1940s to the 1960s for the recording of long-distance phone calls.

Though the machine was the key component of this new technology, the whole operation couldn't have existed without pencils. Electrographic pencils weren't ordinary pencils by any stretch of the imagination. There were two types: a wood-cased variety and a mechanical pencil with a spiral mechanism. For the most part, the two were interchangeable, as the most important aspect of the pencil was what it contained in its core. In order for the test-scoring machines to read pencil marks, the core of the pencil had to be highly electrically conductive. This meant that it had to contain an enormous amount of graphite. Though this worked fairly well, there were a few problems with highly graphitic pencils. First of all, with such a high percentage of graphite, the pencil wasn't firm enough and broke easily, especially when used for a task that required quite a bit of precision. Secondly, even with a large amount of natural graphite, more times than not, the machines still had trouble reading the marks. This was because the electrons in the graphite were not quite small enough for use with a test-scoring machine—something that couldn't really be fixed with natural graphite. The solution here was obvious: to develop an artificial graphite that would behave like natural graphite but contain smaller electrons.

This solution involved taking electrographic-amorphous carbon and heating it at a very high temperature in an electric furnace—essentially a controlled and accelerated copy of the way graphite is produced naturally. The result of this was an extremely dark, soft graphite with a sort of shiny quality to it. It was soft enough to fill in bubbles quickly and efficiently but was also extremely electrically conductive so it could be read easily by a machine. It is unknown whether the earliest pencils used with the IBM 805 machine were made this way, as they may have just contained a large amount of natural graphite.

One popular model of electrographic pencil was made by the Chicago-based Dur-O-Lite Pencil Company, who invented the first spiral mechanical pencil in the early 1930s. The pencil contained a metal spiral inside the barrel, which held a 0.43-millimeter piece of lead. With a twist of the tip, the pencil released more lead, which could easily be refilled when it ran out. With an electrographic lead inside, these pencils were primarily used by the federal government and by phone companies for recording calls. Having enjoyed decades of popularity, not just as a mark sense tool but also as a popular instrument for drafting, Dur-O-Lite hit a bit of a roadblock in the 1950s when their patent expired and the Autopoint Company started making a nearly identical pencil. Though Dur-O-Lite

went out of business in the 1990s, Autopoint still makes pencils of the same design even now.

For educational purposes, the mechanical electrographic pencil was problematic. The lead broke easily and needed to be refilled with heavy use—things that were a nuisance for students. This is where the wood-cased electrographic pencil comes in. When the IBM 805 first hit the market, so did the IBM Electrographic pencil (the company also made a lead refill version for Dur-O-Lite). For some time, it was apparently the only pencil approved for use with the machine, which contributed greatly to its instant popularity. The pencils were simple in their design—black with a silver ferrule, a pink eraser, and simple white text reading "IBM Electrographic" in IBM's trademark typeface. Manufactured in America by General Pencil Company, they were well cased in good-quality cedar and made the perfect tool for testing.

General Pencil Company's history began in 1854 when Edward Weissenborn, a mechanical engineer with experience in the German pencil industry, moved to the United States to start a factory. Six years later, he opened the American Pencil Company factory in Jersey City, New Jersey, just across the river from Manhattan—it became one of the original Big Four of American pencils. He continued to run his pencil empire through to 1885, when he sold the company to the Reckford family in favor of a career in naval engineering. Meanwhile, Weissenborn's son, Oscar A. Weissenborn, had developed an interest in continuing the family business and began making pencils from his home. In 1889 he set up a factory of his own called Pencil Exchange, which was renamed General Pencil Company in the 1920s. It was Oscar Weissenborn who helped IBM pioneer the first electrographic pencils, a pencil that General's still makes today under the helm of fifth-generation owner James Weissenborn.

General's is now the last remaining of the great U.S. pencil companies of the nineteenth century. Their electrographic pencil, now called the General's Test-Scoring 580 and produced with the same white-on-black design as the IBM version, is one of the last manufactured relics of the iconic pencils of the past. Though General's mostly focus on artist pencils and supplies today, their Test-Scoring 580 pencil is still celebrated for its dark, creamy core and immense history.

In this day and age, test-scoring pencils are rarely used for their intended purpose, at least in the United States. Instead, they are appreciated for their ability to look and feel like a soft pencil but have the point retention and relatively non-smudginess of a standard writing pencil. They're especially popular with crossword puzzle enthusiasts who prefer them for their readability. The original IBM Electrographics can often be found on eBay, though for prices that reflect their collectability and reputation for rivaling the legendary Eberhard Faber Blackwing 602 in writing quality. For those who aren't willing to go to such an extreme, similar pencils branded as "Mark Sense" or "Marksheet" in Japan are readily available, as are the General's version and one with a particularly nostalgic design by 100-year-old American pencil maker Musgrave. The story of the electrographic pencils, though often repeated, is not one that can be fully understood without trying out one of the writing instruments themselves. They might be antiquated but their usefulness is all but diminished.

→ Musgrave Pencil Company hails from Tennessee—a state once rich with red cedar, which attracted many pencil entrepreneurs in the early twentieth century. They are now one of only two pencil makers left in the state. Apart from the wood used to make them, Musgrave's pencils haven't changed much in the past few decades. Their Test Scoring 100, like most of their models, has a charmingly old-school design.

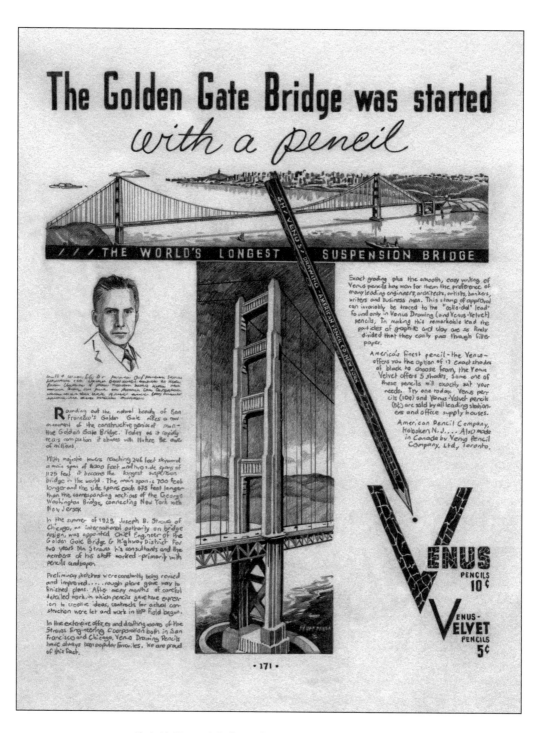

The bold claims made in the American Lead Pencil Company's 1934 ads
for the Venus Velvet promoted the pencil as an inspirational object.

Drawing
Attention

As competition between pencil makers heightened, so did the race for promotion. From playful characters to bold claims, full-page displays to tiny cards, pencils peaked during the glory days of ads.

As competition in the pencil industry grew to its peak in the twentieth century, so did the volume of advertising. In the United States particularly, there was increased pressure to win customers in the mid-1950s, when there were 23 pencil firms operating in the country. Elsewhere, it was less necessary, as competitors were fewer and most had been around long enough to have more established product lines and better-known reputations. Before television and internet, print ads were king and the pencil magnates of decades past went to great lengths to make sure their products were seen.

For most of the nineteenth and very early twentieth centuries, pencil ads served the utilitarian purpose of merely explaining a range of products. They often shared lengthy histories of the origin of the company or long descriptions of the product itself. More times than not, the ads resembled a catalog rather than a modern advert with flashy taglines and eye-catching imagery. In the days before photography was a medium used for ads and images were illustrated, copy was a large part of a successful ad. It wasn't uncommon for the copy to take up more page space than the

images of the product itself. Quite literally, the advertisements were trying to convince the public that the featured products were better than everything else.

The ads were not only made to promote products, but also as snarky replies to what was going on in the market at the time. Likely the most famous example is an early A.W. Faber ad that goes on to instruct that the consumer should not trust any other product with the name "Faber" on it—a direct response to drama with Johann Faber's competitive business. Though the Faber's stab was direct and obvious, most used more subtle tactics. The pencil maker who made the most fuss on the other side of the Atlantic was undoubtedly the Joseph Dixon Crucible Company, who had a very public sense of pride. This amounted to ads that were often meant as a crusade against imposter American pencils and so featured lots of patriotism, as well as Joseph Dixon's trademarked "American Graphite" tagline.

Regarding the structure of the average pencil ad, two things were almost always mentioned. The first, of course, was the claim that the pictured pencil was the best at something, and

the second was that they could be found at your local stationer. Though it seems unnecessary to even suggest that one might look at their stationer, which would be the obvious choice, this was still often printed. Needless to say, early pencil advertisements were wordy.

→ Most ads for pencils in the United States were published in newspapers or popular magazines like Life, Time, Cosmopolitan, or Forbes, and also in publications for children. Magazine ads were full-page and often in color, while the ones in newspapers were smaller, more concise, and often found in the margins of the page.

As we've established, the first couple of decades of pencil ads were focused mainly on heritage. With the commercial pencil industry still a fairly new and quickly growing field, companies were quick to let the reader know that they could be trusted because they'd been around for a while. This was especially the case with European makers. Tradition, factory imagery, and a large amount of egotism were factored in, while the actual quality of the product was left for the consumer to decide upon. This was long before creativity played a key role in advertising; the point was to share information and make the customer familiar with the brand, rather than to impress everyone with a particularly beautiful or clever ad.

It wasn't only pencils that were advertised this way—just about everything was. It wasn't until the 1930s and 1940s that full-page, immersive, and more eye-catching ads were being placed. This was what I consider to be the beginning of the golden age of pencil advertising, when competition began to get really fierce and there was no choice but to pour resources into witty ads. My all-time favorites were those put out for the Venus drawing pencil by the American Lead Pencil Company found in *Forbes Magazine* in the middle of the 1930s. It was a series of at least eight different ads in the same vein, each one claiming that something monumental had started off with a pencil. Included were the Empire State Building, the Queen Mary ocean liner, Pan Am airlines, and the Golden Gate Bridge—all feats of engineering that were current and nationally adored. The ads featured an image of the subject, a much smaller image of a 10-cent Venus drawing pencil, and extensive copy about the history of the subject and how the pencil, not necessarily the Venus pencil, played a role in creating something groundbreaking. The large header of each ad read something like "The world's tallest building was started with a pencil"—the "with a pencil" part always written in pencil, of course.

Not only were the Venus ads engaging, they were also different to what everyone else was doing. They used nationalism in a less obvious way to sell the products and made the consumer feel like they could do something great with their pencil. Like any other ad, the claim was made that Venus pencils were superior in more than one way, but in a less abrasive fashion. The point wasn't that the American Lead Pencil Company makes a great pencil; it was that the pencil in general was a great object. They were the first ads that weren't just about selling a pencil; they were more about striking a chord with the public and helping them make a connection to the product.

Around the same time, Eagle Pencil Company made an important shift in the way they looked at their advertising. Up to now, Eagle's main selling points had been that they'd been around for "x" number of years and that their pencils were, of course, better than the competition's. The pencils also featured a trademark red ferrule band that was advertised as their identifying quality. These things were no longer enough to sell the pencils, though. Noticing that most ads revolved around claims and explanations for which there was no factual evidence, the firm began conducting research on the actual things that made their pencils better.

First they did tests of scribbles and handwriting to see just how the pencil was being used. Ads included in boxes of the popular Eagle Mikado pencil stated that by sending in a piece of the box and 10 cents, the user could have their

handwriting analyzed by a graphologist. This sort of customer engagement spawned many such programs with other pencil makers, where the consumer could get something in return for buying the product and participating. An early example, and one that is another of my favorites, is an Eberhard Faber ad that exclaims "Sure! The Mongol sounds a lot different." In the ad is an image of a girl writing with a Mongol pencil and a boy listening through a paper "sound tester." The ad goes on to explain why the pencil is quieter and advertises that you can get your free sound tester—actually just a piece of paper—at your stationer.

Eagle then hired engineer Isador Chesler, an alumnus of Thomas Edison's lab, to find a way to measure how long a single Mikado #2 pencil could be written with. The pencil was attached to a mechanism that was essentially a roll of paper that the pencil moved across, and the end result was a surprising 35 miles. The ads boasted "35 miles for a nickel"—a ploy that proved successful in winning new customers through the unfathomable size of the number. This sort of quantitative approach to advertising caught on and other pencil makers followed suit, coming up with their own scientific tests. Eberhard Faber once again did something similar by advertising their findings that one of their Mongol pencils could write 16,230 words, even going so far as to advertise exactly how many words per cent the customer could get out of their pencil. Facts were better at selling pencils than long stories and unverified claims, and they offered a breath of fresh air to the stale state of product ads. The lengthy descriptions on the ads didn't go away but at least the information was more helpful in actually determining the quality of the pencil. The idea of writing a certain distance or squeezing words out of a pencil seems a bit ludicrous on a scientific level, but the purpose of this "research" wasn't to be exact, it was to demonstrate potential.

As the pencils themselves became more advanced, there was more to advertise than just

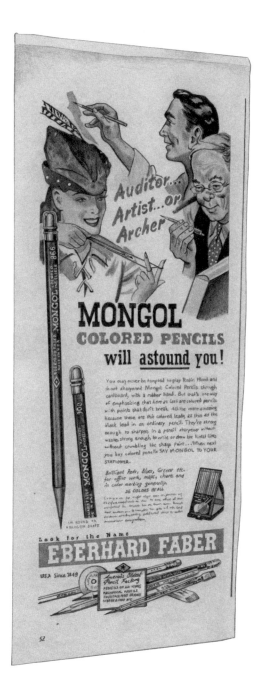

The versatility of the Eberhard Faber Mongol illustrated in a vibrant ad from 1940.

their superiority. Explanations of new technology were used instead of salesy claims, and Eagle Pencil Company yet again set an example for the rest of the industry. While testing pencils for strength with hopes of being able to prove that theirs would come out top, Chesler and his team at Eagle realized that theirs didn't. This led to further development of their manufacturing process to make sure that they could tell the truth about making the strongest pencil. The result was a slightly different pencil, made with impregnated wood to prevent splintering and with a core that was coated to adhere to the glue better. They trademarked the term "Chemi-Sealed" to describe their new, more advanced pencil cores and used their confusing name and new technology to sell their wares. Eberhard Faber was already doing a similar thing with their patented Microtomic lead pencils by using the improvement as a way to bring science into the consumer's decision-making process. For both pencils and advertising in general, the idea of "new and improved" was beginning to become a very powerful tool.

These sorts of costly ventures made it harder for smaller companies to place competitive advertising. Flashy, full-color, large-scale pencil

→ *With the rise of new commercial products in the early 1900s came a trend for putting ads into product boxes. In the case of pencils, they were miniature, perfectly sized little cards that offered more information, a tiny catalog of other products on offer, or some sort of promotional gimmick.*

advertisements in national magazines allowed the bigger companies to use their exposure as yet another selling point. Packaging, which often included advertising inside the box, started displaying stickers for *Life* magazine or whatever publication the pencil had been featured in. Essentially the pencil companies were paying for advertising as well as the right to advertise about the advertising that they paid for. Unless you could afford to utilize the benefits of a national marketing campaign, it was very difficult to compete with a product with a household name on it.

The paid advantages didn't stop there. For a period of time in the mid-century, it was popular to have paid advertising on stationer's cards. These were little cards, about 10 by 15 centimeters (4 by 6 inches), that advertised a certain pencil brand and had the stationer's name and address at the bottom. Primarily used by salesmen, the cards not only advertised a product but also stated exactly where to get it. They were

A recent take on pencil advertising from Faber-Castell and the agency Serviceplan Munich in 2010.

little ads that were more succinct than their larger magazine counterparts, with an elaborate photo and brief copy.

Meanwhile, in Europe, pencils were being advertised much more subtly than in America. The aggressive nature of stationer's cards, box inserts, and full-page ads wasn't considered fashionable. Most advertisements had taken on a more direct approach—fewer words and more focus on the product itself. Usually this meant that the ad was simply a well art-directed pencil image and its name, the maker, and maybe a brief tagline. Simpler was better, and these ads expressed a confidence that the European market could justify. After all, most countries in Europe had just one or two dominating pencil makers so ads were largely an unwise use of resources. Caran d'Ache pencils were among the most heavily advertised, probably because they were one of the newer companies and needed to make a name for themselves outside Switzerland. Their Bonne Mine character is a perfect example of a cartoon character or company mascot used as a more playful approach to selling a product. Eagle Pencil Company used the less-imaginative Ernest Eagle, who was just a regular eagle holding a pencil, and Dixon adapted a pair of mischievous-looking cartoon people for a brief period of time.

Pencil-selling cartoons never fully caught on, but with the approach of the middle of the century, Eberhard Faber picked up on a trend that was sure to sell. A woman, likely in her twenties, with a demure smile and modest hairstyle, started appearing in just about every ad for their office products. More often that not it was the same girl with the same friendly smile posing in an office setting with either pencils or erasers carefully placed between her manicured fingers. These ads were undoubtedly geared towards the secretaries of the 1950s and 1960s and were an attempt to make office supplies seductive. Apart from a few Venus ads employing a graceful female hand, these were the only ads produced during the time that specially targeted a certain demographic of women. Considering that the only thing that distinguished the audience of pencil ads at the time was whether they were looking for a drawing, writing, or school pencil, this was a big deal.

By the end of the 1960s, pencils were being advertised less and less. The market was beginning to desaturate and there was less of a need to spend resources on advertising and marketing. By that point, not many new versions were being made and the ones that had already been advertised for decades had solid reputations. Certain pencils had become household names, thanks to heavy advertising in previous decades, namely the Venus Velvet, the Eberhard Faber Mongol, the Dixon Ticonderoga, and the Eagle Mirado— one pencil from each of the industry's Big Four. Most brands replaced ads for pencils with ads for high-end writing instruments, pens, or stationery products that were more expensive and marketed more as luxury products.

As a child of the 1990s, I've never seen a current pencil ad in a U.S. magazine or newspaper. That doesn't mean it doesn't happen—it's just rare. The closest I've gotten to pencil ads has been in Indian TV commercials watched secondhand on YouTube or ads for European manufacturers' luxury products in duty-free areas of airports. In Germany in 2010 Faber-Castell did a series of ads where they photographed recognizable objects and morphed them into colored pencil points. An eggplant, a banana, a dog, a fire engine—the images were inventive and funny. In the days of cutting-edge technology, stationery advertising might be waning, but reference to the pencil has not diminished entirely. Take the Apple pencil, for example. When the iPad stylus was announced, I laughed a little bit about Apple advertising methods being applied to something that the tech company called a pencil. If that's where we are at today, we can at least be grateful that we're being reminded of the object that was once a bright star in the golden age of ads.

Unashamed
Novelties

The full rainbow of novelty pencils—unusable, souvenir, giant twig, neon, scented, pop-a-point, miniature rock, and more besides—came into its own in the second half of the twentieth century.

Desk belonging to TV-host Johnny Carson, with pencils at the ready.

For every object that exists, there is a novelty version. Whether it's a toaster, a toothbrush, or a pencil—nothing is immune from the designation. In the context of the pencil, the object that's been glorified within these pages, "novelty" could be considered a dirty word. The word is usually associated with things that are considered tacky or cheap, but in this case I think it's more appropriate to use it to describe things for which form is more important than function—the form being something that is often likened to a toy. You'll find proof of this if you go into just about any gift shop or toy store, where it's almost sure that you'll find a cup full of themed pencils near the register or in the stationery section.

When it comes to pencils in the latter part of the twentieth century, the simple, utilitarian versions were largely overshadowed by their flashier counterparts. There's no telling when exactly the trend for novelty pencils started, though the 1960s saw early examples of pencils, in particular for advertising, that could be classified as such. The first one that comes to mind is an option for advertising pencils that had two large erasers stuck on either ends of a ferrule and attached to another ferrule on the end of the pencil to resemble a hammer. In the same vein, pencils were made where both ends were capped with a ferrule and eraser—often with puns about erasing or pointless pencils printed on them. These were largely made popular by late-night television host Johnny Carson, *→ Before novelty pencils* who often fiddled with just *were novelty sharpeners—* such a pencil during filming. *a much easier thing to*

The idea of "novelty" *conceive, as it was easy* items, even in the middle *to glue a standard wedge* of the twentieth century, *sharpener into a hole* wasn't a new one, though *in any hollow object.* it hadn't yet been fully applied to stationery. The fact that more novelty items began to be created might be attributed to the development of inexpensive plastics. By the 1970s, more and more novelty pencils were turning up because it was easier and less expensive to make them. To put it another way, it was easier to make things to glue on the tops of pencils.

It was Japan that really took advantage of the potential of novelty pencils in the 1970s. With the beginning of the popularity of kawaii culture, the demand for novelty items increased. Kawaii roughly means "cute" or "adorable" and is used to describe a specifically Japanese culture of icons and objects that are usually brightly colored and childish in nature. One of the earliest ways this trend took form was in handwriting. Whereas Japanese was traditionally written vertically in thick strokes, teen girls interested in kawaii culture took to writing horizontally in fine lines with bubbly, round characters, often embellished with hearts or stars. The cutesiness of Japanese pop culture and its design is largely attributed to the notion of kawaii and a number of brands capitalized on its popularity in this time period. Sanrio, famous for its *Hello Kitty* character, an icon of kawaii, is credited *→ The Japanese word* *kawaii comes from kao* *hayushi, a phrase that* *means "face aglow" and* *indicates blushing. It's a* *term that's been around* *for over 100 years, coined* *long before its use in* *describing Japanese cute* *culture.*

with starting the trend for using cute, child-like cartoon characters as a marketing tool. Sanrio pencils are among the most recognizable in early novelty pencils marketed towards kids. Starting as regular pencils printed with bright and playful designs and featuring their range of characters, Sanrio's products evolved to have colored ferrules and erasers and later to include elaborate toppers.

By the 1980s, novelty pencils were a full-fledged trend. In Japan, they were being made by a number of brands, including Ribbon Pencil Company, who specialized in novelty pencils. The packaging was one of the greatest reflections of this, but the pencils themselves featured fun designs and toppers that were over the top, to say the least. Often with moving components, the plastic toppers were made to fit comfortably over the end of the pencils and were removable. They could spin, swing, or had charms tethered to string that hung from the end piece. An extra-special example is one that was printed in a primary-colored geometric design and had a giant round mirror on the end, just in case you need to check your makeup while writing. Really, they were toys adapted to fit on the end of a pencil. Another popular manufacturer was Leadworks, also based in Japan. They made pencils mostly featuring popular licensed characters, including Hello Kitty and Howdy Doody, and also specialized in eraser toppers and pencils with heart- or star-shaped barrels.

Of course, these were things that weren't considered serious writing instruments. Many

From monstrous troll toppers to flashy smiley-face prints: the novelty of some 1980s and 90s pencils doesn't wear off.

were made with high-quality wood and graphite cores but for the most part they were marketed for use by kids or for collecting. One particular type of novelty pencil came from Taiwan in the 1980s—one that I'd seen before, though never extensively until I purchased the vast collection of a customer. Their origin is a little mysterious, as they are only branded at the bottom with the tiny text "Taiwan D56." The uniformity of the range is impeccable and each one is a simple wood-cased pencil painted a solid color with foil text towards the end and toppers that were made

out of plastic and often had a flocked finish. The items were hilarious in their simplicity: the text says things like "HOT TOMATO" with a mischievous googly-eyed personification of a tomato on the end, or "YOU SEND ME" with an openable mailbox. Some are even gift-themed, with boxes on the end that pop open. They're almost like greeting cards in the form of a pencil.

It's safe to say that the pencils makers of 1980s Asia solidified the market for novelty pencils and set the scene for a whole new realm of pencil collecting. The 2016 book *Pencils & a Pen* was dedicated to the personal 1980s Japanese novelty pencil collection of Laura Foxman and displays an array of carefully curated and loved pencils that tell a story of the pencil as an object in the twentieth century as well as of the notion of collecting. Though advertising pencils had been collected for decades, novelty pencils, being affordable and available in vast varieties, took on a whole new life, especially for young collectors.

Let's talk a little bit about souvenir pencils. Novelty pencils exist for holidays, events, and branding but they're also a popular item in gift shops. Long before the idea of a novelty pencil, souvenir pencils were found in museums and at tourist destinations, branded with the name and place. With the rising popularity of flashier types of collectable pencils came more creative versions in gift shops. I like to consider these in two different categories. First, pencils that are usable. One version of these that is becoming obsolete, probably even as I write, is the misshaped pencil—an icon of my childhood tourist shopping. They are made out of wood and towards the end the pencils take on a different shape. This could be anything: an animal, the ever-popular heart, or an apple. The strange thing about these pencils is that, more often than not, they are still finished with a ferrule and an eraser, usually upside-down or twisted—totally unusable.

Another favorite usable souvenir is one that I'm sure we've all seen, especially in natural history museums. The pencil part is short, about the length of a golf pencil. The rest of the pencil is made up of an attached plastic tube, closed with an eraser used like a wine cork. Inside the tube are dozens upon dozens of tiny polished rocks. This pencil was likely one of the first novelty souvenir pencils in the United States, dating as far back as 1962 under the Miniature Rock Collection Pencil trademark. As far as nostalgic novelty pencils go, these are on a par with the super-long, 35.5-centimeter (14-inch) pencils made popular by the Disneyland gift shops in the 1960s.

The second type of souvenir pencil is one that serves no purpose but to mimic an actual pencil. These objects came later and, much to my horror, are still to be found these days. For a start, there are those really, really big pencils. They aren't painted but rather wrapped in plastic and have cheap aluminum ferrules, a comically large eraser, and, for some reason, a looped piece of string on the end. Sure, you can write with them, but sharpening will be a problem, since the wood is usually such bad quality that it flakes away with the touch of a blade. On the same tier are the bendable pencils. This specimen houses a super-waxy, bendable core containing little graphite and a gummy, bendy plastic casing. Sharpening proves difficult, not because the plastic doesn't cut, but because the pencil is so wiggly that it's hard to get a good enough grip on it to get it to turn it in the sharpener.

For novelty pencil novices, there is always the eraser topper. This is something I am very familiar with as a child of the 1990s. Like many American kids my age, I received a bulky, multicolored eraser topper in school goody bags for just about every occasion. A Frankenstein head for Halloween, a Santa Claus for Christmas, a cornucopia for Thanksgiving, a bunny for Easter, an apple for back-to-school—they were everywhere. Though these chunky little tools offered the potential of an enormous amount of erasing, the sad truth was that they didn't actually erase very effectively, causing a frustrating situation where you were rubbing and rubbing so hard that the

eraser felt like it was going to pop off the pen-
cil, but instead the hole that the pencil fitted into
just split up the side and you were stuck with
a severed jack-o-lantern. I have Lisa Frank to
blame for this fad. The company's rainbow-col-
ored designs dotted the office-supply aisles of
every store of my childhood—the stationery be-
ing my favorite part of the line. The rainbow pen-
cils with bulky eraser heads came in packs with
matching stickers and letter-writing paper—cov-
eted items that were a huge deal to receive as a
birthday gift in the second grade.

We can consider Lisa Frank to the American
novelty stationery industry of the 1980s and
90s what Sanrio was to the Japanese equivalent
during the same time. Lisa Frank was marketed
to preteen girls, leaving open a gap for teen boys
who weren't fond of the neon pink motifs. Enter:
Yikes! pencils. First introduced in 1992, Yikes!
were made by American pencil giant Berol and
were designed to be as ridiculous as possible
while still serving the function of being a usable
pencil. The wood was colored, the pencil barrel
was offensively bright or holographic, the erasers
were strange shapes and often had hypnotizing
graphic motifs printed on them. The high point,
though, is the television commercial from 1993
that features a boy trying, unsuccessfully, to
pick out an outfit for school. The narrator says,
"Dude, it's not your clothes you need to change,
it's your pencils," and finishes with, "You can't
look sharp with dull pencils." Brilliant marketing,
indeed, but the pencils themselves were pretty
spectacular, too. Not only were they ridiculous
in their aesthetic, they had the packaging and
accessories to go with them. They were the
perfect match for Lisa Frank in the back-to-school
aisle of stores like K-Mart and expertly suited the
neon slime aesthetic Nickelodeon so smartly sold
to kids in the 1990s.

With the good, the bad, and the crazy also
comes the downright impractical. A genre of nov-
elty pencil that is more novelty than pencil is the
joke pencil. Like Johnny Carson's double-ended

A fragrant addition to a
pencil case, scented pen-
cils are best kept sealed
to prevent them from
becoming overpowering.

eraser pencil, there have been a few others that
serve no purpose but to fool the kid who asks you
for a pencil right before a math test. First came
the Japanese joke pencil, one that was short and
had a simple stick of black rubber inside instead
of graphite. Since it doesn't really resemble a full-
sized, regular pencil, I have a hard time believing
anyone could have been fooled but the idea is, ad-
mittedly, funny. A better version is currently made
by Portuguese pencil maker Viarco. It looks like
a regular pencil, is make out of wood and paint-
ed like a regular pencil, but instead of containing
graphite inside there's nothing—the end is dipped
in graphite so it looks like it can be written with.
Try to write with it, though, and it'll make the
faintest mark and an uncomfortable skid across
the page. The pencil is aptly named the "Dummy
Pencil," which is even printed on the body, though
a remarkable number of people fail to notice it.

On a recent trip to Colombia, I found a pencil in a small, dusty stationery store on a side street in Bogotá that was the exact same pencil I'd had in elementary school, a pencil that I'd long since forgotten. This one is tricky to describe because it's not a wood-cased pencil, nor is it mechanical. To the naked eye, it looks like a ballpoint pen with a plastic body and a cap with a clip on it. Inside the barrel is a number of small plastic pieces, each with a sharp, tapered piece of graphite in them. Once the piece on the end gets dull, you pull it out and shove it into the bottom, which pushes out a sharp new point. There is one serious problem with this pencil, though. If you lose one of the pieces, the whole thing is useless because it needs the full stack to fit properly inside. My memory of this pencil is almost entirely associated with a particular one branded "Pioneer," which had stripes and fruit printed on it. They came in Orange, Apple, Strawberry, and Grape and were scented accordingly. They were called pop-a-point or sometimes push-point pencils, and, though they still exist now, the prime of their popularity was in the 1980s and 1990s when they were almost always branded for some sort of popular character or imagery.

This leads me to the most recent and most currently popular novelty pencil: the Smencil. These are a far cry from the scented push-point pencils I loved as a third-grader. Smencil, the brand, makes scented pencils, the barrels of which are made from rolled recycled newspaper and soaked in fragrance. They're really stinky and are sold individually in slim plastic canisters to prevent the scent escaping. There are less potent versions of these around and more grown-up scented pencils by other brands, but the Smencil is a pencil feared by teachers and parents alike for its pungently odorous qualities, while being adored by young children easily swayed by flashy novelty supplies. They're almost like the dangling car air freshener of the pencil world—kind of disgusting but very marketable.

The days of poufs of marabou feathers and moving parts being attached to a pencil might be long gone but a few early examples, including the Miniature Rock Collection pencil, have stood the test of time. The novelty pencils now found in gift shops are usually made in China and have features that seem like cheap imitations of the toy pencils of days past, but thankfully Eyeball Pencil Co. in Japan is still making a few that are just as fun to use as they are to collect. The three best ones, in my expert opinion, are an example that's shaped like a heart *→ Iwako of Japan make a* (which also makes the most *crazy collection of novelty* beautiful flower-like shav- *erasers, including food-* ings), the versions that look *shaped ones that are so* just like cigarettes, and a *detailed they seem im-* type that resembles a pair *possible. As if that's not* of chopsticks and neatly *enough, they're branded* tucks into a paper wrap- *as "puzzle erasers"* per. Pencils that look just *and can be pulled apart,* like Pocky chocolate sticks *piece by piece, and put* can even be found in novel- *back together.* ty stores in Japan. The country is better known now for its masterfully detailed novelty erasers— which amass an unbelievable variety—but in my mind it will probably always be most important for introducing the world's finest novelty pencils.

Whether their purpose is as a collectors' item, an easily found souvenir, or a way to get pre-pen-using kids to do their homework, novelty pencils are wonderful in the way they transform an object considered quotidian into something that isn't just meant for utilitarian functions. That may or may not be a good thing in some cases, but in a world where it seems pencils could be heading towards becoming obsolete, they've helped cement the pencil's undying popularity as a multiform commodity. I can admit that even though I have pencils in my collection far better than those I keep just for kicks, I do occasionally enjoy sharpening a souvenir pencil or putting my trusty pop-a-point to practical use. Novelty pencils may not be able to completely transcend pencil snobbery, but you have to admit that they're kind of fun.

End of the
Century

At the close of this eventful age came the world's first plastic pencil. Then, as the pencil fell victim to the trend for cheaply made commodities, smaller brands slowly started disappearing ...

When all is said and done, we can look back on the twentieth century in terms of pencils in a positive light. Between all of the new companies that established themselves and the incredible amount of innovation that took place during both of the world wars, the pencil industry saw its worst, best, and everything in between, and somehow still managed to hold it together with few casualties. One hundred years is a long time, but considering that it took more than two centuries to even start making a commercially viable pencil, the 100 years of the twentieth century is just a fraction of the pencil's history, albeit one with a particularly dense amount of activity. It's fair to say that the manufacturers of the twentieth century perfected the pencil to the point where there was little left to be desired, leaving economic change as the main variable—and this, along with the rise of the digital sphere, is what would define the end of the twentieth century.

In the pre-computer world, the pencil was used for everything. It was an important tool of the trade for professions that needed something easy and erasable, and there was little that could replace it. It was an exclusive tool in schools, and used by stenographers, illustrators, and writers alike. Little could touch the wood-cased pencil in terms of its function and abilities. That is, before mechanical pencils became a real threat. Mechanical pencils had been around in various forms since the late 1800s, though inexpensive versions with fine-point leads didn't appear on the market until the middle of the twentieth century, when inexpensive plastics had been developed and disposable consumer goods were more readily available and popular. One current example is the Bic mechanical pencil. It comes in packs of 10 or 20 at a time so you probably won't be bothered to replace the lead when it runs out or if it breaks before it's been used to its full potential. The eraser functions as the cap on the end where the lead is inserted, and once used up, it requires stabbing with an actual pencil to yank it out. By most interpretations, it is disposable. Sure, the wood-cased pencil could be considered disposable as well, but it's made from renewable resources and doesn't require much effort to use effectively. This sort of cheap, easily produced plastic product, added together with the impending impact of the modern computer, had wide-ranging results for the pencil industry.

After the Big Four had ruled the game in the late nineteenth and first half of the twentieth century, pencils saw a different type of industrial dominance in the twentieth century's second half. It all started in the late 1960s and early 1970s when Eagle Pencil Company, one of the original Big Four, was renamed Berol and started acquiring a large number of smaller pencil makers, including Blaisdell, which was known for inventing the paper-wrapped china marker and for the Ben Franklin pencil. Berol also acquired the larger Venus-Esterbrook U.K. in 1971. Soon after, everything was being rebranded as Berol and little was left of the iconic brand names known and loved by the American public.

While Berol was becoming one of the biggest names in pencils, another brand, perhaps lesser known and largely forgotten, was experiencing a renaissance of their own. In fact, they eventually even bought Berol in 1987. It's not clear why this one brand in particular hasn't been remembered in the same way its competitors have, despite their evident power in the industry. Apart from acquiring Berol, they are known for one thing in particular: the world's first plastic pencil, and the story of its existence is an interesting one.

It's important here to backtrack just a little bit. Hassenfeld Brothers was a brand founded by Henry, Hillel, and Herman Hassenfeld in Rhode Island in the 1920s. They specialized in selling and working with fabric remnants, producing fabric-covered pencil boxes and zipper pouches that were sold fully stocked with office and school supplies. Though not the largest components of the products, the pencils and other tools inside the boxes were crucial—so much so that the Hassenfeld's pencil supplier decided to put up the prices and start making competitive products. As any smart persons of industry would, the Hassenfelds started making their own pencils. Born out of need but sustained by outside demand, the Hassenfeld's pencil operation, founded in 1935, went on to acquire Empire Pencil Company 11 years later and quickly became one of the largest makers of mostly #2 general use pencils throughout the rest of the twentieth century. Perhaps this was in part because it was funded by the Hassenfeld's business, the name of which was eventually shortened to Hasbro Industries—a name that later became famous for making G.I. Joe, Mr. Potato Head, and Play-Doh, and countless other classic toys.

Harold Hassenfeld, son of founder Henry, later went on to run Empire, growing it into a larger-than-life pencil company. Harold is owed credit for the Epcon plastic pencil, which was his primary labor of love during his time as a pencil maker. By the 1950s, over a decade after Hassenfeld relocated to Tennessee to run Empire, the local cedar supply had been totally depleted and replaced largely by California incense cedar. With immediate need and the future in mind, Hassenfeld sought an alternative, and in 1969

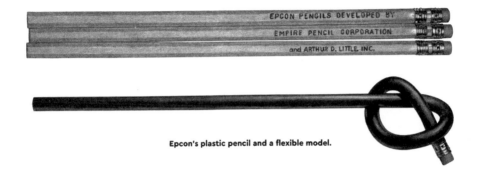

Epcon's plastic pencil and a flexible model.

Empire Pencil Company hired Arthur D. Little—an eponymous firm run by the chemist responsible for discovering plastic acetate—to head up making the pencil of the future.

The idea was that the pencil would look and sharpen like a wood-cased pencil but have no need for hand machining during the manufacturing process. Eliminating the hand-machining element was to be done in order to reduce costs and to allow for more efficient production. But the trouble with a non-wood material was that sharpening was difficult unless the material was soft enough to be cut easily but at the same time, stiff like wood. The result was a substance made from wood flour and ABS plastic (acrylonitrile butadiene styrene—the type of plastic commonly used for injection molds and a vast majority of plastic consumer products, including Lego bricks). Aluminum stearate was used as a lubricant, but otherwise, that was about it. It took roughly five years to perfect the formula and patent it alongside the development of a "plastic" lead by Empire. The most interesting part is how these pencils were made. Avoiding hand-machining was achieved through a co-extrusion process, where plastic leads were extruded into the continuous plastic pencil casing "by the mile" and painted as a whole endless pencil. They were then cut to size, *→ This co-extrusion process meant that the pencil could be just about any length, something that* given a ferrule and an eraser and that was it—a slatless, woodless pencil.

In 1975 the pencils hit *was proven in 1991 when Empire-Berol made the world's longest pencil, measuring 333 meters (1,091 feet)—the length of 1,875 standard-length pencils.* the market and were branded as Epcon pencils; they were also stamped with two other lines of text recognizing the collaboration between Empire Pencil Company and Arthur D. Little. As the proud owner of a few original Epcon pencils—kindly sent to me by Mr. Irv Arons, who worked for Arthur D. Little on the composition of the materials for the casing—I can attest to the fact that they are very different to what I'm used to. They sharpen smoothly, though in a way that feels unnaturally clay-like. The core itself does feel a little plasticky but makes a sufficiently nice mark, despite its slight tendency to flake (though this could simply be due to age). In pencil manufacture, one of the most telling qualities of a product is how well the core is centered. For the Epcon pencils, this is a difficult thing to evaluate because it seems there is more room for error. Since the core doesn't have to be glued to a rigid surface, it's less likely to break inside the pencil, making it more durable to begin with.

This technology was applied to later pencils (and *→ The acquisition of pencil brands by the Newell Company has been dubbed Newellization" by Charles Berolzheimer, a descendant of the founder of the Eagle Pencil Company and the modern pencil man responsible for reviving the iconic Blackwing.* currently also to ones of lower quality), but the original Epcon was a breed all its own.

Towards the end of Harold Hassenfeld's time in pencils, he bought the Berol empire, and, after his retirement in 1988, the whole operation was soon acquired by Sanford, a division of the Newell Company. Though Newell remained in the Empire-Berol factory for about two decades, the legendary pencil names of those being rebranded were soon lost. Pencil Street, where the factory once operated in the bustling pencil town of Shelbyville, Tennessee, was even renamed Sharpie Way—the final straw at the end of an era.

Such a pattern was a common story for the remaining pencil makers, especially with the sale of the legendary Eberhard Faber in 1988 to Faber-Castell U.S.A., which also ended up in the hands of Sanford just a few years later. If not bought by a large company with little history in pencils, most of the powerful pencil makers of the twentieth century slowly vanished. All except for Dixon, which was moved from its Jersey City home in favor of Florida in 1983, where its offices still remain, despite production being sent abroad to either China or Mexico in the early 2000s.

A lesser-known but equally important brand on the final frontier of great American pencils also met its demise when demand for fine wood-cased goods decreased in the late 1990s. I consider the Blackfeet Indian Writing Company to be the last of the small brands to survive and one of the most coveted ones on the secondhand market. Founded in 1971 in Browning, Montana, by Chief Earl Old Person of the Blackfeet tribe, who, concerned about the devastating unemployment rate of his people, approached the Small Business Administration about opening a factory. By 1976 the factory was profitable and employed over 100 members of the tribe. The short-lived success of the small, unconventional pencil brand was due to a few factors. Simply finished and made almost completely by hand, the resulting pencils were as good, if not better, than the popular equivalents of larger brands. Apart from some colored pencils and special models, the appealing products were naturally finished, imprinted with minimal information in either gold or black foil, and had an eraser attached with a simple gold or black ferrule. Sometimes they even came in beautiful little hinged cedar boxes. The thing that really put Blackfeet Indian Writing Company on the map, however, was the fact that they were the exclusive pencil maker for the U.S. government and had contracts to make pencils for universities and other large institutions. That all began to go by the wayside, though, when Skilcraft, a writing instruments company run by blind workers in Wisconsin, started making government supplies and won large contracts with big-box stores. Sadly, by 1997 the 80 percent tribe-owned pencil brand was in enough debt to cease operations. Even now, Blackfeet Indian pencils are in demand from those who knew and loved them in the 1980s, and they fetch prices on the secondhand market that rival those of pencils three times their age and popularity.

If you look on the back of a box of pencils (or today more likely a blister pack) found in any chain store in America now, you won't find New Jersey, New York, or Tennessee as the place of manufacture as you once would have; instead you'll find China or any of the number of countries in South America that house factories for large brands. Maybe if you're lucky, they'll advertise the cedar as being from the United States. Fortunately for the European market, the opposite is generally true as most brands still remain where they've always been and still make at least some of their products on home turf. American pencils, like so many things once made in the country, largely fell victim to outsourcing by the late 1990s—a manufacturing trend that caused major repercussions for the employees and families affected as well as for the once-dazzling reputation of the American pencil.

The real champion of this story is General Pencil Company, the last of the American greats, whose factory still stands in its hometown of Jersey City and is recognized as the last of the original factories of its kind in the country. A pair of others remain in Tennessee, where Empire once thrived. Moon Products—now part of MEGA Brands, a subsidiary of toy giant Mattel—still make their pencils in Lewisburg, and Musgrave, family-owned for 100 years, still operates in Shelbyville.

By the end of the twentieth century, so many things about the modern pencil had changed. What was once packaged in elaborate boxes and featured careful foil stamping and decorative ferrules became a cheaply made commodity sold in flimsy cartons or plastic. Long gone were the days of painstakingly detailed advertisements and sales ploys for one pencil or the other. In some respects, we shouldn't complain about all of this, because, in terms of global industry at the end of the twentieth century, the pencil industry was no different than any other. What we can be grateful for is what the pencil makers of the 1990s didn't know: a renaissance was on the horizon and all was not lost for the legacy of the old-fashioned, well-crafted, wood-cased pencil.

THE

21st

CENTURY

With the arrival of the twenty-first century, the pencil had become all but obsolete. Easy access to disposable mechanical pencils and ballpoint pens left the wood-cased pencil as a less-desirable writing instrument—one deemed essential only for schools and for artists but not for the everyday life of an adult. The rapid rise of computer technology and the ability to utilize the internet on a variety of platforms made writing by hand seem a thing of the past.

All hope was not lost for the humble pencil, though, as shiny, superior varieties began to make their way out of Japan and smaller brands worldwide experienced revivals. Arguably the biggest event in favor of the wood-cased pencil was the comeback of the Blackwing 602, or rather, the reproduction of a legendary, unrivaled pencil once made by Eberhard Faber. The cool factor of these new pencils and the rise of online shopping helped the pencil take on a new life as a part of an analog lifestyle. It's a way of living that takes a step back and embraces the nostalgia, usefulness, and simplicity of stationery items of decades past. The backlash against the effects of the internet has opened doors for the rediscovery of these tools as a medium to reconnect with the benefits of doing things by hand. With the opening of boutique stationery stores worldwide (including this author's pencils-only shop in New York City), the pencil has once again been put in the spotlight as an object rich in history and close to perfection in its design and function.

Big in
Japan

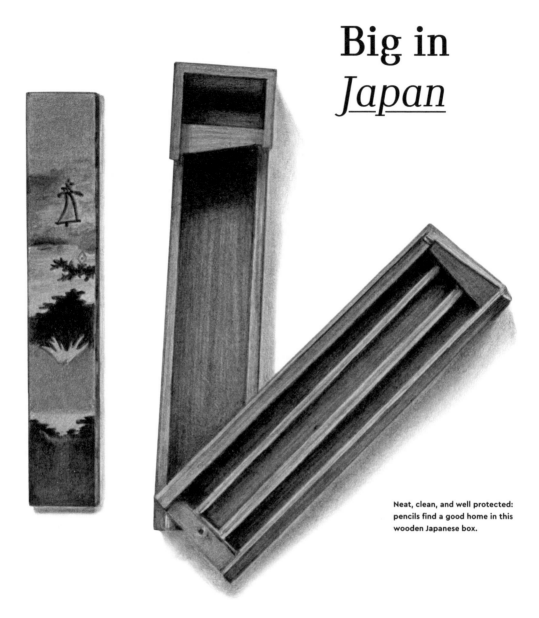

Neat, clean, and well protected: pencils find a good home in this wooden Japanese box.

With their own unique feel, famous brands, and unparalleled range of hardnesses, Japanese pencils are far from limited to the novelty objects they are often seen as.

Any modern pencil user knows this to be true: Japanese pencils are in a league all of their own. If you're a novice, a Japanese pencil will feel uniquely smooth and will run a little bit softer and darker than what you're likely used to. The pencil designs are often refined and the objects themselves rarely have noticeable flaws. Japan is the most expensive production market for these things, but even a lower-end Japanese pencil priced like a mid-range European or U.S. pencil can still feel and look remarkable.

Much of this can be attributed to generally high standards for quality and design in the Japanese marketplace. It's also clear that Japan is a country obsessed with stationery products in a way no other nation is. Even in the twenty-first century, general goods shops in Japan have immense stationery selections, featuring products so specific that I can only fantasize about how organized my life would be if I lived in Japan. Itoya, perhaps the most famous of Japanese stationery stores, is housed in a multilevel, stationery-specific pseudo-department store in Tokyo and even has an annex in another building dedicated to writing instruments. It's a serious business set up for a market that is most certainly serious about stationery.

The first thing you'll notice in a Japanese stationery store is that the pencils come in multiple grades and are always sold loose, in addition to being sold by the dozen. You're likely to find HB, B, 2B, and maybe a couple of others made for general use. This inclination towards softer pencils is not something I am equipped to explain, but it's refreshing to see a culture that leaves the hardness of a pencil up to preference, instead of what is a national standard. You'll also notice that there's a wide selection of red pencils and red/blue double-ended pencils for checking, marking, and editing. Not just that, but vermilion and red, in case you have an opinion on the matter. I once asked the president of a Japanese pencil company why there are both options and his response was that teachers preferred vermillion pencils because the slightly orange-tinted hue is less aggressive for grading students' papers.

Continuing down the pencil aisle, there will likely be multiple shelves full of erasers; not just the old standbys like the Tombow Mono and the Pentel Hi-Polymer, but multiple versions and sizes of each and of many other brands. High-quality famous-brand erasers are also often sold in sleeves with designs to appeal to children and different demographics—a far cry from the similarly styled "novelty" erasers most of us are used to. I'm not even mentioning the part of the shop that inevitably houses more mechanical pencils than wood-cased because that subject deserves a whole book of its own.

→ Even in the United States, most mechanical pencil refills are made by Pentel, a Japanese brand that makes a huge number of mechanical pencils. This is something that Japanese stationery companies often do well— high-tech, accessible mechanical pencils. One particular Pentel model houses five ballpoint pens and a mechanical pencil all in the same body.

Why Japanese pencils are different is a complicated subject. The first noticeable difference is the consistency in the quality of the finishing. So many coats of paint go on Japanese pencils that they shine as bright as water-based lacquer possibly can and consequently have a softer hex edge. In addition, the pencils not only have names but also product numbers that make them sound more like sports car models than pencils. If you're used to American and European pencils, then you'll also notice that they're never pre-sharpened. Pre-sharpening is a serious faux pas for Japanese pencils. Certainly this is because it's cleaner to have a fresh, unsharpened pencil instead of a convenient but messy pre-sharpened one. Even when sharpened, pencils are usually capped with a metal or plastic point protector to keep pencil cases and pockets tidy. From the unsharpened ends to the perfect finish, everything is extraordinarily

The recycled 9800 EW is a green update on
Mitsubishi's 1940s success: the 9800.

neat, especially the actual construction of the pencil. These days, Japanese pencils are always cased in cedar. This is a standard that is taken more seriously than in some of the higher-end producers in other countries who still use other woods for some of their models. The specimens are also perfectly cut, with the cores perfectly centered—to find an off-center or poorly constructed Japanese pencil would be an anomaly.

Most of this is cosmetic; what's really distinctive is the graphite inside the pencil. That unmistakably smooth, dark quality of a Japanese pencil has everything to do with how fine the graphite particles are. For the most part, the graphite that Japan's pencils are made out of comes from China, which is where some of the world's finest graphite originates. From there, it's ground to a purity and fineness that makes for an extra-creamy mark. Some models of Japanese pencil contain various forms of polymer that act as a binder in the same way as clay or wax and make the pencil that much smoother. This doesn't mean that every Japanese pencil is of the absolute highest quality, though. It's not uncommon for lines of Japanese pencils to be called the same thing but classified on different levels. There will usually be an entry-level version, a regular version, and a premium version of the same pencil. The better the object gets, the finer the graphite is, the more elaborate the

finish, and, of course, the more expensive it is. When shopping for Japanese pencils in a regular stationery store, you're not only given a choice of hardness but also a choice of quality. When selecting, it's a matter of how serious you are about your writing tools and how much you're willing to pay for them.

Though pencils have been made in Japan since the late 1800s, they were particularly brought to light in the United States during the Great Depression. At this time, Japan started exporting pencils that were perceived as less-expensive imitations of the American standbys, many of which weren't labeled as being made in Japan—a trait that was met with quiet controversy. This was a great threat to the smaller U.S. manufacturers, and great lengths were taken to prevent any serious disruption to the domestic market. Distain for Japanese pencils in Europe and America lessened during the Second World War, when trade lines were limited and most Japanese pencils stayed in Japan and in its ally countries. Though Japanese pencils had always been graded in English characters, during the war, when English-speaking countries were the enemy, pencils were graded in Chinese characters instead.

As you can imagine, the post-war years were rough for the Japanese pencil industry (as they also were for Germany and some other

pencil-making countries). It took years for most manufacturers to recover completely and start exporting again, and new price controls in most pencil markets, Japan included, meant that certain pencils for certain uses had to be priced within regulations—just as American 5-cent pencils had to abide by very specific guidelines. Drafting pencils, writing pencils, drawing pencils, general use pencils, and even photo retouching pencils all had their own classification, and each pencil manufactured had to fall under one of the categories in accordance with the regulations. This is why Japanese pencils—even to this day, long after the regulations have been lifted—usually have text written on the back to designate their purpose. Certainly minor characteristics of the pencil might make them better for certain things, but the designations are no real indicator of what they have to be used for.

In Japan, there have always been two main pencil makers. The first one has a name that is usually more recognized for cars and appliances. Mitsubishi Pencil Company was founded in 1887 by Niroku Masaki and is the oldest existing Japanese pencil maker. Operating under the name Masaki Pencil Manufacturing Company until after the Second World War, when it was renamed Mitsubishi, the firm is now known mostly for the Uni-ball range of pens and other Uni branded products. But long before anything was branded as Uni (short for "unique") came the 9800 pencil, the pencil that put Mitsubishi on the map and offered Japan a higher-quality pencil. It's a pencil I consider to be the entry-level Japanese pencil and is one that is still made with a barrel and packaging design that is almost identical to how it looked in the late 1940s, when it was first introduced.

→ Mitsubishi Pencil Company has no relation to the rest of the Mitsubishi brand names, though their logos are similar. It's a combination of the word mitsu, which means "three," and hishi, which denotes a diamond shape.

The 9800 was just the beginning for Mitsubishi. In 1958 they introduced the first pencil in the now-ubiquitous Uni range. We can assume that this pencil was released in response to the Tombow Homo-graph, which was brought out by their main competitor just a few years prior. Up until these two pencils, the difference between a Japanese pencil and any other pencil was minor. The Uni and the Homo-graph were the finest, most elaborately finished pencils around and both led to greater things for both companies.

Tombow, in the meantime, was working on reinventing their new, snazzy flagship pencil. As a brand a few decades newer than Mitsubishi, they'd long established roots in Japan with their recognizable dragonfly logo (tombo means "dragonfly" in Japanese) and famous 8800 and 8900 pencils, which were similar to the 9800s that Mitsubishi made. As the social climate was changing worldwide and sensitivity towards the name's various connotations increased, Tombow made the decision to rebrand their Homograph pencil in the 1960s. The newly named Mono pencil came in 17 different grades and had a graphite core that contained a shocking eight billion particles per millimeter. Like the Uni, the Mono eventually became a product line of more than one pencil. These have changed names over the years, but they're now known as the Mono-J ("J" for "junior"), and Mono-R ("R" for "regular"), in addition to the highest-quality Mono 100, which was introduced in 1967.

→ Tombow numbered their original flagship pencil 8800 after the height of Mount Everest in meters. The now popular 8900 pencil is its contemporary.

The Mono 100 might be one of the most beautiful pencils ever made. Its black lacquer is so shiny it's almost reflective. The excessive text is finely embossed and the end of the pencil has a delicate white stripe over it. This pencil ticks all of the boxes for a well-designed pencil but is unconventional in its detailing. Designed in 1967 for the brand's 55th anniversary, it was made by renowned Japanese graphic designer Takashi Kono, who was on the 1964 Olympics

design committee and was also known for his contributions to the Japanese pavilion at the Osaka World's Fair in 1970. Tombow's designer pencil was daring, and likely a very expensive risk, but it was nothing all that new, as it was introduced one year after Mitsubishi started selling the Hi-Uni pencil as part of their growing Uni range. Like Tombow's product, this one was created by a well-known name in Japanese design. Yoshio Akioka, an industrial designer and carpenter, modeled the Hi-Uni to have a streamlined look, like the rest of the Uni pencils, but with the tiniest little details to make it special. The end was dipped in black paint, with a gold foil stripe stamped around it and a yellow dot pressed into the very tip.

Once again, Mitsubishi and Tombow were in sharp competition. With both of their premium new pencils on the market in the late 1960s, a period of time that can be called the golden age of Japanese pencils, they both had something special going for them. The Hi-Uni, for one, came (and still comes) in a huge range—larger than any other on the market—of 22 hardnesses, from 10H to 10B. The Mono 100, on the other hand, was numbered to reflect the massive 10 billion particles per cubic millimeter in the lead—something that is responsible for its unmistakable smoothness.

By the 1970s, both brands started to split into slightly different arenas. Tombow started making a range of Mono branded erasers, which went on to become bestsellers worldwide, and also high-tech correction tape, while Mitsubishi started making colored pencils and eventually spun off a Uni range of ballpoint pens, moving into the sector they're most known for today under the Uni-ball name. One thing that never quite caught on with Japanese pencils, though, is the ferrule and eraser. Mitsubishi makes a couple of models with them and Tombow makes the 2558, a pencil they inducted into their range after buying pencil-making machinery from America that included the machine needed to attach the ferrule and eraser.

→ In 2015, Mitsubishi announced the discontinuation of their 7700 colored pencils. The line of a dozen different colors was first introduced in 1971 and was greatly preferred by animators. As a result of immediate outrage from the Japanese animation industry, within 24 hours of the announcement, Mitsubishi had decided to keep producing light blue, orange, and yellow-green, along with red, a color deemed essential.

Though both Mitsubishi and Tombow have focuses outside of pencils these days, their heritages are in wood and graphite. The packaging for most of their products has remained unchanged in decades, as has the design of the pencils themselves. The vintage and new versions of their product lines are almost indistinguishable. Until the Second World War, it may have been common to find Japanese pencils in the United States, but it's since become harder and harder to get them, as most Japanese pencil companies don't have distribution outside of Asia.

With the growth in product lines for Japan's biggest pencil manufacturers also come super-specialized products. The best example of this is the Kohitsu Shosha pencil. Because learning calligraphy is an important part of primary education in Japan, a special pencil was created to make practicing a job significantly less messy than with a brush and ink or even a pen. The word *kouhitsu* is used to describe calligraphy pens with a hard tip, as opposed to a traditional softer brush, and has spawned a whole calligraphy subculture around its defining properties. In English, these models are referred to as penmanship pencils. Mitsubishi and Tombow both make their own *kouhitsu* versions and on the exterior they appear like any other wood-cased pencils. The distinguishing qualities, however, are drastically different. The core is always significantly thicker, measuring around 3 millimeters (1/8 inch) in diameter at its largest, and comes in very soft hardnesses, from 4B to 10B. Since calligraphy is an activity that requires different amounts of pressure applied to the instrument, the pencils must be extra-strong to bear

the weight. This might be something difficult to achieve with such a soft pencil but, then again, Japanese pencil makers are known for making strong softer pencils. Because of the soft, almost ink-like glide of the pencil and the width of the core, speed and line thickness are extremely variable.

At the height of Japanese pencil manufacture there were upwards of 125 pencil companies in operation. That number has since diminished greatly, but the tradition of Japanese pencil making certainly hasn't. Among the smaller brands still in existence is Kita-boshi Pencil Company, which was founded by the Sugitani family in the 1940s. Originally in the lumber industry, the Sugitanis produced slats for the Japanese pencil industry and started making their own pencils when they acquired assets from one of their customers. They've long since made licensed novelty pencils for big brands and this has helped other pencil brands realize their own product lines. In addition to the work they do for others, they make their own range of pencils, including a drawing pencil called the Super Drawing, designated very specifically "For photo retouching and special drawing," an eraser-clad pencil for "Academic Writing," colored checking pencils, and some simpler ones that highlight the quality of the wood. Their factory outside of Tokyo is small but full of character. They're one of the few companies who offer tours and have set up an education program for children. In the same vein as CalCedar's Duraflame logs, Kita-boshi has a strong interest in repurposing the wood refuse from pencil making. In addition to a paint made with wood, they make a wood clay called Mokunesan from "wood flour," which can be used like modeling clay, and a product called Pencil Flame, which is made with compressed wood chips and used as a fire starter.

Another interesting small maker is Camel Pencil Company, whose president Eiichi Kato designed the first ferruleless attached eraser in 1985. The round rubber eraser, usually black, gray, or white, is glued onto a peg at the end of the pencil, creating a seamless attachment. These pencils are most famous in the store-branded form that's sold at Ito-ya but are also available from a few outlets, including Japanese designer-stationery company Craft Design Technology, from Camel directly, or, most recently, from the MoMA Design Store, which highlights their history as an important design object. They're known especially for being excellent tools for writing music, because the graphite cores aren't too reflective and marks are dark but not smudgy and are easily erasable.

Japanese stationery history might be rooted in paper craft and have been popularized by high-tech pens, but as far as writing instruments go, it's critical to recognize the importance of the pencil, which precedes most of the Japanese stationery we find on shelves today. The separation between famous brand, superior writing pencils, and the novelty pencils the country is known for might be blurry but there's no doubting that Japanese pencils have a character all their own. Currently, they're making a huge comeback and gaining notoriety through Western brands like Palomino, which is based in California but mostly produced in Japan. The celebrated Blackwing 602 revival has proved a game changer for the twenty-first-century pencil and highlighted the characteristics that make Japanese pencils unique. As for stationery shopping in Japan—it really is an incomparable experience for anyone looking to overdose on pencils and their numerous accessories.

→ Mitsubishi's most prized recent pencil isn't wood-cased but mechanical. It's revolutionary mostly because it contains a mechanism that slightly turns the lead every time it's removed from the page to keep a sharp point. It's called the Kurutoga and is a prime example of Japan's move into modern pencil trends.

The _Blackwing_ Rises Again

Eberhard Faber's creation, much loved
by writers, died out in the 1980s.
Luckily—or controversially, depending
on your viewpoint—the Blackwing was
revived by Palomino in 2010.

The Blackwing displaying its distinctive
flat and square ferrule.

ll was not totally lost for the humble pencil at the beginning of the twentieth century. This can be attributed in great part to a single example: the Blackwing 602, one of the most storied pencils in American graphite history. With its famous fans and unique ferrule shape, the Blackwing 602 took the pencil from being a utilitarian necessity to a must-have office tool. As a favorite of John Steinbeck, among countless other writers, composers, and artists, it was the first pencil of its kind and one that, over time, proved to be irreplaceable. When Eberhard Faber was bought by Faber-Castell in 1988, the pencil slowly disappeared from shelves, leaving its die-hard fans in a frenzied panic. For the couple of decades following, as the American pencil industry fell on hard times, no pencil was deemed an adequate replacement, causing the price of secondhand dead stock to skyrocket online. However, one newly manufactured pencil stood out amongst the competitors in the hearts of American pencil sophisticates: the Palomino. Originally made under the brand name California Republic Stationers, it has been lauded as the most premium pencil available from an American brand since its launch in 2003. Though it's manufactured in Japan, the brand behind it is based in Northern California and has a history that's much deeper than you might think.

The Berolzheimer family has been involved with pencils for over a century. Most will recognize the name in association with Eagle Pencil Company, as Heinrich Berolzheimer, originally from Germany, was Eagle's founder. Later changing the business name to Berol, the brand was one of the few to stand the test of time, through all of the mergers and acquisitions towards the end of the twentieth century. What you may not know is that in the 1920s, the Berolzheimer brothers at the helm of Eagle Pencil Co. went separate ways: one remaining to run the pencil company in New York, the other moving to California to pursue a burgeoning California cedar business. Remaining in California proved to be a smart move for Charles Berolzheimer, since California cedar would prove to be the future of pencil wood once eastern cedar became scarce. At the ripe age of 25, he bought California Cedar Products (CalCedar) and began producing pencil slats for the world pencil market, mostly outside the United States.

→ The Berolzheimer's CalCedar company also invented the Duraflame firelog (originally called the California Cedar Firelog) in 1968 as a way to repurpose the cedar waste from their pencil slats. The cedar dust was mixed with petroleum wax to create a dense log that was used for home fires and has since become a U.S. household name.

Thinking back to how complicated it must've been to make wood-cased pencils in Henry David Thoreau's days (the 1800s), the idea of premade pencil slats made pencil making a much more efficient and accessible industry. CalCedar rose to become the largest supplier of cedar slats in the world, selling them to just about every premium pencil maker. By the 1990s, CalCedar, in its third generation of family ownership, gained FSC certification for their cedar slats—the first time this had been done in the pencil industry. This was a formal recognition by the Forest Stewardship Council of CalCedar's well-managed forests and high standards of environmental responsibility. On many pencils made with the company's wood, you'll find a little FSC logo stamped on the end—something that has become a benchmark for quality on a modern pencil.

While everything was booming in the cedar industry, fourth-generation CEO Charles Berolzheimer II took the business one step further by actually making pencils: a harkening back to his family's history and a serious passion project. This started with the ForestChoice pencil

in 1999, a naturally finished, eraser-tipped, affordably priced pencil that was the first model to be FSC-certified. From there the range grew with the Palomino, Golden Bear, Prospector, and Spangle—all pencils with different qualities and all made with CalCedar slats. These pencils were made under the California Republic Stationers brand name, under the CalCedar umbrella, and the superior Palomino was the superstar of the line from the beginning. It was a unique pencil for the early twenty-first century, mostly because it's simply branded, has a Japanese-quality shiny lacquer, and lacks the bar codes, model numbers, and frills that most pencils have. For long-time Blackwing 602 users, this was the best pencil on the market for replicat- *→ In 1996 CalCedar* ing that dark and smooth *launched pencils.com—the* feeling of the beloved *first marketplace of its* Eberhard Faber original. *kind for pencil aficionados* For those not yet inter- *looking to buy and learn* ested in pencils, it pro- *about pencils on the* vided a gateway into the *internet. Even 20 years* undiscovered world of *later, it's the leading* pencil snobbery. It wasn't *retailer for premium* long before California *pencils online.*

Republic rebranded itself as Palomino, following the popularity of the sleek pencil.

In 2010, due to the growing following of the Palomino and the longing for a revival of the Blackwing 602, Berolzheimer acquired the rights to the Blackwing name and introduced the Palomino Blackwing. When the pencil first launched, it came in one variety. It was painted a perfect matte black with a simple brass ferrule holding a white eraser resembling that of the later Blackwing 602 and was branded simply as the Palomino Blackwing; the Blackwing part of the name was designed in what looks like a more contemporary form of the original pencil's typeface. The design was bold—it was a modern twist on a classic, and apart from the ferrule and the name, its differences were noticeable. The core itself, though of high quality, was significantly softer than the original Blackwing: around the 4B range, which is generally considered too soft and too smudgy for general use. All of this considered, the point of such a pencil was not to replace or replicate the famous predecessor but rather to reignite the story and make a Blackwing pencil for a new generation of pencil users.

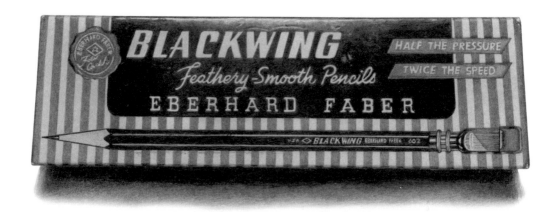

Original packaging with the Eberhard Faber pencil's slogan displayed on the front. The Palomino Blackwing has this emblazoned on the pencil barrel.

The following year it was no surprise when Palomino introduced the Palomino Blackwing 602—a tribute to its namesake with all of the physical attributes of the original, save for the black eraser that stood in place of the pink one. This pencil's core, though not identical to the original Blackwing 602, does come pretty close. The pencil even has the "Half the pressure, twice the speed" motto emblazoned on the back. Palomino perfected the formula with this pencil, and for the most part, fans of the original, including internationally renowned composer Stephen Sondheim, approved. This was not without a backlash—though the ill feeling had little to do with the pencil itself. Some members of the online pencil community were displeased with Palomino's marketing of their new pencil. They perceived Palomino as having claimed the Blackwing 602's history as the company's own, without properly acknowledging that the pencil is a reproduction, not the original made by Eberhard Faber. However, one of the new Blackwing 602's selling points is the heritage of its name and design, and if it wasn't for that very legacy, there wouldn't be a reason to constitute bringing back the pencil at all. Despite this conflict, there's no doubting that Palomino have made the Blackwing 602 relevant again in cultural dialog.

My first Palomino Blackwing 602 was purchased shortly after its introduction in a very small shop down the street from my home in London. Though I was a self-proclaimed life-long pencil enthusiast, my taste hadn't really veered far into premium territory. My favorites were the American classics and the exotic European pencils and this new Blackwing, something I thought was simply a part of history, was a shocking find. This was the pencil that turned me on to Japanese pencils, or rather, the world of softer, higher-quality pencils. It was something that encouraged me to delve deeper into pencil history and explore the great depths of pencildom. Today I'll admit that it's not my favorite pencil currently made

but it's one I regularly keep in my arsenal and one I love sharing with pencil skeptics. In my shop, we often refer to the Palomino Blackwing 602 as the "gateway" pencil. By that, we mean that it's alluring—the story, the shiny ferrule, the smoothness of the graphite—in just the right way to turn a naysayer on to the joys of a premium pencil. Those are the people who come back, wanting to know more and wanting to discover others. The Palomino Blackwing 602 has provided a perfect opportunity to engage pencil users of the twenty-first century and remind them that there can be such a thing as a pleasurable pencil.

In addition to the Blackwing and the Blackwing 602, Palomino now makes the Blackwing Pearl, which is a sparkly white version, graded right between the other two. Since 2014, they've issued quarterly limited editions, themed around different stories or histories. You'd be surprised how quickly these things sell out and how much they go for on eBay. The Palomino Blackwing has become a coveted item, just as the original was and still is.

→ Blackwing Volumes, as the limited editions are called, have been designed around Joe DiMaggio's hitting streak for the New York Yankees, John Steinbeck, and Georges Méliès's 1902 film A Trip to the Moon, to name just a few.

The buzz surrounding the new Blackwings and the clever limited editions has opened up a whole new market for pencil users. The pencils have played a major role in the revival of analog tools by being accessible, useful, well-made, heritage-rich objects. While it might be argued by some that Palomino has exploited the Eberhard Faber Blackwing 602, we can still be excited that someone is shedding light on a story that is worth telling. And, for newly minted adults who grew up in a world where pencils aren't the necessity they once were, both the story and the pencil function as an opportunity to understand a medium that has such an important place in history.

National *Treasures*

A pencil company's heritage is valuable. And while our prejudices might color our views, companies around the globe prove that making pencils in countries with low-cost manufacturing isn't a sin.

It has been a long time since pencils were a thing of excitement in most households. While shopping for school supplies in the United States in August, you'll find more unbranded pencils made from unidentifiable wood in China, India, or Mexico than not. There was once a time when "Made in x-country" was expected to reflect the place where a consumer product was actually crafted. But today that is rarely the case as the product is likely to have been made in China or one of the other typical manufacturing countries. As for the pencil, it has certainly been affected by this shift in manufacturing trends, but what most don't realize is that there are so many wonderful exceptions—you just might not find them on the shelves of your most convenient chain store. A quality pencil is not something impossible to source—you only have to know what to look for. That said, the pride so many existing companies exude for their "Made in" status is crucial to their branding as heritage products. Pencils are something made simply and easily in any climate. The raw materials are plentiful and making pencils on home turf, wherever that may be, is as easy as outsourcing—it just comes at a greater cost.

Most of the large brands known in the United States and Europe have either been bought out by other large companies, like Dixon Ticonderoga's acquisition by Fila, or they have themselves slowly acquired other brands over the past couple of decades, as Sanford, for example, have done. What usually happens with outsourcing is that either smaller subsidiaries are set up in other countries to support the local market or manufacturing is contracted out entirely to a larger multi-brand factory elsewhere, likely in a place unrelated to the origin of the brand. This is something that's been happening since many of the larger European companies started sending family members to set up shop in North America over a century ago.

For the pencil, though, outsourcing the labor entirely is a fairly new thing, considering the fact that until the 1990s most pencils were made within a certain proximity to where they were sold. Up until the last two decades, we'd long been used to seeing mostly branded, recognizable pencil models on the shelves of stores, varying depending on geography, but the norm has since become the ambiguous variety that says little more than HB or #2. In the United States, where even the beloved Ticonderoga is no longer made domestically, this is especially the case.

In the beginning of the twenty-first century, there was a shift. Greater awareness of the

origin of goods and a global desire to support regional economies have kept the remaining "local" pencil companies in business. It's been a couple of decades since any beloved brands have closed down and we can hope that this is going to be a pattern that continues for many more decades to come. With a need still to be met, there remain many pencil innovators out there who are willing to tackle the next century of pencil making with fervor and one eye always open to the future of analog tools.

→ Faber-Castell's South American pencils are made out of local wood and often branded as "eco." Though with nearly identical product names and general features to the German-made versions, South American Faber-Castell products have unique packaging and minor tweaks to their design depending on their exact country of manufacture.

There are two types of pencil users in the twenty-first century so far: ones who use them strictly for their intended purposes and ones who use them for a feeling of nostalgia. Of course, both do go hand in hand, but another factor we must consider is the comeback of "vintage."

Pencils themselves are not a vintage idea, but the modern use of them can be partly attributed to a desire to use a tool that is aesthetically and sensually pleasing, analog in its design, and a reminder of a time when communication was a less complex process. Over the past few decades, vintage items—the things that fill thrift stores and flea markets—have transcended the realm of being "trendy" and have become a lifestyle. The use of analog tools plays a big role in this, and an object as nostalgic as the pencil is no exception. Genuine vintage pencils are part of a market all their own but there are still pencil makers who, instead of discontinuing "vintage" models, are bringing back ones long defunct. It's an opportunity to take advantage of the popularity of such an aesthetic and an even greater opportunity to share the pencil's history while showing off a sense of pride in things that are still made the same way they always have been. Viarco, a brand based in Portugal, is a good example.

Viarco was founded, under a different name, in 1907 by French industrialists. Due to

The products by Portuguese firm Viarco sometimes have retro packaging, but the firm creates forward-looking blends of graphite such as this kneadable graphite putty.

bankruptcy and an interruption from the First World War, the company didn't actually introduce pencils to the commercial market until the late 1930s, when Manoel Vieira Araújo purchased it and resumed production. Araújo's first big move was to relocate the firm to São João da Madeira in the 1940s. From this small city in northwest Portugal, which the brand still calls home, they successfully began making pencils for the Portuguese market. Mostly simple writing and drawing pencils, the products were of exceptional quality, even from the beginning. The design of Viarco products, and the packaging in particular, is something characteristic of Portuguese design as a whole.

As one of Europe's oldest countries and a former colonial power, Portugal has unique influences from diverse parts of the world, including Africa, Central and South America, and Asia. The inherently "vintage" look of so many products Portugal is known for—from tinned fish, to hand creams, to pencils—is a historically important aesthetic that was founded under the Estado Novo regime between 1933 and 1974, when little outside influence was allowed into Portugal by its authoritarian government. On Viarco's classic Desenho pencils, the foil stamping looks nearly the same as it did over 50 years ago. The recently reintroduced copying pencil, one of the only copying pencils still manufactured, adapts the company's old box design, featuring "Viarco" written with an elaborate, undeniably Portuguese flourish. What makes Viarco most interesting, though, has been their ability to adapt to shifts in the global market in more recent decades. Like pencils from so many smaller brands, Viarco pencils are still a rather rare find in the United States, as they aren't often exported outside of Europe, especially the more nostalgic models.

However, what Viarco pencils lack in notoriety, they make up for in innovation. Their water-soluble Art Graf Soft Carbon model comes in packs reminiscent of how the pencils would have been sold in the 1940s: each bundle is wrapped in a strip of paper and tied tightly with string at both ends. Individual pieces are filled with a wide, dark, matte-black carbon core, which also happens to be water-soluble. They're unlike anything else on the market and part of a line of similarly unique products that also includes long, jumbo drawing pencils meant for sharing and a graphite clay that can be drawn with in huge, beautifully messy smudges. From magnetic pencils, to joke pencils, to a pencil stuck into the middle of a spinning top, the Portuguese brand have transformed old classics into playful and desirable twenty-first-century objects.

One product Viarco are especially recognized for is a range of scented pencils called Quintais e Jardins de Portugal. The scents, rather than reflecting those of sugary sweets and generic fruits, are of plants from the backyards and gardens of Portugal. These scents include lily of the valley (Lirio do Campo), orange blossom (Flor de Laranjeira), peony (Peonia), fig (Figueira), and jasmine (Jasmim)—little reminders of grandparents' gardens. The pencils themselves are made from cedar with no finishing, no eraser, and text that is very subtly printed. They're then soaked in perfume so they're not only pungent but also faithful to the scents they claim to be.

Viarco has done a remarkable job of taking their heritage and making it modern, interesting, and accessible. For so many of their patrons who aren't Portuguese, or maybe have never been to Portugal, they offer a refined taste of something distinctively local and a little education on design and culture. Recently, they brought back the designs of some of their products from the 1940s to 1960s, but in such a thoughtful manner that referring to these simply as reproductions would be insulting. The pencils themselves are flawless replicas of pencils from old and existing product lines and their packaging is so finely crafted and true to the original that if you found them in a stationery shop you'd

think they were decades old. Even before this, much of Viarco's product line included vintage remakes of old novelty pencils, including ones with iconic Portuguese characters, fruit and vegetables, animals—the list goes on. What is most pleasing about this little-known but iconic brand is their dedication to not only discovering the new but also celebrating the old.

A similar story can be told about the Danish brand Viking, which, like Viarco, has been around since the early twentieth century. Part of a popular Danish matchstick company, Viking, the firm's pencil sector, was set up by the owner's daughter's husband, who had a vision for expanding the company into other wooden goods. Viking operated on home turf until the 1970s, when the matchstick company was purchased by a major Swedish competitor, Svedska Tändsticks AB, who decided to shut down the pencil operations. Later, events took a rare turn: after slowly diminishing from the stationery landscape in Denmark, Viking resumed production in 2010 when it was purchased by a Danish company. They have since worked hard to preserve the brand's history and integrity by keeping production predominantly in Denmark.

Though they now have a large range of stationery products, Viking still make a core group of writing and drawing pencils, all of which are of premium quality and have the brand's signature little Viking ship stamped on them. Their two starter-level writing pencils for school (Skoleblyanten) and office (Skjoldungen) even have their names stamped on them in Danish instead of English—something that is a rarity for modern pencils. The most remarkable pencil, though, is one that requires a bit of explanation. It's large—even a little bit bigger than most pencils labeled "jumbo"—hexagonal, and has a hole drilled into the end of it. It's called the Valgblyant and is a pencil that was originally commissioned by Danish authorities for voting. The core is a super-thick, super-dark graphite that leaves an aggressive mark. As for the hole,

it's there so the pencil can be tethered to a voting booth or, well, anything. The Valgblyant is about as handmade as a pencil gets these days, and though it is significantly more expensive than most currently manufactured pencils, it is a remarkable writer and was created with a specific function in mind. It's these sorts of pencils—the ones that have purposes so specifically connected to their origins—that help the brands retain their history. Just as the Kohitsu Shosha pencil is a link to the heritage of Tombow and Mitsubishi, and as the Test-Scoring pencil is a connection to General's history, the Viking Valgblyant is a vital part of the dialogue between the past and present.

The aforementioned brands, Viking and Viarco, both, even now, have websites written entirely in the languages of their home countries. In a world where English is the third most widely spoken language and where websites very often have English translations, this seems like a very deliberate choice. Certainly it has something to do with the fact that the majority of the firms' sales markets are domestic, but it also exhibits, to the outsider, an amazing stubbornness towards conformity and mass marketing. Thankfully, web browsers can translate, but the exclusivity of the whole thing makes both brands a little nationalist in a way that is almost a charming preservation of their roots.

For many pencil-using countries, this dedication to local sales is something not uncommon. Though we live in an era where it's easier to import and export than in the past, many products don't make it out of their home markets and are hard to find online or are made inaccessible by websites in foreign languages. Perhaps it's because of cost, but from what I've observed, it's mostly because the demand or need isn't there. In the United States we have chain stores like Staples, where perfectly fine pencils, some still made by recognizable names, are sold, and in other countries there's an equivalent. These brands are to their countries as

The Belle pencil cutter and
sharpener, circa 1893.

French-made pencil cutter and
sharpener, circa 1857.

Morrisharp electric sharpener, circa 1946.

Raymond Loewy mehanical
sharpener, 1934.

Faber Castell double-hole
sharpener box, contemporary.

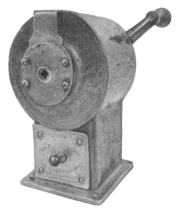

Olcott Climax sharpener, 1904. The
first pencil sharpener with a cylin-
dricalcutter with spiral cutting edges.

DUX adjustable sharpener,
available since the early 1950s.

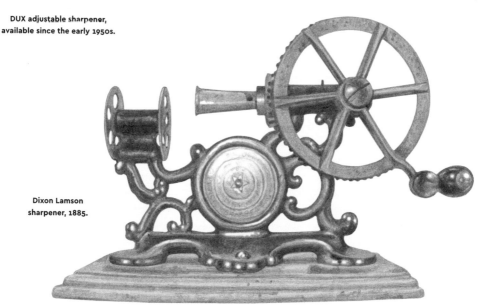

Dixon Lamson
sharpener, 1885.

Ticonderoga is to the United States, or Staedtler Noris is to most of Europe—they're old standbys that have no need to export.

It's hard to ignore the inherent sense of national pride these small companies exhibit. They have successfully achieved the impossible feat of making a product well and have garnered reputations that can thrive purely in their own environment. The strange thing about this, though, is that as analog tools continue to make a strong comeback, there's more and more desire for these hard-to-find brands who pride themselves on being their nation's designated pencil hero.

→ Considering how few pencil companies still exist in the United States, Made in the U.S.A. pencils are especially a rarity. In big-box stores the only one to be easily found is the Write Dudes USA Gold, which is made by Moon Products in Tennessee. General's pencils are often exported as America's quality pencil, but otherwise, American pencils are hard to find outside of the United States.

There is one brand in particular that I'd never heard of before I joined the pencil industry. One day I received an email from a man by the name of Shezhad Shah telling me that his family owns Pakistan's largest pencil company. Nearly two months later, a package showed up, gently weathered from weeks of travel. Inside was a very old, very beautiful box of vintage pencils from the family's Shahsons brand and a long letter from Mr. Shah, who is currently at the helm. Those pencils were early examples of the company's prized Goldfish Autocrat—a pencil well known in Pakistan. Each one was painted a shimmery brownish color and had a black tip with a yellow band. They used to be scented to smell like sandalwood and the packaging still says "12 scented pencils." As for the peculiar name, Mr. Shah speculates that his grandfather meant to call it the Goldfish Aristocrat but somehow it got a bit lost in translation. After testing the pencils, I was a little surprised to find that they were really wonderful. Since the Goldfish Autocrat—the Shahsons classic—a whole range of other Goldfish pencils have been added,

each with equally strange names, including the Goldfish Vista and Goldfish Blue Bird, in addition to an artist range under the Picasso name.

Shahsons are an example of a company started mid-century to serve a country's need. They were founded in 1953 and are by far one of the youngest pencil manufacturers in existence. Though their pencils are rarely found outside of Pakistan, and the name of the Goldfish Autocrat will never make complete sense, Shahsons's very existence makes a convincing argument that these things don't necessarily need to be exported. A similar situation stands in India and most of Southeast Asia, where Hindustan Pencils reigns supreme. Like Shahsons, Hindustan Pencils Pvt. was founded in the 1950s, and they have quickly grown to be the largest maker of pencils for their home population (in India) and for surrounding countries. They make pencils under the Nataraj, Apsara, and SiVO brand names. Originally specializing in writing pencils, the company now have a range that includes colored pencils, crayons, pens, sharpeners, and erasers. Their Nataraj 621 model is an icon of international pencils with its signature red and black stripes. It's long been the star of a well-known television commercial where the 621 races other familiar pencils around a track. All of the other pencils break, but the 621 finishes unscathed. Television commercials are something that makes Hindustan a little bit different—they're the only company to regularly advertise this way.

With 10 factories in five locations, Hindustan churns out an incredible eight million pencils a day and makes everything, even down to the screws used to attach the blades of their sharpeners, on their own premises in India. As for the wood—Hindustan are the best example of a company outside of the United States who make their pencils out of local wood that is sustainably sourced. You certainly won't find a pencil in their range made out of cedar, as the preferred wood for their high-quality pencils is usually poplar.

The difference with Hindustan, though, is that their products are actually exported to 50 different countries—you just wouldn't know it. Pencils under their three brand names are sold almost exclusively in Southeast Asia, and known very little in the Western world. However, their pencils are very often disguised as others made for and sold by big-box stores looking for a less expensive alternative. If you find an unbranded pencil that says "Made in India," it is very likely made by Hindustan.

Being made in another country isn't always a bad thing. Hindustan pencils are great, especially given their extremely low price point. The same can't be said for many other inexpensive pencils, but the "Made in x" phenomenon seems to criticize any product that doesn't clearly advertise its country of manufacture or, similarly, any object that isn't made in the country in which the brand has a clear and reputable heritage. If you go to a supermarket in South America, chances are that in the school and office supply section you'll find pencils branded as Faber-Castell or any number of European brands. They will probably be products you're unfamiliar with or perhaps products that appear to be lower quality or almost fake versions of their originals. Don't be fooled—they're the real deal; they're just made locally, with the domestic market in mind.

Pencil sharpener manufacturers exhibit their own share of national pride. The brands Kum, Dux, and Möbius & Ruppert, all proudly made in Germany, the original pencil nation, hold court as the makers of the world's finest affordable sharpeners. In fact, Germany makes the vast majority of sharpeners that are available in art supply stores or otherwise. If not branded with a recognized German brand name, many of the sharpeners currently available are very likely made by another company in Germany. Even so, these tried and true German sharpening heavyweights make sharpeners whose designs are as well known as their reputation for quality. Still, there are certain models made to service the demands of modern pencil using that are remarkably hard to find outside of Germany.

The long-point sharpener phenomenon is a recent trend but a powerful one. As pencil users develop more discerning tastes through exposure to more varieties of pencils, the same standards have started to apply to sharpeners. The ability to sharpen a pencil to an extended, gradually tapered point is credited to Kum's two-step long-point sharpeners. These consist of two holes where the first blade sharpens the wood and the second sharpens the graphite. This was taken to an extreme in 2015 with the introduction of the Masterpiece, a handmade magnesium two-step sharpener in elaborate protective packaging, which creates the longest point on the market. Since then, Möbius & Ruppert have upped the ante of their range of classic solid-brass sharpeners by introducing a long-point version and a concave version, both of which have a demand so high that they've become rare commodities.

I'll admit that, like a lot of people, I love a proudly Made in the U.S.A. product, but there's also a lot to be said for a product made in a country known for inexpensive manufacturing that actually serves its function well. National pride is an interesting thing when it comes to something that has become as easy and inexpensive to manufacture as the pencil. You can meditate on the importance of origin as much as you like, but pencils come from all over the world and they're mostly made domestically for the local market (with the exception of the United States, strangely enough)—a strong sense of national

> → *Today, writing by hand is is appreciated more and treated with greater care and importance outside of the West, where many schools don't even teach cursive anymore. For example, in India, Pakistan, and Japan, handwriting is still considered an important part of the curriculum and standards are extremely high, even in adulthood. Though the art of writing by hand is slowly becoming obsolete, the need for pencils in these countries hasn't faltered.*

Jasmine scented pencils made by Viarco. The fragrances in the
Quintais e Jardins de Portugal range are designed to be an
"olfactory portrait" of gardens in the company's home country.

pride keeps most pencils in the countries where they are most loved. Brands like Viarco, Viking, Shahsons, and Hindustan all have something important in common: they're extremely proud of where they come from and that is reflected in the design, use, and manufacture of their products.

Even though we in the West may be in the habit of frowning upon Made in China products, there are, of course, Chinese brands who exhibit a great amount of pride in their nationally branded pencils. Pencils crafted by Chung Hwa, a company founded in 1935, are known throughout the country, especially the beloved 6151, which is the most recognized branded pencil in China, and, like the Nataraj 621, has alternating black and red stripes. Like Mitsubishi, the Chung Hwa name is synonymous with other companies in its home country and the firms in other sectors are unrelated. → *Chung Hwa pencils and* In a price bracket similar *their similarly priced* to Shahsons or Hindustan, *competitors usually retail* Chung Hwa is an example *for less than $1 per* of a rarely exported but *dozen—shocking, as any* nationally adored everyday *pencil of that price* object, one which writes *outside of Asia would* beautifully and lives up to *normally be unusable.* its reputation.

In the context of the pencil, national pride, though the feeling is usually frowned upon, is something necessary to the product's identity. To glorify a pencil made in an unusual place is not such a bad thing. With the decline of analog

tools, what's amazing is that pencils are still being made in far corners of the world and not entirely by the same old subsidiaries. I've heard the word "artisanal" used to describe unknown, small-brand pencils before, but I'm not convinced that's the correct label. Can't a pencil just be a pencil? Can't it exist in the world and be celebrated more for its interesting origin and less for its appeal as something niche? We've talked about Caran d'Ache, whose Swiss heritage is vital to the brand and whose Swiss flag is proudly used to market products. Or Faber-Castell and Staedtler—the old greats of Germany, whose reputability through age and history almost precedes the products themselves. It's the backstory that's selling all of these pencils.

During the war-stricken early twentieth century, the country of origin was an important aspect to advertise because of tricky trade laws and embargos. That's no longer so much of a concern; today it's the heritage and reputation of the pencil maker that are important. Whether a brand is 70 years old or 200, where they come from and how that origin is honored has everything to do with the place of their products in the twenty-first century. The importance of retaining heritage by keeping production local is certainly part of the story these companies have to tell, but as it becomes easier and cheaper to outsource labor, that part is more valuable than ever.

Current Tendencies

The internet changed things for the pencil. Fresh ways of discovering history, new (and stranger) fan bases, and an increased appreciation for analog pleasures have all helped the tool grow.

As I write this, it's September 2016. A lot has changed since the pencil was born centuries ago and most of that has to do with a thing we know as the computer. Instead of crediting the computer, or, really, word processors and the internet, for the decrease in pencil use in the past three or so decades, I'd rather take a look at all of the ways the internet has been good for the pencil. We must first consider that without the internet, it would have been much more difficult for me to write this very book. In 1992, a mere year after the internet went live for the general public, *The Pencil: A History of Design and Circumstance* by Henry Petroski was published. This book is the one and only comprehensive resource for all of pencil history and should be given credit because it was written before such a magnitude of information was available without even leaving a desk.

→ Henry Petroski, an American engineer and academic, has dedicated his career to studying and writing about failure analysis in design and engineering as well as the invention of well-known objects, including paperclips and, of course, pencils. His prolific works on engineering have cemented his reputation as an authority on all things related to the way things work.

What the world wide web has allowed is the ability to easily access the history of the pencil (a history that hasn't been documented as extensively as you might think). It has also allowed e-commerce, giving us the ability to know about and buy not only pencils of decades and centuries past but also little-known pencils from countries far away. Without the internet, my interest in pencils likely wouldn't be what it is today. I should mention that I was born in 1990, the same year as the first web server and browser were developed. By the time I was old enough to have interests worth researching, I had a boxy Dell computer in the attic of our house to give me all the information I needed. When I first developed an interest in pencil history, it was the internet that told me what an Eberhard Faber Blackwing 602 was and what on earth the pencil-grading scale is. I'd be willing to bet that the same goes for most of those long-time pencil users who blog about them—the internet not only made it possible to have a worldwide conversation about pencils but also provided a place to discover them. The beautiful thing, though, is that a tool as analog as the pencil hasn't been totally uncovered by the internet. There are still models that are unsearchable or nonexistent according to your web browser.

One resource that can be credited for exposing the rare pencils of yesteryear is a website called brandnamepencils.com, which was founded in 2005 by pencil collector Bob Truby. It's a place that I, along with my colleagues and pencil friends, use as a vital resource for identifying

found pencils and validating the existence of the mythical ones. What you'll find is a website divided into two categories: type and brand. Once you've made your selection, you're taken to a page where all of Mr. Truby's pencils in that category are photographed clearly and listed alphabetically by model name. There are thousands of pencils. Rare ones, famous ones, ones that you won't even believe to be real—the collection is quite simply beyond comprehension. Mr. Truby comes from a family of collectors, and finds interest in pencils because they're easily collectable and because there's no comprehensive catalog of everything that's out there. His website, though still growing, functions as that very thing—the largest catalog of known pencils on the internet. What you'll also find on his page is a Most Wanted section where he lists the pencils he's still on the hunt for. The search is never-ending, as Mr. Truby believes that there will always be new ones to find, and from the looks of it, he's most certainly correct. This idea of an unknown frontier of collecting is a fascinating thing. The holes in the available information and catalogs make for an especially rare type of hunt—one that the internet can only help with so much.

I'm not sure that Mr. Bob Truby really realized what he was doing when he took on such a project. He's created the largest known catalog of pencils known to anyone. There are so many that even he's lost count. As a person whose interest in these things is unending, I feel extremely indebted to have access to such a resource. I also wonder if Mr. Petroski's book would have been affected by this or by any of the other pencil-related developments on the internet since. In the near decade and a half since his book's publication, little else has been formally written about pencils, but when it has, I've found that most of it cites only Petroski as a reference.

Tools used by artisanal pencil sharpener David Rees.

Apart from Petroski's influence on people's exposure to pencil history, the internet has allowed a new dialog around the objects and a way to share information. Numerous blogs exist solely dedicated to pencils and analog tools, and platforms like Facebook have offered a chance for continuous discussion. Even a podcast called *Erasable* exists for this reason and hosts a community of like-minded utilitarians and nostalgists who still care about the humble pencil. The involvement of the internet in the discovery of pencil information has also attracted a new demographic of user: individuals who hadn't given the pencil a single thought since elementary school shopping lists.

→ *The* Erasable *podcast is hosted by Tim Wasem, Johnny Gamber, and Andy Welfle, all of whom started the conversation about pencils online through their respective blogs. They've opened up the subject to a worldwide audience by talking from a stance that the most knowledgeable aficionados and recreational pencil users alike can relate to.*

One person who has helped to build up the pencil's good name in the twenty-first century is David Rees. He is known online as an official artisanal pencil sharpener, who, until recently, charged $40 on his website to have a single pencil sharpened. You could mail in your pencil, very strictly a #2, and a few weeks later you'd have it returned in the mail with a fresh point. With a knife, a handheld sharpener, and a single- or double-burr hand-crank sharpener, and usually along with the help of sandpaper or an emory board, he'd sharpen your pencil perfectly, protect the tip with vinyl plumber's tubing, place it in a shatterproof tube, and send it back to you, along with a certificate and the shavings neatly collected in a tiny bag. This spawned an entire book on the subject, the aptly named *How to Sharpen Pencils*, published in 2012, which upon first glance is assumed by most to be purely satire. Around the same time, a video lasting 9 minutes and 27 seconds went viral, pushing the simple act of sharpening a pencil to a point where it became a conversation again. Mr. Rees

became known worldwide for his incredible dedication to such a quotidian, menial task—one that most pay little mind to. His book—well-designed, thorough, hilarious, and easily marketable—brought the pencil to light as a still-relevant, desirably analog object. Perhaps the whole thing was an experiment, but Mr. Rees surely played his cards right as his odd job eventually landed him a television show called *Going Deep with David Rees*, which, for the two seasons it was aired, explored other activities in a similar vein. In 2016, he announced he was retiring from pencil sharpening—or, rather, he raised his price to $500 per pencil so as to eliminate his customer base. It was a short-lived career, perhaps, but one with a lasting impression. What Mr. Rees did for the pencil was to put it in a new context and make a claim for its longevity and value using brilliantly employed humor.

Before Mr. Truby and Mr. Rees, though, publisher Bill Henderson's Lead Pencil Club began the conversation about the effect of the internet on activities usually performed with a pencil or, similarly, a pen. In a book of essays published in 1996 called *Minutes of the Lead Pencil Club*, he explored the idea of the depersonalization that could be induced by technology and took an active anti-technology stance. His statement, made through his well-regarded albeit extreme "club," is something that we still ponder as the importance of pencils is minimized by quicker and more convenient digital alternatives that record more accurately. The conversation regarding this is more about computer technology and less about pencils, though in their functions the analog and digital objects aren't actually so dissimilar.

The thing about the pencil, though, is that, just like the computer, it is a communication technology. A few centuries ago, the idea of a pencil may have seemed convenient, but it was also disruptive to the order of things. What the pencil lacks in high-tech power, it makes up for in freedom and privacy. When you write with a

pencil, you can be sure that those words are not only erasable but entirely yours. When was the last time you could confidently say that about anything you put on the internet? There's a certain freedom to writing with a pencil and a connection to the mind that can never be matched by a computer. Fortunately for people like me who are attempting to keep such things alive, there are scores of people still interested—perhaps more than the pencil's analog power will ever let us know (it's not as self-advertising as digital media).

Maybe some industries that once relied on the pencil have a choice now. Draftsmen have programs like AutoCAD, illustrators have products like the Adobe software range, and writers have word processors. The claim that Venus Pencil Co. once made about everything being started with a pencil may now be a romantic notion of the past. A few icons of culture and

Mary Norris, comma queen and fan of the #1 pencil, sharpens the tools of her trade.

industry have advocated the pencil, but none with more influence in recent years than Mary Norris, famed copyeditor of the *New Yorker,* who published the book *Between You and Me: Confessions of a Comma Queen* in 2015. Chapter 10, towards the very end of the book, is titled: "Ballad of a Pencil Junkie." For 23 pages, Ms. Norris reminisces about, expresses disdain towards, and ultimately declares her love for the wood-cased wonder that is the #1 pencil. She tells of the days when a young man with a tray would traverse the *New Yorker* office offering seemingly unlimited numbers of freshly sharpened pencils, as well as of a horrific time when her beloved #1s became impossible to find and couldn't be replaced by the comparatively scratchy #2. She perfectly describes her struggle: "Writing with a No. 2 pencil made me feel as if I had a hangover. It created distance between my hand and my brain, put me at a remove from the surface of the paper I was writing on." Eventually, at the peak of her frustration, Ms. Norris discovered the Palomino Blackwing 602—the addictiveness of which she likens to that of Oreos.

For literary types as well as academics, the musings of a journalism icon about the pencil stirred up interest in rediscovering the thing that was once so defined by a writing career. Writing with a pencil after spending years doing most things without it is a refreshing sensation. As for the internet, let's face it—we can't live without it, so it's really just a matter of finding a successful way to live with it. It has opened up a whole new world for learning about tools of communication, just as it has stolen from the personal nature of those very things. Certainly there's a balance to be found somewhere. For those of us who decide to use pencils in the twenty-first century, it's not just about getting information down on paper, it's about connecting with the thoughts that are being written, and making the writing process as much a mental exercise as it is a form of communication.

CW Pencil Enterprise

Offering both "gateway pencils" and fodder for self-confessed addicts, this little piece of pencil paradise was a leap into the unknown.

During the truly miserable dead of winter early in 2014, I decided to quit my day job and focus on starting a business that I'd decided to call CW Pencil Enterprise. First came the idea, which was thought up many years prior when I became frustrated knowing that there were scores of amazing pencils I wanted to try but couldn't get my hands on. I thought maybe there were other people out there looking for them too. Maybe there was more to the story of this thing I loved so much. As much as I joked about the whole thing, in the back of my mind I was crunching numbers and dreaming of my own pencil paradise.

Next came a tattoo—a simple line drawing of my "gateway" pencil, an early 2000s matte-black Ticonderoga, drawn to scale by my mother and emblazoned on my left forearm. When people asked why I had a pencil on my arm, I usually replied with an embarrassed quip about my love for the things, rarely mentioning my plan.

Finally, something switched. As a recent college graduate trying to figure things out in New York City, I realized that if there was ever a time to take a risk, I ought to do it while I was young. I slowly sent emails to the companies whose products I'd long used or whose products I'd never been able to track down. Much to my surprise, few companies thought I was joking when I said I was opening a pencil shop. The closets in my apartment started to overflow. I spent my summer building a website, and in November I was ready to put it online. Even then, I didn't tell

anyone apart from my friends and family. I am not a businesswoman, nor am I marketing genius. I thought often about the implications of selling an analog item on the internet. The two things didn't belong together (or so I thought), and I didn't feel I could do the pencils justice by simply taking a picture and writing a description.

Word got out and my online POS system started filling up with orders. Before I knew it, I was signing a lease for a tiny storefront that I serendipitously found on a Lower East Side street that I considered to be the last frontier of gentrification in downtown Manhattan. That winter, one year after I seriously started considering all of this, I began designing my dream pencil shop. In my mind, it always had a checkerboard floor reminiscent of a school hallway. In the back of the shop there would be a red velvet curtain. The shelves would be lined with labeled glasses, each containing a pencil. Most importantly, there needed to be desks: one for pencil testing and one for me to sit behind. No counter—just a desk with a chair on both sides. There was also going to be a rolling library ladder if space allowed. The objective: to create a fantasy land that glorified a nearly forgotten object but also made it an accessible luxury—one that didn't take itself too seriously. A place where everything begs to be touched and used, and where that sort of thing is very welcome.

The day the shop opened that following March, I still had not told anyone about it besides the couple of hundred of Instagram followers I

had amassed and a few friends and family. A few neighbors and curious passersby came in. With each purchase, I carefully placed the pencils in a yellow envelope and tied them with string, and each customer was surprised, even amused, to see such care taken. There was no marketing plan—PR is expensive and I always imagined this place as something that would just be discovered naturally. For a shop like mine not to seem too "niche" or "hipster," it seemed right to let it take on its own life. Romanticism aside, I decided to give it two months before coming up with a strategy. Fortunately for my fledgling business, a blogger came, and then a bigger blogger, and then a few online magazines, and then one day, the *New York Times*. It happened quickly and posed quite a challenge: how does one maintain the integrity of a specialty store and also keep up with demand? I still haven't fully figured this out. After the snowball effect of sudden success and the hiring of a few wonderful like-minded analog-tool users, CW Pencil Enterprise is a place I proudly call home and one I'm happy to have as a part of my city's landscape.

I'm a dedicated pencil user. I'm not really an artist or a writer but fall into a category I refer to as "recreational pencil user," a category that doesn't receive much attention in the twenty-first century. My expertise lies in convincing others that a pencil, a good pencil, doesn't have to have a designated purpose but can be a part of everyday life like it once was. The more I learned, the more I uncovered companies with little-known histories and tales of accidental design and innovation. From the beginning, I knew a store that only sells pencils would be just as much about the stories each object told as it was about the objects themselves. More so than selling things, my job is as a storyteller.

When you visit CW Pencil Enterprise, you'll find a wall with alphabetized pencil brands, each section divided by model, and the models standing in champagne glasses. The displays on the tables hold every type of eraser one might need,

accessories you never knew you needed, and a small but comprehensive selection of sharpeners. With the addition of a few paper products and a case full of vintage models, that's it. The shop is small, so interaction with whoever is behind the desk is encouraged, as is some time spent at the testing station, which contains every pencil in the shop. Rarely do people come in and stay for just a couple of minutes. There's a pencil vending machine full of antique advertising pencils and walls covered in ephemera. What people come for, or what I hope they come for, is an experience. When you walk into the store, you're immediately hit with the smell of cedar. There's a lot to look at but even more to talk about.

It's all of the strangers I've met in the past two years—the stories they've shared and the passion they've grown with my help—that have made my business a success. This is the type of social generosity that's hard to find in an internet-driven world. Of course, there's the online business to consider and the inevitable fact that my shop is often labeled as being "twee" or "niche," but those things are overshadowed by the human element. It's the community of people that has accidentally formed around the pencil that validates the existence of a shop like mine. It's the letters from individuals I've met while ogling new finds, or those people I meet on social media through a photo we've posted. As I've grown with my strange little business, I've discovered how important it is to find a balance between working with something physical and living online. My shop has helped me navigate that territory, and through the pencils purchased, I hope it does the same for visitors. My job is to remind people of how wonderful pencils are. These things are not forgotten on the whole, they're forgotten by individuals who, for whatever reason, have become out of touch with the idea of writing with something physical or unplugged. It's my job to share what I know and to show that there is a pencil that everyone can relate to, whether that's through its function, its design, or simply its story.

Future Staples

The fully stocked shelves of CW Pencil Enterprise lined
with items for both pencil nerds and recent converts.

Ephemeral, tactile, and physical: the pencil connects the hand to the brain in a way that a mouse and monitor can't. But is there a place for it in the long term?

Now we're faced with a reckoning that can't go without discussion. The future of the pencil is a topic I'm often asked about and one that can be argued at great length. This has as much to do with analog tools as a whole as it does with pencils specifically. With each new cell phone introduced and each new app, the need for such things diminishes a little bit more. The pencil's importance is overlooked as it is deemed increasingly unnecessary. The word "necessary" is one I'd rather refrain from using because, though I can make a claim in favor of pencils, they're not "necessary" by the standard definition of the word. What they are is a novelty—and by that I mean that they are novel. According to *Merriam Webster*, this is "the quality or state of being new, different, or interesting." What we've forgotten about the pencil is now being rediscovered, and new life is breathed into it with each fresh one being sharpened and used. It offers a change of pace that's drastically different to what we've become accustomed to. Through distance from daily staples like the pencil or any of its stationery friends, we are gaining a new appreciation. What is actually a very old object is made new again to so many twenty-first-century adults, meaning it is reborn as a thing of pleasure, rather than something one must have on their desk to make it through the day. To write with a pencil is to acknowledge the past and also to seek creative freedom for the future.

Pencils offer a type of ephemerality that no substitute will ever be able to compete with. They disappear with use, leaving only a messy pile of shavings. When you sharpen them, they smell like the wood, or even the forest, they were harvested from. When you write with them, you can hear a sound with each little scrawl. When you pick them up, they're light in weight but sturdy in their perfected construction. If you regret the words or lines that you put down, you can erase them with the friction of another simple object whose dust will remind you of the marks that no longer exist. You might argue that the only sense that isn't stimulated by a pencil is taste, but can you chew on your keyboard or phone in a time of frustration? Using a pencil is a sensual experience that truly nothing can replace. It can take you back to a time when all you needed to have in your bag was your homework and a few dull pencils.

Nostalgia is the most powerful sensation with an object like this. I dare you to find a single person on this planet who doesn't associate a memory with the smell of a wood-cased pencil. You may not be able to remember the last time you wrote with a pencil but you can probably remember what is like to write with one, the place you were when you did, and the purpose for which you were using that pencil. So many memorable moments in life have a pencil involved. Whether it be learning to write for the first time in kindergarten, filling in the bubbles on an SAT exam, voting as a fresh 18-year-old, or marking down product numbers during your first trip to Ikea. I may be a sentimentalist, but if we take a moment to slow down and pick up a pencil, the

result will always be the same in the end. Once you get past the fear of making your first mark, your brain will connect with the paper, through your hand and through the instrument in it, and open up a sort of freedom that you won't find on an LCD screen.

By removing ourselves from writing by hand, we're also putting our memories at risk. The thoughtfulness that goes into taking notes by hand leaves a lasting impression on your brain. The words that you write are more likely to stick because of the physical involvement you've dedicated to them. A pencil can't help you remember where you lost those written notes, but what it can do is provide a vehicle for retaining them mentally, and in a more lasting way than typing them can.

As for the future: for as long as the pencil exists, there will be a use for it. For the majority of this chapter, I've ignored the pencil for its purposes for drawing, as this is an activity for which the pencil will always be appreciated. We don't have to worry about the pencil in the context of art. What we need to worry about is the pencil's place in everyday life. Should you be stuck in a bind and need something quick to write with, the pencil is your best friend. It's hard not to wonder about what might happen when the generations who remember the pencil as an essential item aren't around any longer to remind us, but I have hope that the pencil will remain on the aisles of office supply stores for considerably longer. Will there be a time when pencils are no longer at the top of school shopping lists? Will they become an icon of the past? I can't answer any of those questions, but as someone who was born a millennial, I can tell you that part of the reason I glorify the pencil to such great length is because to me it is a luxury. I feel privileged to have so many outlets of expression—computer-related ones included. I love Instagram as much as the next person and use my iPhone to send messages and emails to my friends as much as I write letters to them. The thing is, I have a choice. I don't have

to use a pencil, but I choose to because it feels natural and nostalgic and because it's something I choose to do for myself, not something I have to do.

I want to be stimulated by the thing I use to express myself and to make note of observations and essential information. One thing I think is important to always remember is that a traditional pencil is an object made simply out of wood and graphite. As you use it, it becomes smaller and smaller. Its physicality is diminished by thought and creativity. Think about a pencil and all of the words, ideas, images, and revelations that a single pencil has the potential to contain. Midcentury American pencil advertising executives had the right idea—though they used the number of words a pencil holds as a way to express value, instead of a more abstract idea. The pencil provides an opportunity to make those thoughts put onto paper a tangible thing. It offers freedom of expression and a sense of forgiveness.

My computer is a vital part of my job and my existence. It will always be the first thing I interact with when I get to work, and it will always be something I turn on every day, but that will never be an act as pure as picking up a pencil and writing down the things I dare to think but might not dare to say, do, or admit to. What we need to do is take the time to remember how to communicate like humans, using objects that reflect and encourage that. As long as there is a story to tell, a letter to be mailed, an object to be made, or an image to express, there will always be a pencil to help you along the way.

How to *Start* a *Pencil Collection*

Pencils are an excellent thing to collect for connoisseurs of all ages because not only are they very accessible but they're also small and easy to store and useful should you ever choose to surrender your collection. When starting a pencil collection, there are many things you must consider. What kind of pencils are you going to collect? What is your goal? What will you do with your pencils? These are all important questions, as trying to collect every pencil without parameters will likely leave you feeling totally overwhelmed and spinning in a downward spiral of unhealthy pencil obsession. First and foremost, though, you need to decide what kind of collector you want to be. These are a few options:

THE PENCIL HOARDER

Your pencils will stay in mint condition, totally unused. If this is what you choose, be prepared to invest some time and money into a proper storage or display system.

THE PENCIL USER

If you so choose, it is totally okay to collect pencils and still use them. Maybe you want to know what it feels like to write with them before you put them away in the archives, and in that case, just be prepared to never resell them, as rarely do others want to buy used pencils.

THE INDECISIVE

Should you have the funds and the will to do it this way, it's not uncommon to buy two or more of every pencil you wish to collect. Presumably, one will be used and one will enter the collection. This option is recommended for those who wish to have the most thorough knowledge of their subject.

Once you've decided what type of collector you wish to be, it's crucial that you narrow down the playing field a bit. You could choose a single brand, or even a single pencil model (the Eberhard Faber Mongol, for example, has existed in over a hundred forms and would make a lovely collection). You could also choose to collect novelty pencils, hotel pencils, or some sort of specialty pencil.

By now, you should have all of the important decisions out of the way. You're ready to start a pencil collection! Follow these steps with care:

STEP #1: BUY OR FIND A PENCIL

This seem like an obvious suggestion, but it's more important than you might think. For as long as you are pursuing your collection, you will be fondly recollecting the pencil that started it all. Perhaps you already own this pencil. Maybe you're going to search for a specific one. Choose something interesting, or something with a particular personal meaning.

STEP #2: SET YOUR STANDARDS

Pencils are generally inexpensive and plentiful, so if you choose to make a collection of them, it's important to set rules for yourself. Is there an end goal? How many is too much? Are you going to display your pencils? What is your price limit? Perhaps you have no rules, in which case please be prepared to spend a lot of money and run out of storage space very fast.

STEP #3: HOW ARE YOU GOING TO STORE YOUR PENCILS?

Once you start acquiring pencils, you will inevitably have to find the perfect place for them. For this, you have a few options. Should space not be an issue, an old library card catalog is a fine choice. If you're working with a closet or a shelving unit, cigar boxes are a terrific size. For something more streamlined and organized, a small filing cabinet with shallow drawers is an excellent option. You may also want to display the pencils. If that is the case, a shadow box, wooden stand, or decorative pencil cup will allow you to swap out the chosen pencils as often as you wish—this is ideal, as you can keep a constant rotation so as to enjoy your collection without getting bored of it.

STEP #4: DOCUMENTING YOUR PENCILS

While collecting your pencils, you'll want to keep track of the ones you have so you know what to keep searching for. If you're tech-savvy, setting up a spreadsheet is not a bad idea. If you are a little more analog, as it can be assumed you might be if you're collecting pencils in the first place, I'd recommend keeping a notebook to track your date of acquisition, finding place, model number, era, etc. This might require a bit of research to learn more about the pencils you have, but the internet is your friend in this situation.

Photographing your pencils, as Bob Truby of Brandnamepencils.com has done so thoroughly, is not a bad idea, as you may want to review your collection without disturbing the actual pencils. Be sure to use a good camera, as the foil detailing on pencils is often difficult to photograph.

STEP #5: ADMIRING YOUR PENCILS

What's the point of having a collection if you're not going to enjoy it? Be sure to visit your pencils often, share them with your friends, and use them as an opportunity to learn more about them and their history. They are utilitarian objects; please make sure you utilize them in some way. Maybe you should even consider setting up a mini pencil museum in your home or your workplace. Or perhaps you're saving them for your future children or grandchildren or great-grandchildren who may (heaven forbid) be relatively unfamiliar with the pencil in the distant future.

OTHER THINGS TO CONSIDER:

· Are you interested in eventually selling your pencil collection? This is something I highly discourage. You are not buying pencils to let them sit in a box and appreciate in value, or at least I hope you're not. Even the pencils with the most value aren't expensive enough to count on for retirement, so don't get your hopes up.

· Flea markets and estate sales are great places to search for pencils. Do not be afraid to rummage or to be that strange person who walks into every antique store and immediately asks where the pencils are.

· If you have children or pets, be sure to store your pencils in a safe place. They may be mistaken for school supplies or chew toys.

Starting your own pencil collection is not a hard or difficult thing to do. What matters most is what you put into it. The whole point of a collection is to acquire a large quantity of a single item to admire and study. As long as you're sure to choose a type of pencil that you enjoy hunting down and learning about, you're bound to get the most out of your collection. Let your pencils tell a story.

Pencil
Destinations

UNITED STATES

American Pencil Collectors Society Convention
Biennial, in varying locations

Once every two years, members of the American Pencil Collectors Society meet to trade, sell, share, and show off their collections. It's the largest known gathering of such a group of like-minded pencil enthusiasts in the world. Admission can be gained by filling out an application and contributing the $10 membership fee annually through pencilcollector.org.

Joseph Dixon Memorial Forest
Lake George, New York, U.S.A.

Off of Route 8 near Lake George in upstate New York, you'll find Graphite Mountain: a place to take you through some of the sites of the famous American graphite mines of yesteryear. It's all part of the Joseph Dixon Memorial Forest (dedicated in 1958), which stands where Dixon once mined his graphite. Take a hike along the Fenimore Cooper Trail for the full experience.

Eberhard Faber Factory
61 Greenpoint Ave., Brooklyn, New York, U.S.A.

The factory that once made Eberhard Faber pencils in Brooklyn might now be full of apartments and offices, but remnants of its past are still evident. Look at the top of the building to spot the art deco ceramic pencils on the facade. Across the street you'll find a bar called "Pencil Factory" where you can have a cocktail and pretend it's still the dawn of the twentieth century.

Little Saint Simons Island
1000 Hampton River Club Marina Dr.,
Saint Simons Island, Georgia, U.S.A.

The Berolzheimer family (pencil giants of the twentieth century) originally purchased this island for its abundant natural cedar in the early 1900s. However, the wood there was found to be too splintery for making pencils, so the area was instead turned into a private retreat for the family. The public can now book stays at the intimate, all-inclusive The Lodge at Little St. Simons for the full eco-lodge experience.

Shelbyville, Tennessee — Penciltown U.S.A .

Should you find yourself driving across America, be sure to roll through Shelbyville, the original pencil hub of the south and home to 100-year-old Musgrave Pencil Company. If you're lucky you might spot remnants of the pencils of decades past.

Paul A. Smith Pencil Sharpener Museum
Hocking Hills Visitor Center, Hocking Hills, Ohio,
U.S.A.

Not far off the highway in the lush Hocking Hills region of Ohio you'll find a small shed outside of the visitor center that contains the vast and well-organized pencil sharpener collection of the late Paul A. Smith. You'll find sharpeners of all types and eras, mostly of the novelty variety and absolutely no duplicates.

The Henry David Thoreau Collection
at the Concord Museum
200 Lexington Rd., Concord, Massachusetts, U.S.A.
The majority of the earliest American pencils were craft-
ed in Concord, including those made by Henry David
Thoreau and his father John Thoreau. Visitors to the
Concord Museum can learn not only about the historic
town but also about the Thoreaus and their legacy.

The World's Largest Pencil, housed at City Museum
750 N 16th St., St. Louis, Missouri, U.S.A.
The current record holder for the world's largest pencil
was set by Ashrita Furman in 2007, when he contracted
a 23-meter-long, 8,164-kilogram (76-foot, 18,000-pound)
pencil in Queens, New York. The pencil is made from
wood and has a graphite core as a regular pencil would.
It can be viewed at the City Museum in St. Louis.

ASIA
Ito-Ya
2-7-15 Ginza, Chuo 104-0061, Tokyo, Japan
For one looking to witness the Japanese appreciation
of stationery at its finest, a trip to Ito-ya is a must. It's
a stationery department store of sorts and also has a
separate annex building that houses the writing instru-
ments, including the large number of pencils.

EUROPE
Cumberland Pencil Museum
Carding Mill Ln., Keswick, Cumbria, U.K.
Run by and located near the Derwent Pencil Company
in England, the Cumberland Pencil Museum is dedicated
to the history and manufacture of Derwent pencils
and the history of the Cumberland pencil industry and
graphite mines.

Faber-Castell Castle and Museum
Nürnberger Str. 2, Stein, Germany
For a thorough glimpse into the history of German
pencil-making history, Faber-Castell occasionally opens
the doors of its spectacular castle, plant, and museum
to the public—just be sure to book your tickets in advance
on the Faber-Castell website.

Seathwaithe Plumbago Mines
Borrowdale, Cumbria, England
Borrowdale was once famous for its graphite mines,
which date back to the earliest days of pencils. The
mines may now be depleted, but they're still open to
visit. Situated in the Lake District of England,
Borrowdale is a beautiful setting for mine exploration,
outdoor adventure, or a relaxing weekend in the
countryside. Be sure to search online for companies
offering official mine tours.

Glossary

BARREL The fully assembled wood casing of a pencil is often referred to as the barrel. Barrels usually tend to be triangular, hexagonal, or round in shape.

"BIG FOUR" During the early to mid-twentieth century, the term the "Big Four" was used to describe the four biggest pencil companies in the United States that made up the vast majority of pencil sales. It included the American Pencil Company, Dixon, Eagle Pencil Company, and Eberhard Faber.

BORROWDALE It is widely accepted that graphite was discovered in the Lake District of England in the middle of the 1500s. For the first couple of centuries of its existence, the best, purest graphite in the world came from Borrowdale, England, until the mine was totally depleted. To this day, it is believed that Borrowdale graphite was the finest graphite ever known to man.

BRIDGE PENCIL A bridge pencil is one that is about 1/3 smaller in length and diameter than a normal-sized pencil. It was once popular for use when scoring card games.

CLUTCH PENCIL First invented in 1929 by Caran d'Ache, a clutch pencil is a non-wood-cased pencil that features a "clutch" mechanism that holds a 2 millimeter (5/64-inch) lead inside the metal body. The clutch is released with the push of a button on the end of the pencil.

CONTÉ METHOD The modern method for making stronger pencil cores was developed by Nicolas-Jacques Conté during the French Revolution. Conté mixed finely ground graphite with clay and fired it in a kiln—the first example of an effective method for making strong, usable pencils out of lower-purity graphite.

COPYING PENCILS Also known as an indelible or an ink pencil, a copying pencil contains aniline dye, which allows it to be transferrable when pressed with a wet sheet of paper. Due to the presence of dye, it is also non-erasable. This made it an ideal writing instrument for writing and signing documents during the First World War.

CORE What is on the inside of the pencil is called the core, or rather, the graphite core. The core is an extruded mixture of graphite and clay that is fired in a kiln and then glued into the groove of the wood slat during pencil production.

FERRULE The little metal tube that connects the eraser to the end of a pencil is a ferrule. They're usually made out of aluminum, though originally they were made out of brass. During the Second World War they were made out of plastic or cardboard due to metal shortages.

FOIL STAMPING The method used for branding pencils is called foil stamping. It involves setting type into a machine that heats up to a temperature upwards of 93 degrees Celsius (200 degrees Fahrenheit). The machine holds a roll of foil and pushes the type into the foil and onto the pencil, leaving a slightly embossed foil stamp on the pencil.

HARDNESS The hardness of a pencil describes the ratio of graphite to clay in its lead. If a pencil's hardness is described as soft, the pencil contains more graphite and is marked with a "B" following the number of its hardness. The higher the number, the softer the pencil. If it's described as hard, it contains more clay and is marked with an "F" or an "H" following the number of its hardness.

KAOLIN CLAY Pencil lead is made out of a mixture of graphite and clay. Kaolin clay is the most common clay found in pencils because it's soft and fine. It can also be found in many cosmetic products and can be ingested as a natural remedy for many ailments.

NON-PHOTO PENCIL Usually in a particular shade of blue that can't be detected by a photocopier or scanner, a non-photo pencil is popular for use while doing first drafts of illustrations and drawings.

POINT RETENTION A pencil's ability to hold its point. If a pencil stays consistently sharp after use, it has good point retention. If it dulls easily, it has bad point retention.

PUMICE Erasers are traditionally made out of a combination of natural rubber and pumice, which acts as an abrasive. Pumice used for erasers is very finely ground volcanic rock, originally preferred to have Italian origin.

SLATS In a modern pencil factory, pencils are made in batches of multiples, which are cut from wood slats. These are rectangular pieces of wood used to sandwich the pencil lead before the pencil is cut out by a machine.

WATER-SOLUBLE In reference to pencils, the terms "water-soluble" and "aquarelle" are used interchangeably. These terms describe a type of pencil—either graphite or colored—which contains a binder that dissolves in water to allow a paint-like effect when used with a paintbrush.

WOOD FLOUR When pencils are produced in a factory, a large amount of sawdust is left behind. Called wood flour, the fine sawdust is often repurposed. Alternately, wood-composite or plastic pencils are made with wood flour.

Bibliography

Abramovitch, Seth. "Why Is Hollywood Obsessed with this Pencil?" *The Hollywood Reporter*, 8 Aug. 2013, http://www.hollywoodreporter.com/news/blackwing-602-why-is-hollywood-600265.

Arons, Irv. "The EPCON Plastic Pencil." *ADL Chronicles*, 23 July 2008, http://www.adlittlechronicles.blogspot.com/2008/07/epcon-plastic-pencil.

"At the Sharp End." *The Economist*, The Economist Newspaper, 3 Mar. 2007, http://www.economist.com/node/8770415/print?story_id=8770415.

Baron, Dennis E. *A Better Pencil: Readers, Writers, and the Digital Revolution*. Oxford, Oxford University Press, 2009.

Bernard, Bush. "Tennessee's Pencil City Still Makes its Mark with Flair." *Cincinnati Enquirer*, 12 Oct. 2003.

Betz, Paul R., and Mark C. Carnes. *American National Biography. Supplement 2*. New York, Oxford University Press, 2005.

Bolin, Robert L. "Guide to Autopoint and Dur-O-Lite Spiral Pencils: A Working Paper." *Http://Unllib.unl.edu/*, 25 Feb. 2005, http://www.unllib.unl.edu/Bolin_resources/pencil_page/mystery/spiral_guide.

"Chronology." *Viarco*, http://www.viarco.pt/cronologia/.

Cirkel, Fritz. *Graphite: Its Properties, Occurrence, Refining and Uses*, vol. 2, Ann Arbor, MI, University of Michigan Library, 1907.

"Company History." *CalCedar*, http://www.calcedar.com/company-history/.

Dube, Liz. "The Copying Pencil: Composition, History, and Conservation Implications." *The Book and Paper Group Annual*, vol. 17, http://www.cool.conservation-us.org/coolaic/sg/bpg/annual/v17/bp17-05.

Dubnet, Stephen J. "How Can This Possibly Be True?" *Freakonomics*, 18 Feb. 2016, http://www.freakonomics.com/podcast/i-pencil/.

"Emile Albert Berol, 81, A Pencil Manufacturer." *The New York Times*, 9 Oct. 1993.

"Evolving the Lead Pencil." *The American Stationer*, vol. 69, 21 Jan. 1911.

Ewing, Jack. "Hands-On Bavarian Count Presides Over a Pencil-Making Empire." *Nytimes.com*, The New York Times, 3 Dec. 2013, http://www.nytimes.com/2013/12/04/business/international/hands-on-bavarian-count-presides-over-a-pencil-making-empire.

Ferreri, Marco. *Pencils*. Mantova, Corraini Editore, 1996.

Fleming, Clarence C. *The Pencil: Its History, Manufacture and Use*. Bloomsbury, NJ, Koh-i-Noor Pencil Co., 1936.

"Graphite Industry Is Growing Here." *The New York Times*, 4 Sept. 1917.

Harding, William. *The Days of Henry Thoreau: A Biography*. Mineola, NY, Dover Publications, 2011.

Haynes, George Henry. *The Tale of Tantiusques: An Early Mining Venture in Massachusetts*. Worcester, MA, American Antiquarian Society, 1912.

Henderson, Bill. *Minutes of the Lead Pencil Club: Pulling the Plug on the Electronic Revolution*. Wainscott, NY, Pushcart, 1996.

"The History of the American Lead Pencil." *Scientific American Supplement*, vol. 187, 4 Jan. 1879.

Kennedy, Pagan. "Who Made That Built-In Eraser?" *The New York Times*, 13 Sept. 2013, http://www.nytimes.com/2013/09/15/magazine/who-made-that-built-in-eraser.

"Kita-Boshi Pencil Co., Ltd." *Bureau of Industrial and Labor Affairs*, 19 Mar. 2015, http://www.tokyo-ritti.jp/english/special/voice/ui72b20000000w8h

Malone, Sean. "A Conversation With Eberhard Faber IV." *Contrapuntalism*, 6 Sept. 2016, http://www.contrapuntalism.wordpress.com/2015/06/08/a-conversation-with-eberhard-faber-iv/.

Malone, Sean. "No Ordinary Pencil: A Portrait of the Eberhard Faber Blackwing 602." *Blackwing Pages*, 22 Feb. 2012, http://www.blackwingpages.com/no-ordinary-pencil/.

"Mitsubishi Pencil Museum." *Uni Mitsubishi Pencil*, http://www.mpuni.co.jp/museum/.

Munroe, William. "Memoir of William Munroe." *Memoirs of Members of the Social Circle in Concord*. Cambridge, MA, Riverside Press, 1888.

Norris, Mary. *Between You & Me: Confessions of a Comma Queen*. New York, W.W. Norton Company, 2015.

Norris, Mary. "Pencils Up." *The New Yorker*, 9 Nov. 2015, http://www.newyorker.com/magazine/2015/11/09/pencils-up.

Owen, David. *Copies in Seconds: How a Lone Inventor and an Unknown Company Created the Biggest Communication Breakthrough since Gutenberg: Chester Carlson and the Birth of the Xerox Machine*. New York, Simon & Schuster, 2004.

Pat Sorokin. "Graphite." *The Michigan Technic*, vol. 78, no. 6, Mar. 1960.

Petroski, Henry. *The Pencil: A History of Design and Circumstance*. New York, Knopf, 1990.

Rees, David. *How to Sharpen Pencils*. Brooklyn, NY, Melville House, 2012.

Secrest, Rose. "Erasers." *How Products Are Made*, vol. 5. Farmington Hills, MI, Gale, 1996.

Stock, June Duran. *Twenty-Five Cent Gamble*. Bloomington, IL, AuthorHouse, 2012.

"The Story of the Viking Pencil Factory." *Viking Creas*, http://www.viking1914.com/page/maerker/viking/blyantfabriken-viking.

Tombow Perfect Book. Japan, Ei Publishing, 2013.

Truby, Bob. "Bob Truby's Brand Name Pencils." *Bob Truby's Brand Name Pencils*, http://www.brandnamepencils.com.

Ward, James. *The Perfection of the Paper Clip: Curious Tales of Invention, Accidental Genius, and Stationery Obsession*. New York, Touchstone, 2015.

Wilkinson, W.T. "Photo-Lithography and Photo-Zincography." *The Photographic Journal*, 1 May 1896.

THE
PENCIL PERFECT

The Untold Story of a Cultural Icon
by **Caroline Weaver**

This book was conceived, edited, and designed by Gestalten.

Written by **CAROLINE WEAVER**
Illustrated by **ORIANA FENWICK**

Edited by **ROBERT KLANTEN** and **SVEN EHMANN**

Art direction, layout, and cover by **BRITTA HINZ**
Creative direction design by **LUDWIG WENDT**

Typefaces: Catalog by Mika Mischler and Nik Thoenen
(Foundry: www.gestaltenfonts.com), Cera by Jakob Runge

Editorial management by **VANESSA OBRECHT**
Copy-editing by **AMY VISRAM** and **NOELIA HOBEIKA**

Made in Europe

Published by Gestalten, Berlin 2017
ISBN 978-3-89955-675-9

© Die Gestalten Verlag GmbH & Co. KG, Berlin 2017

Bibliographic information published by the Deutsche Nationalbibliothek.
The Deutsche Nationalbibliothek lists this publication in the Deutsche Nationalbibliografie; detailed bibliographic data are available online at http://dnb.d-nb.de.

This book was printed on paper certified according to the standards of the FSC®.

FSC
www.fsc.org

MIX
Paper from
responsible sources
FSC® C057358